Praise for *Women in the Picture*

"I'm glad this book was written because it felt like the scales were
falling fr

ence, *Herald*

"*Women* iting for. It's
the first at the history
of art through the lenses of gender, intersectionality, and contem-
porary pop culture. Essential reading for anyone interested in this
subject, it's gripping, inspirational, beautifully written and highly
thought-provoking."

—**Helen Gørrill,** author of *Women Can't Paint*

"Catherine McCormack succeeds in the nearly impossible task of
discussing both the representation of women throughout the history
of art as well as how women artists have challenged these male-
centric images. She writes beautifully and with an accessible voice,
moving effortlessly from the Rokeby Venus to contemporary cul-
ture's narcissistic obsession with social media selfies. A wide range
of readers will benefit from her synthesis of thousands of years of
art about the female body and how this has impacted and occluded
our understanding of women's experience."

—**Kathy Battista,** author of *New York New Wave*

"I loved Catherine McCormack's terrifically smart and sometimes
scathing *Women in the Picture*. On this grand tour of Western visual
culture from Botticelli to Beyoncé, virtuous mothers to monstrous
women, from Lilith to *I Love Dick*, you couldn't ask for a better
guide than McCormack, an art historian with attitude who offers
a rousing new lens for looking 'beyond the exchange of seeing and
being seen.'"

—**Bridget Quinn,** author of *Broad Strokes*

WOMEN IN
THE PICTURE

WOMEN IN THE PICTURE

WHAT CULTURE DOES WITH FEMALE BODIES

CATHERINE McCORMACK

W. W. NORTON & COMPANY
Independent Publishers Since 1923

*To my beloved S&D, that they might see
the world clearly. And to Barny, for that
spider diagram all those years ago.*

Text copyright © 2021 by Catherine McCormack
First American Edition 2021

Originally published in the UK under the title WOMEN IN THE PICTURE:
Women, Art and the Power of Looking

For information about permission to reproduce selections from this book,
write to Permissions, W. W. Norton & Company, Inc.
500 Fifth Avenue, New York, NY 10110

For information about special discounts for bulk purchases, please contact
W. W. Norton Special Sales at specialsales@wwnorton.com
or 800-233-4830

Manufacturing by Lakeside Book Company

Library of Congress Cataloging-in-Publication Data

Names: McCormack, Catherine, 1980– author.
Title: Women in the picture : what culture does with female bodies /
Catherine McCormack.
Description: First American edition. | New York : W. W. Norton & Company,
2021. | Includes bibliographical references.
Identifiers: LCCN 2021029604 | ISBN 9780393542080 (paperback) |
ISBN 9780393542097 (epub)
Subjects: LCSH: Women in art. | Sex role in art. |
Man–woman relationships. | Art and society.
Classification: LCC N7630 .M39 2021 | DDC 704.9/424—dc23
LC record available at https://lccn.loc.gov/2021029604

W. W. Norton & Company, Inc., 500 Fifth Avenue, New York, N.Y. 10110
www.wwnorton.com

W. W. Norton & Company Ltd., 15 Carlisle Street, London W1D 3BS

1 2 3 4 5 6 7 8 9 0

Contents

Preface

At first glance, there was nothing unusual to see. A story was unfolding across three panels in an art gallery. At its centre stood a long-haired woman surrounded by a lot of men in tights and a menagerie of animals. In the painting, men talk a lot. Big dogs bark at smaller ones, their fur fraying and their

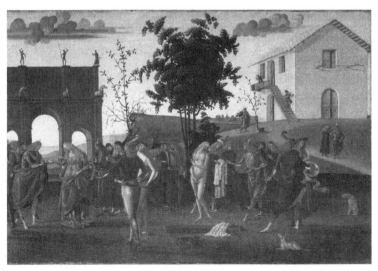

Master of The Story of Griselda, detail from *The Story of Griselda, Part 1: Marriage*, about 1494. © The National Gallery, London

eyes bewildered. In one panel, a small, depressed-looking bear is delicately chained to the decorative architecture. In a few instances, the same long-haired woman appears stripped naked, and even the dogs in the image look at her with pity, their ears down, feeling the heat of her shame.

I was in the Sainsbury Wing of London's National Gallery, bouncing my fractious baby on my hip, trying to keep engaged with my work as an art historian and educator after the birth of my second child and keen to view the gallery's rehang of its Renaissance collection. I wanted to see which works had come out of their dark and silent storage like time-travellers to the present. After all, museums' collections are not static: they get rearranged and reconfigured, making pictures from the past speak to one another, and to the public who owns them, in endless ways.

And this story of the long-haired woman definitely had something to say. For, while I was looking more closely at the panels, a man appeared at my shoulder. 'I wouldn't look too deeply into the symbolism in this one,' he said with a note of warning. 'The message it promotes isn't fashionable at the moment.'

His manner was both avuncular and imperious. 'Oh?' I replied with a nervous laugh, taken by surprise by the unsolicited commentary delivered so close in my ear and so close to my body. 'But this symbolism is exactly what I am interested in, you see. I'm an art history lecturer and I'm preparing for a course I'm teaching on feminist art history and the depiction of women in paintings.'

But the man in the gallery didn't listen to me. He just saw a woman with a baby, a woman who was not too young to be

unapproachable, but young enough that he expected me to listen to him when he wanted to talk. He saw me as a mother, and perhaps not so much as a mind. I wanted to be rid of him, but I also wanted to look at the painting and didn't have much time. So I stayed in that room, with this man who needed me to know that he knew this troublesome story, narrated in a painting that had at one time hung in a home in Italy in the late fifteenth century. The story goes like this.

An Italian marquis known as Gualtieri was reluctant to marry, but knowing he needed an heir, he set out to find a wife. He found a peasant girl called Griselda, who was well known for her virtuousness and obedience. Still, Gualtieri needed to be sure that this peasant girl was going to always do exactly as he asked, so he put her through a series of cruel tests to prove her constancy (sometimes known in medieval literature as the 'wife-testing plot'). First, he stripped her naked in public, ostensibly to reinvent her in the clothes of her new noble life, but conveniently exposing her body to humiliation and the mercy and desire of his and the public gaze. Graciously accepting this indignity, she had passed the first test. After their marriage and the birth of their first child, he ordered that their newborn daughter be killed without explanation. The child was taken away, and Griselda was forbidden to ask any questions. When Griselda bore a son, he too was taken from her and killed on his father's orders. But Gualtieri had secretly ferried his children to other families. Then, he dissolved the marriage. He dismissed Griselda from their home, stripping her once more of her clothes and her claims to any status. Many years later he invited her back as a servant, and gave her the task of preparing a banquet

for his new wife. Ever tacit and compliant, Griselda agreed. But the new marriage was revealed to be a trick – and the 'bride' was revealed to be the long-lost daughter. Griselda was 'rewarded' for her constancy and compliance, and was finally granted her role as wife and mother in a noble family.

With tired patience, I listened to this tedious 'mansplaining' of a story of unmitigated misogyny, smiling to myself, thinking how funny and ironic this was going to be as an anecdote to share with my students, who would inevitably all be women. And how we would all laugh about the crude and ridiculous posturing of men inside and outside of pictures. But I also knew that really it wasn't funny at all, and that the laughter, camaraderie and camp indignation we would treat it with, tutting with the exasperated retort of 'MEN!', was really a way of not despairing, because this sort of thing happened so often that it felt like the inevitable order of things. The painting's message was also inevitable for any fifteenth-century bride. The husband was master, to be obeyed at all costs. Abuse was to be endured, marriage and motherhood the ultimate prize. In the final panel's scene, Griselda is embraced and kissed by Gualtieri, but she has the lobotomised glassy stare of an obedient automaton stunned into submission, like a Renaissance Stepford wife.

The three panels that make up the 'Story of Griselda' are among the National Gallery's collection of over 2,300 paintings. Among these are some of the world's favourites – Van Gogh's sunflowers wilting in a vase, Seurat's proletarian swimmers at Asnières, Leonardo da Vinci's *Virgin of the Rocks*. Over the past twenty years I have been inspired and delighted by the details of so many works in the collection: the reflection of the clouds

in the stream in Piero della Francesca's *Baptism of Christ*; the detumescent Mars in Botticelli's joke about men rolling over after sex in his panel painting of *Venus and Mars*; the bristlingly red room of Degas' *La Coiffure*; the silhouettes of the birds seen from the window of Antonello da Messina's impossibly detailed study of Saint Jerome. But there are also the things I can no longer reckon with: things that I see, which cannot be unseen. Irritated by my encounter in front of *The Story of Griselda*, I turned the corner and found a woman on the ground with her throat pierced, oozing blood from her jugular and with a deep gash on her forearm; her wrists already hooked with rigor mortis; her high round breasts and gently curving stomach egregiously exposed. The only witnesses were a satyr and a mastiff, both looking on vacantly at the dying woman, the dispassionate limpid blue of the horizon flatlining any of the scene's horror.

Piero di Cosimo's undated painting is given the loose title 'A Satyr Mourning over a Nymph', but the narrative draws on the mythological story of Procris, who was suspicious of her husband Cephalus and spied on him by hiding in bushes in the forest where he hunted. When he called to his beloved Aura to 'come into his lap and give relief to his heat', Procris stirred, creating a rustling in the bushes, and Cephalus shot her thinking she was a wild beast. It is a cautionary tale about the fatal consequences of wives spying on husbands.

On my way to the exit I passed by the malignant biblical story of Susanna and the Elders, the comely young woman spied on while bathing by two lascivious old men who say they'll denounce her as an adulteress unless she sleeps with them. I walked past the figure of the mythological nymph Leda, curled

into a conch-like shape as she is violated by the god Zeus who has taken the form of a swan. I glanced again with a shudder at a portrait of a woman posing as Lucretia, the Roman noblewoman from Livy's histories who killed herself with a dagger to her breast to atone for the shame brought on her family after she was raped.

Seeing these images in their heavy gilded frames, tenderly lit and guarded by tasselled ropes and attentive guards, somehow made male desire and violence both precious and part of the unquestionable natural order of things. They seemed to celebrate the fact that female virtue is rewarded when it is bravely guarded, and that threatening male behaviour is tolerated. They celebrated that being the focus of male sexual desire is an honour (if you are Leda) unless it sullies the patriarchal bonds of honour because you are owned by another male (if you are Lucretia or Susanna), in which case the victim always pays the price for the crime.

The walls of our galleries have a sacrosanct charge that absorbs any censure. Oil paint is a soothing medium that smooths out the brutality and double standards of these narratives and turns them into lessons in culture and civilization for the general public. But what other alternative histories lie buried in plain sight beneath the gilded frames, the imposing ceilings, the tasselled ropes and the protective glass surfaces that deflect proper scrutiny? What discomfiting things are we prepared to overlook in the name of 'beauty' and the art-historical concepts of value, 'genius' and achievement that we tend to so readily accept? Through whose power and at the expense of whom did they even get here?

Explanatory wall-text often casts no judgement, focusing instead on artistic invention, achievement, style or value – and a pat on the back for the mostly male artists for their singular genius.

The mostly male artists.

While there is no shortage of pictures of women on the walls of the National Gallery, in a collection of 2,300 paintings, only 21 are actually *by* women.[1] It is a discrepancy that the gallery has only very recently openly recognised. The National Gallery is not the only collection with this problem – the invisibility of women artists is part of a much wider, pervasive system of exclusion. In 2019 the Freelands Foundation annual report on gender disparity in the creative arts sector found that 68 per cent of artists represented by London's top commercial galleries were men, and only 3 per cent of the top-grossing works at contemporary art auction were by women. This is despite the fact that women take up more than two thirds of places on creative arts and design courses in higher education.

The statistics are even worse for artists of colour; the Black Artists & Modernism's National Collection Audit found that there are only around 2,000 works by black artists in the UK's permanent collections. In the US, African American women make up just 3.3 per cent of the total number of female artists whose work was collected by US institutions between 2008 and 2018 (190 of 5,832).[2]

This absence of women as creators and professionals can be felt not just in our prestigious national collections of art, but also in the public spaces of our cities. The Public Monuments and Sculpture Association of the UK has a database of 828 known

sculptures on its (non-exhaustive) inventory. Just one fifth of these are sculptures of women. But this number represents sculptures of women's *bodies*. When we take away the statues of nymphs and generic nude female figures (for example, representing allegories or symbolising geographical locations), then the actual number of sculptures of named women from that total of 828 is reduced to just 80. Almost half of these are of royalty, many are of the Virgin Mary, and none of them is of a female politician. (By contrast, there are 65 sculptures of named male politicians in public spaces around the country.)

Historically speaking, women have not been allowed to look; held back from studying and entry into the professional sphere, they were not allowed to look at books nor at the world – more specifically, they weren't allowed to look at the world of men, in case they found something that they wanted to challenge. This restriction also meant that women have historically been excluded from looking at bodies, either as doctors or as artists. This privilege not only gave men near total control over the way women's bodies worked but also over the way women's bodies have appeared, in everything from paintings and sculptures to medical textbooks, cinema and political cartoons – and these representations are not necessarily reflective of the myriad ways in which women see themselves.

Some of our best loved works of art are about stopping women from seeing: John William Waterhouse's *The Lady of Shalott* (1888) hangs in the collection of Tate Britain in London and consistently features in polls of the UK's favourite paintings. Its subject is taken from Alfred Lord Tennyson's 1833 poem of

the same name. It is about a woman trapped in a tower, under a curse that stops her looking directly at the city of Camelot. Instead she is only allowed to see the world through the reflection of a mirror and must obediently get on with weaving representations of it. One day she tires of seeing the world mediated in this way and looks at the passing knight Lancelot, with whom she falls in love. For this she must die. The curse erupts. She climbs into a boat in a white dress and floats away down the river until, as Tennyson puts it in his verse, 'her eyes were darken'd wholly, and her smooth face sharpen'd slowly'. Like the fate of Procris, shot by her husband, the story is about the perils that afflict women who look.

While paintings of flowers and landscapes were just about tolerated as a hobby for the amateur 'lady-painter' as part of her portfolio of charming talents, women were excluded from professional training in art academies. Up until the twentieth century, formal, academic art training always emphasised the mastery of drawing the nude body as the foundational bedrock of everything, in the form of the 'life class' or 'anatomy class'. And the nude model, especially the male nude, provided the basis for the sorts of paintings and sculptures that communicated lofty ideas about humanity, culture and civilization, and religion – the sorts of subjects that made it onto murals, church altarpieces and ceilings in the palaces of the powerful, or as sculptures in public places. The male nude body in art, from its very beginnings in ancient Greece, was about heroism, strength and even intellect. And images of nude, white men subsequently became the normal signifiers of not only the infallible period of classical antiquity and all that was considered impressive about

white European civilization, but also of any worthy cultural and intellectual ideas.

But there was such anxiety over the thought of a group of women scrutinizing and understanding a nude male body that women were almost entirely kept out of professional artistic training until at least the end of the nineteenth century, and even up to the middle of the twentieth century in the UK. Among the founding members of the Royal Academy in Britain in 1768 were Angelica Kauffman and Mary Moser – two women artists who had managed to slip through the institution's systemic gender discrimination. This presented a problem when Johann Zoffany produced a group portrait of the founding members. In his painting *The Academicians of the Royal Academy* (1771–72), a bevy of cultivated men gaze with reverence on one of two nude male life models, their eyes twinkling with inspiration, their expressions settling into satisfied recognition of something approaching the divine. In the foreground, looking out to the viewer, the other male model sits casually peeling off his stockings to add to the growing tumble of clothes on the floor at his feet. Beneath him the sculpted nude torso of a woman's limbless body lies on the ground, skewered by the walking cane of the green-jacketed man beside him. Zoffany's painting leaves us in no doubt as to whose bodies count when it comes to the production of 'great' art, and whose are treated as little more than meat.

The presence of these two nude men in the studio erased the possibility of any women appearing in the scene, whether they were artists and founding members or not. In order to tolerate their presence, Zoffany turned Moser and Kauffman into pictures and hung them on the wall (above the two men in black

on the right-hand side), where they appear as painted portraits, not as people. Let me put that in different terms: women – even when they were seminal artists themselves – could only be depicted as they were seen by others and not in the act of seeing the world themselves.

After the demise of these eighteenth-century women, whose presence within these circles was so precarious, another woman was not elected as a full member of the Royal Academy until 1936. In the minds of the British establishment, therefore, *there were no women artists* between 1768 and 1936.

The anxiety about women looking at naked men in the studio and manipulating their bodies at will with their pen or brush is at the crux of everything. It is an admittance that looking, and who gets to look, and make art, is more about power and control than we might first be inclined to think. It is about who gets to tell their version of the story and who makes an object out of whom. It is also an admission that men and women's bodies have historically always been seen differently.

And because, until recently, men have had almost exclusive access to creating our cultural images, they've also been able to control the archetypal constructions of womanhood that have influenced ideas of how women should appear and how they should behave, from the meek and patient Virgin Mother, to the always-available, sensuous Venus pin-up, or the vulnerable damsel in distress to the terrifying witch, all of whom we will meet across the chapters of this book.

We'll be looking at how patriarchy has used images of women to contain and limit them, and how these archetypes

persist in our contemporary culture, shaping our ideas of not only beauty and taste, but also national identity, political authority, sexuality and our deepest fears and expectations about what it means to be human. After all, historical images have lives and histories that go beyond the context of their creation. While not everyone goes to Western art galleries, more or less everyone living in the developed world is caught in the unescapable capitalist slipstream of advertising and social media – where historical images of women contour and inform popular culture, from music videos, to advertising for formula milk, to album covers and fashion photography. Some media reference this legacy explicitly, from Beyoncé and Jay-Z's music video for 'Apeshit', shot in the Louvre; to Reebok ads ripping off Renaissance artist Botticelli to sell sportswear; to fashion and lifestyle shoots inspired by the horizontal or docile women in our art collections. Many more are influenced tacitly as our heritage of fine art and cultural images becomes part of our shared visual language. And, as we have seen in the National Gallery's collection, many of these images objectify women, normalise violence against them, stereotype or exclude racial diversity, or demonise ageing and non-normative bodies and sexualities.

We'll also be looking at how women artists have challenged these scripts with images that expose culture's misogynistic legacy and help us to rethink the value of women's work and the politics of their pleasure, sexuality and power.

Wherever we find them, pictures are not neutral; they can be pernicious and powerful. They help us to form attitudes towards ourselves and others, and sustain our understanding of history, culture, race and sexual identity, among many other things. Most

of this power is silent and stealthy, sold to us under the guise of leisure, or an appreciation of beauty and achievement.

Art history has a reputation for being elitist and often irrelevant, and certainly a stereotype of the suited and booted (generally white male) art connoisseur offering judgements about virtuosity and taste has been sold to us in popular TV art history programmes. But art history offers us so much more than luxury connoisseurship for the leisured classes, or background knowledge to inform cultural visits on holiday between wine tasting and artisan shopping trips. Art history can help us see how everyday images of women are steeped in ideas about body shame, how Renaissance paintings can start conversations about rape culture, how pictures of the classical monster Medusa relate to white nationalism and supremacy, or how lifestyle blogs promote the same ideas of wifely virtue as Golden-Age Dutch paintings.

I'm certainly not the first person to raise this. Feminist scholars have been calling out the cultural ramifications of misogyny for half a century. Some of these ideas have also entered mainstream discussions: for example, the concept of the 'male gaze', which is the idea that most images, films, plays and works of culture are produced for the pleasure and satisfaction of an implied male spectator; or the concept of 'sexual objectification', which is the presentation of someone not as a complex human being but one whose worth is based on their sexual attractiveness to the person looking at them.

Some 50 years ago the American art historian Linda Nochlin wrote the now famous essay 'Why Have There Been No Great

Women Artists?', which broached the institutional exclusion of women as artists but also asked us to reconsider the glorifying category of 'greatness' that is given to some (generally white male) art and artists in the first place.

There have since been numerous projects to recuperate the absent women from our art collections and correct the historical archives that overlooked them. One early example was the 1972 exhibition 'Old Mistresses' curated by Elizabeth Broun and Ann Gabhart, a title that exposes how the language we use in discussing art and artists is heavily biased according to gender. While the term 'Old Master' communicates status, value and an accepted place in the canon of esteemed art for well-known artists, such as Leonardo da Vinci or Rembrandt, there is no equivalent term to describe women artists from similar periods. The word 'mistress' holds altogether different and sexual connotations.[3]

Throughout this book I use the term 'woman artist', but it's worth mentioning what is at stake in using this: the gendered distinction enforces the idea that the default identity of an artist is male, and that women artists are a subversive anomaly. (We have, for instance, dropped the terms 'lady surgeon' or 'lady judge' that do a similar job in undermining women's professional status.) You might instead choose to adopt art historian Griselda Pollock's suggestion of 'artist-woman' where it's relevant to note gender.

While many continuing efforts are devoted to making women's contributions to culture more visible, for example with new books and exhibitions, it's also vital to also consider *why* this is so important, particularly when it comes to making pictures. Since 1985, a group of anonymous women artist-activists

known as the Guerrilla Girls have been calling out gender and racial disparity in the works that line the walls of our museums and institutions. In a poster from 1989 they make the obvious case for why we should care about this marginalisation: 'You're seeing less than half the picture without the vision of women artists and artists of color.'

These critical voices have not exclusively belonged to feminist art historians and artists. Cultural and literary critic John Berger's book *Ways of Seeing*, first published in 1972, has sold over a million copies and has never gone out of print. Berger was the first to set up a framework for seeing how images in everyday life, such as photographs and advertising, echoed traditional and much valued images of European art. Moreover, he

YOU'RE SEEING LESS THAN HALF THE PICTURE

WITHOUT THE VISION OF WOMEN ARTISTS AND ARTISTS OF COLOR.

Please send $ and comments to:
Box 1056 Cooper Sta. NY, NY 10276 **GUERRILLA GIRLS** CONSCIENCE OF THE ART WORLD

Guerrilla Girls, *You're Seeing Less Than Half the Picture*, 1989, Tate, London. © Guerrilla Girls, courtesy guerrillagirls.com

showed us how seeing this clearly could open up illuminating discussions about the politics of looking itself.

His iconic aphorism that in the history of painting 'men act, women appear' neatly sums up the gendered power dynamic that women have been depicted for how they look rather than how they see. Then there was his take on the real-world impact of the male gaze on women's lives: that a woman 'has to survey everything she is and everything she does because how she appears to others, and ultimately how she appears to men, is of crucial importance for what is normally thought of as the success of her life'.

Despite the legacies of these ideas in academia, in the mainstream, discussions of how women are seen and how they see keep getting lost. It is knowledge that tends to keep getting obscured as too specialist, too academic, too radical (too annoying) for a general audience, and this is where I hope this book will come in useful because the conversation about women, art and women's art is far from closed. Public discussion of pictures of women's bodies continues to stoke inflamed debates. Late in 2017 thousands of people signed a petition asking curators to change the context of a painting hanging in the Metropolitan Museum of Art in New York. The painting in question, called *Thérèse Dreaming*, is a voyeuristic depiction of a twelve-year-old girl, her eyes closed in pleasant reverie with her arms behind her head. It was painted by the controversial French-Polish artist Balthus in 1938, a man who throughout his career regularly had girls as young as eight take off their clothes and sit for him in his studio.

In the painting the girl's legs are splayed and one rests on the stool in front of her to give a view of the white gusset of her knickers. In the foreground a cat laps at a saucer of milk. If we were to discuss the image along the lines of 'how to read a picture', we might say that her raised knee makes the top of an axis that continues with the white gusset covering her crotch and culminates in the cat's head delicately supping at a saucer of milk (also white) directly below. The arrangement makes no ambiguity in suggesting what the external manifestation of her daydream is.

The petition called not for the removal of the work but an acknowledgement that the painting was an eroticised depiction of a child by an adult, and moreover an adult who had a controversial reputation that drew parallels in his time with the fictional character Humbert Humbert from Vladimir Nabokov's novel *Lolita* – a man with a sexual passion for young girls. (Throughout his career Balthus repeatedly denied any erotic intention on his part, suggesting instead that any sexual inferences were down to the viewer's projected perversions.)

The petition and media coverage opened up many thorny issues. Voices of the art establishment clamoured to suggest that sexual experience, especially the nascent desires of children on the threshold of sexual activity, is a valid motif for art to explore because, although uncomfortable, it is a fact of the human condition and therefore art's role to document and explore it. But the difficulty remains in who precisely is doing this exploring. Balthus' painting is not an individual's own expression of their privately burgeoning sexuality – it is an adult male's adaptation of a child's sexual inner life.

While some saw the request as a violent puritanical clampdown on human desire, others highlighted a hypocrisy in society's criminalisation of paedophilia but tacit romanticisation of it in Balthus' work, seeing it as an example of the widespread sexualisation of young women – not least in the midst of the Me Too movement that had recently erupted.

The Met refused either to take down the work or alter the wall text to acknowledge any allusions to sex between an adult and a minor, and lots of smug articles were written – by male and female authors – suggesting ultimately that these voices of opposition just didn't get what 'real art' was. The inflections were subtle, but the condescension was there in referring to Ms Merrill, the originator of the petition, as 'an HR manager' and therefore an outsider to the art cognoscenti, unqualified to voice what she and over 11,000 other people felt when standing in front of Balthus' painting.

A matter of weeks later, a similar discussion about censorship and women's bodies erupted over a curatorial intervention at the Manchester Art Gallery in the UK. After discussions and research with gallery staff, curator Clare Gannaway and artist Sonia Boyce discovered that many women within the institution had opinions about how gender was represented in the images hanging on the gallery walls – in particular the way in which women tended to be depicted either as 'femme fatales or as passive figures of beauty', especially in a climate where the exploitation and sexualisation of women was dominating public discussions.

Boyce decided to create a space on the gallery walls where this conversation could be aired, as a way of asking questions

about power and taste and who gets to decide what story of culture we are offered by our cultural gatekeepers. John William Waterhouse's painting *Hylas and the Nymphs* (1896) was taken out of the 'In Pursuit of Beauty' gallery for a week, leaving a blank space where it had hung for gallery visitors to post comments on yellow sticky notes. This was part of a series of 'interventions' that aimed to look at the Manchester Art Gallery collection from a more contemporary perspective.

The painting is a Victorian fantasy of an episode from classical poetry in which the young Hylas, the male lover of Heracles, is lured to his death by a group of bare-breasted long-haired water nymphs who pull him underwater. It is a classic example of the Victorian era's fascination with the imaginary figure of the sexually enticing yet villainous 'femme fatale'.

The intervention provoked another row of mixed opinions in the press, and plenty of umbrage vented on Twitter. Right-wing voices tweeted: 'why is a curator for fake contemporary "art" allowed to interfere with real art like *Hylas and the Nymphs* in the first place??' Others were quick to underline that the women and not Hylas were pictured in a predatory role, and others yet cried about the dangers of censorship and compared feminists to ISIS. One of the many responses on the discussion board of the gallery's website stated that: 'provoking discussion through this is just dangerous.'

As the gallery lost control of the discussion and it spiralled online, what failed to be duly noted was that in a room devoted to the 'Pursuit of Beauty', only *one type* of beauty was represented – youthful and white. Misinterpreted almost unanimously as an act of puritanical 'censorship', what was also missing from

the furore over Boyce's intervention was that *Hylas and the Nymphs* (like Balthus' *Thérèse Dreaming*) is a man's version of what adolescent female beauty and sexuality should look like – that is pert and attractive and objectified. Even more importantly, Waterhouse's painting is not something that celebrates young women's sexuality but instead casts it in a negative light, as something dangerous and malevolent. This idea has fed into real-life attitudes towards young women's bodies and continues to do so, and, to my mind at least, it is far more 'dangerous' than any questions of censorship.

The fact that artist Sonia Boyce, as a woman of colour, should challenge this singular white male view of beauty and sexuality inspired a violent urge to protect it as sacrosanct and inviolable. Her intervention then was not about banning certain depictions of women in paintings, neither was it only about questioning sexualised depictions of adolescents; it instead revealed how deeply images touch us and affect us, how violently we rush to defend them, and how they shape our lives for better and for worse.

What both incidents at the Met and the Manchester Art Gallery have made clear is that the meanings of collections, images and artworks are not static but fluctuate according to the rush of the outside world. In recent years racial justice movements and feminism's fourth wave have made us look around at what we have taken for granted as normal or everyday. Sculptures that have existed for decades or centuries celebrating colonial or imperial violence have been toppled. New sculptures have been put contentiously in place. Advertising images that demean people of colour have been pulled (such as Aunt Jemima

and Uncle Ben). Meanings of works of art or film that we have loved and grown up with have been revisited, their politics questioned, the values – about race, about women's bodies – that they promote re-examined. Art museums and galleries have been compelled to address whose stories they celebrate and show on their walls, as they seek to rebalance the exclusion of women and people of colour from the version of culture they promote as historical truth.

The overwhelming popular response to these discussions also confirms that the art of the past must be freed from privileged knowledge and made able to speak to lived experience in the now. Art and culture are not separate to our discussions about the politics of gender, race and representation; they are at its very heart.

I'm going to be asking you to look again at well-known images, but to look at them 'slant', approaching from a different perspective to see how they might cast light on the discussions we are having about women and women's bodies today.

With all this in mind, we're going to start with Venus – the mythological goddess of love, beauty and sex – who we've been led to believe represents the icon of womanhood itself, but whose body is something of a battleground on which discussions of shame, desire, race and sex play out.

Venus

Room 30 of the National Gallery in London is like a giant jewellery box, a grand hall lined with crimson damask. On its walls hangs a collection of seventeenth-century Spanish 'masterpieces'. There is one naked body in the room. It's a young woman's, reclining with her back to us, fully nude on a bed whose covers are agitated with the promise of sex. The ripples of silk and cotton echo the curves of her body. Her waist is impossibly small, her buttocks smooth and peachy, and her skin pearlescent, free from blemish, bruise or hair. Spectators ebb and flow to gaze at her body, seemingly unperturbed by their voyeurism. She doesn't seem bothered either. A pot-bellied toddler with wings props up a mirror in front of her and on its charred surface you can just see her face, looking back at us, as we look at her body. She isn't smiling, or scowling. She doesn't look scared or anxious – or even surprised. She's just seeing you looking at her, and she knows that's the way it goes. After all, she has been here a long time. Gallery visitors amble past, the word 'beautiful' dropping casually from their lips and amateur artists copy her curves. Images of illustrious men surround her. Like sentinels, they flank her – one

an archbishop, one a king. Do they guard her or own her? It's hard to tell.

The woman is Venus, the mythological goddess of love and beauty. But if we want to be literal, it is a painting of a woman with no clothes on who in the late 1640s posed as the goddess Venus for the male artist Diego Velázquez who produced this for a male patron to enjoy, either in private or as an envy-stoking trophy in his art collection that would be looked at and discussed with other men in his elite circle. The context of its commission is undocumented, but it was in the collection of the Marqués del Carpio from 1651, shortly after its creation. It's often described as the only surviving nude by the Spanish painter, a precious relic of a wealthy man's display of status and power that escaped the punitive clampdown on sex and luxury in the religious climate of seventeenth-century Spain, perhaps painted in more tolerant Italy during a visit by the artist. (Velázquez took a risk in even producing it – the usual consequence for an artist painting a picture of a nude woman in seventeenth-century Spain was excommunication.)

The 'Rokeby Venus' is not the painting's original name but recalls one of the places it was on display before arriving at the National Gallery in 1906. J.B.S. Morritt bought the painting in 1813 to hang in his collection in his house, Rokeby Park in Durham. He wrote to his friend Walter Scott in 1820 describing how its position above the fireplace made for a flattering play of light on Venus' painted buttocks and observed how the picture made women feel uncomfortable.[4] Before it entered a British collection, the painting had been owned by the Spanish president Manuel Godoy. It represents (at least in part) what

a sequence of powerful male owners have historically wanted to look at unchallenged and untroubled. But for over a century, Velázquez's Venus has been the '[British] nation's Venus', hanging in public among the tourists and the schoolchildren who circulate around the National Gallery. Guided groups are brought before her to revere the extraordinary achievements of the master artist, or to be teased by the play of gazes in the image – that Venus sees us seeing her – and, most of all, to be educated, enlightened and inspired by a picture of a woman with no clothes on.

The naked body of a woman in an art gallery is so normal, who would be pedantic enough to question it? This Venus is one of a bounteous number of female nudes currently hanging on the walls of the National Gallery. She's an iconic goddess from classical mythology who represents love, fertility and beauty, and a reminder of our unerring belief in the cultural authority of ancient Greece and Rome. Venus means 'Art' with a capital 'A'. Good art. High culture. Unimpeachable value. The inviolate tradition of beauty. Wander into the gallery shop and there she is again on the most popular postcard, a vehicle of the culture industry's mythmaking. You can take her home on a poster or wear her printed on a cotton tote bag. She is a hot commodity.

The mythological goddess Venus may be shorthand for love, sex, beauty and fertility, all aspects of the human condition that warrant contemplation and celebration, but I can't help but think that here – as the only nude surrounded by portraits of illustrious men – the Rokeby Venus seems to be cast as little more than a rich man's plaything.

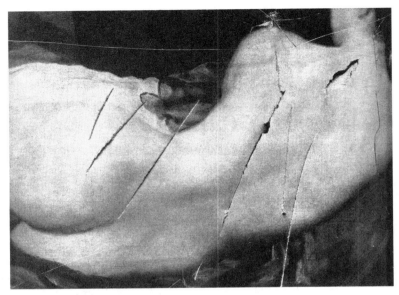

Illustrated London News, 14 March 1914 or Unattributed photograph, published in *London Life Magazine* – January–March 1966.
© Imagno/Mary Evans Picture Library

There's an important story concerning the Rokeby Venus that's nowhere to be found in Room 30 of the National Gallery. Get too close to her and alarms trill: she must be protected. She's been hurt before. Look closely at her body and you'll see the sutures. The scars are well-disguised, but the silver slithers stretch across her hips and back. In March 1914, the suffragette Mary Richardson walked into the National Gallery with a cleaver concealed in her coat and calmly approached Velázquez's painting before slashing the canvas, leaving deep gashes in the alabaster surface of Venus' body. Guards rushed to defend the gallery's most prized nude, and Richardson was willingly detained while awaiting transfer to police custody.

The press seized on the attack and positioned it as a tale of two types of womanhood. On the one hand, there was the mutilated canvas that was animated into a passive victim: the gorgeous painted Venus who represented the silent and wounded paragon of ideal femininity. On the other was Mary Richardson, or 'Slasher Mary' as she became known: a monstrous example of deviant womanhood whose destructive impulse was taken as confirmation that suffragettes couldn't be trusted with the business of political responsibility or respect for public property.

But Mary Richardson's attack was not a mindless act of high-profile vandalism. She had a mission in destroying Venus, and justified her actions cogently:

> I have tried to destroy the picture of the most beautiful woman in mythological history as a protest against the Government destroying Mrs Pankhurst, who is the most beautiful character in modern history.[5]

Richardson was referring to the notoriously brutal treatment of imprisoned suffragettes, including their founder and leader Emmeline Pankhurst. While prisons inflicted torturous force-feeding on inmates, police were also beating and maiming women on the streets as they demanded to have a say in how their lives were governed. In her assault on Venus, Mary Richardson wanted to highlight the hypocrisy that a picture of a nude woman demanded more respect than the actual bodies of half of the population; her action was part of a wider guerrilla campaign of defacing public property that drew attention to the

suffragettes' aims. Years later she added that she also hated how men gawped at the painting all day.

By violating the ideal representation of passive, beautiful and enticing femininity, Richardson dismantled an illusion; she tore open its painted surfaces and showed that it could not bleed or suffer or die because, unlike the abused suffragette prisoners, it was an object and not a real body.

Visitors to London's National Gallery very often don't know this story. I've told it many times when teaching students or the general public, and it always piques mixed reactions. Indignation is the most common. 'How could someone do something so sacrilegious to a beautiful work of art?', they often ask, shaking their heads in disappointment. 'Haven't they done a good job at restoring her?' is the other.

The intent behind Slasher Mary's militant attack has long since been absorbed by the damask-lined walls of the National Gallery; the intervention is acknowledged in neither the accompanying wall text nor in the room's interpretative materials. (*Why would it be?*, you might be asking yourself, but to me the silence speaks volumes about the way in which women's critical voices become smothered and marginalised.)

When in 2018, the centenary year of the Representation of the People Act (which granted some women the right to vote), it became impossible not to mention the suffragette intervention, I heard a talk by a gallery educator in front of the painting, who dismissed any readings of sexual objectification that have since been levelled at the Rokeby Venus – as if the obstruction to women's suffrage, and the viewing of women as sexual objects to satisfy a male patron's gaze, could not possibly be related to one another.[6]

This wilful suppression of the gender politics written across the body of the Rokeby Venus makes me think that perhaps we don't want inconvenient truths to get in the way of consuming the beautiful images we've become accustomed to enjoying, or that we don't like being asked to accept that seductive highlights of culture contain more complex issues about gender, class, racism and capital behind their painted surfaces. Perhaps most of all, we really don't want to consider how looking at art in our free time plays a part in all of this.

Maybe we feel like the public museum should be about uncomplicated and restorative leisure, diversion and the appreciation of human cultural achievement. Which they can be, but they are also about social aspiration and status, and about a complicated sense of virtue that we derive from visiting them. 'Culture' or 'the arts' is certainly one of the smuggest clubs to belong to. This is in part because appreciating the sort of art found in the National Gallery has often meant acquiring a new language of symbols, stories and references from texts such as the Bible and books of classical mythology – so the appreciation of art history beyond surface appearances has been contingent on access to privileged learning. Curators and directors of museums also privilege a certain sort of knowledge when they decide what goes on the walls, what remains in storage, what gets acquired to add to the collection, or how we change conversations about what images mean. Who is seen, how they are seen and who or what is erased from the walls of the gallery is a loaded issue.

Somewhere like London's National Gallery is a place deeply informed by social aspiration. Since the gallery's foundation in

1824, the working man could see the art collection of kings for free on any day of the week. Its founding ethos was to always be free of charge, and it was intentionally built in the midway point between the wealthy residential west of the city and the working-class slums in its east in order to be accessible for all. With its imposing, temple-like façade, the National Gallery sits in a space of pomp and pageantry: the building takes up one whole side of Trafalgar Square, a space designed and built to celebrate British military supremacy and Nelson's defeat of Napoleon. Visitors get spat out onto the portico on the building's façade as they exit, where the gilded monolith of Big Ben, at the political heart of the nation, strikes the eyeline. Immediately in front of us is Nelson's Column, guarded by its yawning stone lions, and something of a connection is implied between the works on the walls of the gallery and the sense of stability in the British establishment. No wonder then that there are those who avidly defend the Rokeby Venus with a reverence that mingles with patriotism, aspiration and the satisfaction that looking at paintings like this is a morally virtuous and edifying pursuit. But how, you might wonder, does the proud display of a painting of a nude woman fit into this?

The original male owner of Velázquez's Rokeby Venus was also driven to look at paintings like this one as a means of securing his status and political identity as a man in seventeenth-century Europe. In the 1650s, as is still the case now, looking at the Rokeby Venus was about education, taste, social aspiration and luxury. The presumed but undocumented first 'owner' of the Rokeby Venus was a social elite who built his status among other men by possessing and looking at beautiful objects – from

intricately painted still life scenes to luscious female nudes. As art historian Maria Loh writes: '"Woman" was the cipher that enabled men to parade their prowess and power in front of one another.'[7] (We might argue that looking at naked women is still a means of heteronormative male-bonding – take for example the ritual tradition of groups of men visiting strip clubs on stag, or bachelor, parties.)

The allure of Venus is also her classical pedigree, which speaks to Western culture's faith in the pillars of ancient Greece and Rome as the benchmark for our understanding of 'civilisation'. At best this has obscured (and at worst erased) the possibility of other expressions of taste, cultural achievement and beauty that derive from cultures outside of the ancient Mediterranean. Taste and beauty are therefore unerringly political issues: while each geographical region may have its own traditions of beauty, the default in global culture is always the classical white Venus. And this is important because our reverence for Venus and for classical culture has trickled down into the way in which we see women's bodies generally and the expectations that we place on them.

In the house I grew up in, a poster of the Rokeby Venus hung above my bed in a gold frame. It was given to me by my mother when I was a teenager after I decided to study art history at university and I loved it. I had been seduced by Venus into internalising a patriarchal fantasy of womanhood. A child of the 1980s, I had grown up with beauty pageants on TV and men's magazines hovering at the edges of my vision on the top shelf of the newsagent. The Rokeby Venus fitted right into the fantasies of girlhood I had been exposed to: she was a grown-up

version of a Disney princess or teen mag model, and a more refined version of the *Playboy* pin-up. I wanted to learn more about her because on some level I thought I was meant to aspire to become her, because she was the apogee of what the world I lived in wanted me to be: fertile, graceful, desired and moreover that I would enjoy being desired before I atrophied into another archetype on my biologically predetermined destiny as a woman. And understanding Venus to me meant understanding and accessing the lofty echelons of art and culture that as a girl from a working-class family I was so fascinated by. But placing that image in my adolescent boudoir, that sanctuary of secrets and self-development, feels very wrong to me now.

After Mary Richardson's assault on the canvas, Venus was put back together for our viewing pleasure. Order was restored. And Venus has been remodelled in every era since. I'd like us to open up the idea of Venus again and see how her image has spawned an avalanche of imitations within and beyond the walls of the gallery in pictures that have impacted the way women live and perceive their bodies.

Venus is an ubiquitous figure in collections of Western art around the globe. Her prime position and visibility in art and culture is a symptom of what art historian Griselda Pollock has called 'culture's deep, phallic unconscious'. But Venus is also in your pocket right now on a social media feed on your phone. She's in a magazine you'll pick up in the next couple of days or in a television commercial you'll see in the next few hours. She's on a billboard at the bus stop selling fast fashion and making girls feel bad about their breasts. She's reminding you that you need to shave your legs so that men will like you. Or she's

educating boys on what to expect when they first get laid. Until recently she was in the newspaper in the UK, every day, on the third page.[8] Venus is everywhere that there are women's bodies representing ideas about female beauty, sex, wealth and status: from Renaissance paintings to the Victoria's Secret runway; from cosmetics adverts to paintings by Picasso.

By looking more closely at what makes the mythical image of Venus, we can think about the repressed fears and desires that are projected onto the female body in our collective cultural consciousness. These include fears about our human physiology, how our bodies bleed, grow hair, and have diseases. I'd like us to think about how pictures of Venus can start conversations about racial and sexual difference and how the female body has been exploited to shape ideas about male genius and creativity. How it has stifled female sexuality and stoked racist assumptions about women of colour. How it has become a legitimate spectacle for objectification. I'd like us to think about how Venus has been employed to make ideal versions of femininity seem normal and to teach us patriarchy's version of sex.

Venus is the Roman name for the Greek goddess Aphrodite, who probably derived from an earlier Mesopotamian deity of sexuality called Ishtar. Early depictions of the goddess are varied and sometimes show her as an armoured warrior who originally symbolised both war and love. But we're going to meet her in her most well-known and most reproduced identity in a fourth century BCE sculpture that has inspired not only a whole history of art and contemporary visual culture but also the internalised fantasy of what womanhood should look like.

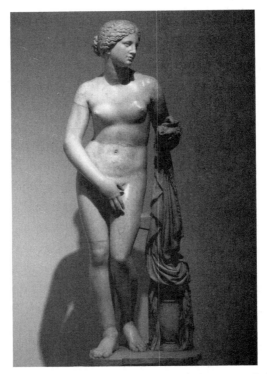

Praxiteles, Knidian Aphrodite, Museo Nazionale Romano – Palazzo Altemps. Photo © akg-images / Eric Vandeville

The first fully nude freestanding statue of Aphrodite appeared in 350 BCE. It's called the 'Knidian Aphrodite' and is carved from marble. It was made by the Athenian sculptor Praxiteles and was once a focus of devotion in a temple in Knidos in Greece which celebrated the cult of the goddess. It also, as far as I know, gives us the first recorded example of sexual intimacy with an image.

The sculpture depicts a young woman standing with her weight on one leg, the other leg bent at the knee, poised on the ball of her foot. The now white marble gives an impression of

smooth and flawless flesh and, as is customary with many classical sculptures, she is entirely nude. But it's the robe that she grasps in her left hand that offers us a tantalising narrative. Aphrodite is caught reaching for her towel after her bath, as if we've just stumbled into her private space. She, like the Rokeby Venus, is acutely aware of being seen. A hand rushes to cover her groin – unlike classical sculptures of male nudes who wear their nudity unselfconsciously, this woman knows that she is vulnerable and has something to hide. But while her hand conceals her sex from view, it also seductively leads our attention and interest to what we cannot see.

The Knidian Aphrodite gained quite a reputation and appealed to a broad audience, not just the local community served by the temple but also the tourists who travelled specifically to see it. In the *Erotes*, a fourth-century-CE text written in Greek, Pseudo-Lucian describes a sailing trip with two friends who went to visit the acclaimed and exciting beauty of the sculpture for themselves. Once they were alone in the sanctuary with the marble figure, one friend tried to kiss it on the lips, while the other, who was homosexual, went for her buttocks, claiming that they were as arousing as those of any young boy. The friends also noticed a stain on the statue's thigh. When they asked the priestess custodian of the shrine what had happened, she told them that a sailor had ejaculated on the statue when trying to have sex with it. The Roman author Pliny also discussed how the statue had to be protected from men masturbating on it.[9]

'Ha ha! Silly, smutty ancients. So far we have come!' we may guffaw, as we titter gleefully at a tale that seems made to entertain schoolboys. But that would be missing the point that for

as long as we have had nude images of women, they have been sexually objectified.

In 2018 another sculpture of a nude 'Venus', this time called Gloria, made not of marble but from privet bushes adorning the porch of a home in Sheffield, was reportedly assaulted by male admirers who mounted the topiary sculpture to simulate sex, damaging its shape in the process. In the eighteenth century it was customary for aristocratic visitors on the Grand Tour to lust over a reproduction of the Knidian original that had driven men wild with desire. Known as the 'Medici Venus', the sculpture is a Roman copy of the Knidian Aphrodite and still stands in the Tribuna of the Uffizi Gallery in Florence. The sculpture became one of the set pieces for foreign travellers and was mediated to a wider audience through rapturous reports and letters and even poetry devoted to the thought of spending a night alone with her delightful body.

Johann Zoffany captured the appetite for the Medici Venus among grand tourists in a painting from 1777 called the *Tribuna of the Uffizi*. Here a huddle of five bewigged men clamour around the rear of the sculpture, focusing on the buttocks, as one excited spectator holds up a magnifying glass to scrutinise the marble glutes in more vivid detail. It couldn't be more obvious (and wryly teasing) that visits to the Tribuna of the Uffizi were as much about admiring Italian masterpieces as they were an exercise in culturally sanctioned leering over images of the female nude body. But despite the frank lasciviousness of Zoffany's painting, the Medici Venus was also enshrined by Coleridge as one of 'the most noble works of human genius'. This presents us with a conundrum: 'the most noble works of human genius' (or the ones most preciously guarded, like the

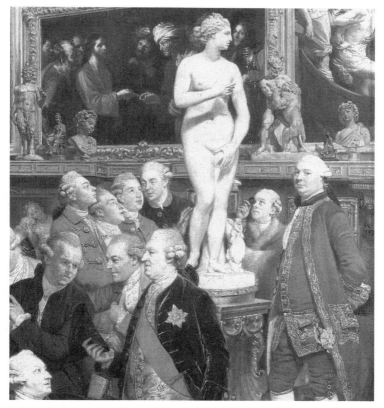

Johann Zoffany, detail from *Tribuna of the Uffizi*, 1777, Royal Collection Trust. © Her Majesty Queen Elizabeth II, 2020

Rokeby Venus) are sometimes also the ones that make women into sex objects.

The problem here is not that erotically charged images can't also be seen as culturally valuable expressions (they can), but that woman's highest cultural expression has been as a passive sex object, and not as an artist or creator of culture herself. This has limited what women have been able to achieve in a

patriarchal society that cannot separate women's value and worth from a very fixed idea of their sexuality.

A similar point was implicitly raised in 2014 when the Swedish National Assembly made the headline-grabbing decision to remove a titillating painting of a bare-breasted goddess from its parliamentary rooms, on the request of the deputy speaker Susanne Eberstein. The parliamentarian expressed how erotic images of women in her workplace distracted dignitaries and guests and impacted the way the women were perceived in that professional environment. What I think she was getting at is the same thing argued by the campaign to end topless photos of women in the daily redtop papers – that images of women as sex objects, whether in newspapers or in oil paintings, have the power to shape archetypes that can threaten and undermine gender equality. Women are socialised from an early age to comply with hyper-sexual stereotypes found in both fast-moving media and 'high art' and cultural representations, which consequently become the default norm. And seeing women as sexually available in images found everywhere from the art gallery to the workplace to the top deck of the bus on the way to school, creates a totalising environment of erotic privilege for straight men.

Neither is nudity itself the issue here, more the fact that men's and women's nude bodies have always been viewed differently, from the images of classical antiquity to today. When Praxiteles made the Knidian Aphrodite, there had been sculptures of male nudes in ancient Greece for around four centuries. But none of women. Sculptures of nude male bodies represented aspirational intellectual and political ideas for the ancient Greeks. Nudity was not considered to be a state of undress or

vulnerability, but rather it represented a form of heroic external dress, with muscles depicted to resemble armour.

The classical male nude has since symbolised political strength and heroism in numerous images and sculptures. Napoleon Bonaparte posed for a life-size nude sculpture as Mars, god of war, when he appointed himself as emperor of France. Michelangelo's colossal nude sculpture of the Old Testament hero David was chosen as the fitting symbol to stand sentinel outside the seat of government in Florence in the Piazza della Signoria. And in London, a nude sculpture of a classical warrior wearing nothing but a helmet and sandals is the war memorial outside of the Army and Navy Club on Pall Mall. They stand proudly oblivious of their nudity and as such are a world away from Aphrodite emerging from her bath, aware of her body under our gaze.

If you are in any doubt as to how men and women's unclothed bodies are seen differently, just try to imagine a sculpture of a nude woman in a public space in which her body signifies actual, real power, and represents something like government or a revered institution. The language does not exist.

The differences in the perception of women and men's bodies has real impact and implications that go beyond the way in which we look at art and monuments. While men are free to bare their chests in public, women in the United States are routinely arrested and fined for going topless. Or shamed for using their breasts to feed their children in public. Social media channels such as Instagram and Facebook continue to censor any pictures that contain a female nipple, claiming that the images violate community standards, without considering context (while male nipples are unproblematic). The impact of this affects multiple

groups of women, one in particular is breast cancer patients who bolster and educate one another by sharing images of their changing bodies in online communities. Instagram claims that post-mastectomy images are justifiable content for the sharing platform, but their algorithms have repeatedly censored and shut down numerous accounts sharing such examples and flagged them as inappropriate because they depict 'sexual activity'. In October 2020, the site banned the account The Breasties from hosting a livestream community education event for breast cancer survivors.

This censoring of women's real bodies both in everyday life and in the photographs they share of themselves and their experiences not only inhibits their physical freedom but also admits to a deeper crisis in our collective psyche – that women's bodies are always taboo and cannot be seen neutrally but as objects that have to be controlled and manipulated in order to be acceptable.

Let's turn to the default Venus of art history in Sandro Botticelli's painting *Birth of Venus*. Emerging from the sea, all slick surfaces and whiplash curls, a life-size Venus surfs onto the shore on a giant shell amid a flutter of roses. Her skin is opaque and flawless, like polished marble. There are no bruises, no scars, no stretchmarks from hormonal growth spurts. Her breasts are high and round like apples, her stomach softly curved, but still reminiscent of time spent in the Pilates studio. She is hairless apart from the thick vines of gold that flurry around her face and lead us tantalisingly down to her groin, where they both hide and draw attention to her vulva.

Botticelli's monumental female nude is now the centrepiece of its current home in the Uffizi Gallery in Florence and has become symbolic shorthand not only for feminine beauty but for the triumphant creations of Western art during the Italian Renaissance. Can we imagine a history of art without her? The *Birth of Venus* has featured on two *New Yorker* magazine covers, has been appropriated by everyone from Andy Warhol to Lady Gaga and Beyoncé and also appears on the Italian 10 cent coin. She belongs to both high and low culture. And, along with her prototype the Knidian Aphrodite, she provides the DNA for all other images of Venus.

The original owner of the image remains unconfirmed, but it is presumed to have been a member of the Medici family, a Florentine banking dynasty around whom the intellectual and artistic elite of Florence revolved in the fifteenth and early sixteenth centuries. Sandro Botticelli painted the panel in around 1486, most likely for one of the cool villas outside of the city. This Venus was a refreshing salve for a privileged minority – a reminder that their status afforded them no uncertain amounts of pleasure. But this pleasure was not just immediate and sensory, it was also wrapped up in an intellectual framework for thinking about beauty. Botticelli's paintings were informed by an intellectual circle of Renaissance humanists who believed that there were two types of Venus – one celestial (*Venus Coelestis*) and one earthly (*Venus Vulgaris*). *Venus Coelestis* was thought of as a pure and unearthly body of a woman which stimulated thoughts about divine love and the beauty of the soul, while *Venus Vulgaris* was the earthbound Venus associated with fertility, sex, procreation and the beauty of the living world. Both

identities depend on the sorts of sentiments that Venus arouses in the viewer – whether sensual or spiritual – and set a familiar framework for how men have historically looked at and related to women in reductive ways, as either idealised virgin goddesses on a pedestal or as sex objects.

Botticelli's Venus conforms to the concept of the divine *Venus Coelestis*: she lacks the velvety sensuality of the Rokeby Venus, and her body is more mineral than flesh, her pallor bloodless. According to Renaissance ideals, this Venus' physical form was a way to contemplate the grace and harmony of the universe, the immaterial beauty of the soul. Knowing this context, it would be hard to level charges about sexual objectification – after all, we might ask, what really is so wrong with contemplating the divine beauty of the world in the form of a human body?

But Botticelli's Venus has had a long afterlife in which she has represented the unrealistic, impossible-to-emulate standards of beauty that we continue to impose on women, and a suppression of their sexual maturity. Let me explain why.

The narrative that inspired Botticelli's *Birth of Venus* comes from Homeric myth, updated with Renaissance poetry by the classical scholar Agnolo Poliziano. Contrary to what we see in the painting, the myth holds that Venus' birth wasn't a sweetly perfumed seafoam-surfing story, but something much more violent. The god Cronos, son of Uranus and Gaia (deities of sky and earth), sawed off his father's testicles just as Uranus was about to make love to Gaia. The severed genitals were then thrown into the sea where they frothed and transformed into a beautiful woman who was goddess of love, beauty and fertility, who sailed to shore on a giant shell.

Let's take a pause and just think about this for a moment: the enduring Western symbol of feminine beauty and sexuality did not come from the body of a woman but the sex organ of a man. Venus is the butchered testicle of her father's body. She is motherless. Maybe this is news to you. (It certainly was to me when I discovered it many years after studying Western art, which begins inevitably with the study of classical nude sculpture.)

Firstly, the fact that Venus did not come from the body of a woman actually made her *more* divine within the Neoplatonic concept beloved of Botticelli and the Medici's circle. Poliziano's poetry makes it clear that Venus does not look like a real human woman made of flesh and blood, and describes her as having a non-human countenance. And because she was thought to be immaterial, this Venus occupied the highest plane of existence, closest to the divine. It may not at first be obvious, but the mythological story describing Venus' birth erases the reproductive power of the female body. In Latin, the word 'mother' ('mater'), comes from the same root of the word as 'matter' and 'material'. To be of a mother then is to be part of the material fabric of the world. But *Venus Coelestis* is divine because she is immaterial and not weighed down by the earthly procreative body of a woman.

Venus' violent genesis was cleaned up to make a stone goddess of bloodless and impenetrable beauty in Botticelli's archetypal image – look again at her cold compact flesh that is sealed tight. What we're actually seeing is the primordial and messy procreative power of woman, whose body swells and bleeds, zipped up into a manageable and rational form and translated into high culture. (Remember this when we get to thinking about the politics of shaving and period taboo.)

The Knidian Aphrodite and her reappearance in countless spin-offs has become the irreducible icon of womanhood: that pose, with one leg straight, the other cocked at the hip to accentuate her curves is the default pose for beauty queens in swimwear, or drag queens relying on camp in performing universally understood ideas of femininity. And it's also the pose that women learn to adopt when the camera turns its lens on them, hand on hip, body kinked to one side to showcase what they have been taught are their greatest assets.

In art history class you will learn that this pose is called the 'Venus pudica', a term to describe a nude female with one hand self-consciously covering her groin from sight. Hence the term 'pudica', meaning modest. But it's unlikely that you will learn in class that the word 'pudica' comes from the Latin term 'pudendus', which simultaneously means shame, as well as being the anatomical term for vulva.

Venus pudica (the prototype for all Venuses) is not just a representation of a goddess of love and fertility who became a symbol of sexual desire and later of cultural achievement; it is also an example of how pictures of Venus have culturally reinforced women's feelings of shame about their sex organs and their sexuality.

This is why, starting broadly in the 1970s, feminists have reclaimed images of vaginas and vulvas from patriarchal associations with shame and reinvested them with female power. Examples can be found in artist Judy Chicago's vulva-inspired artwork of the 1970s such as The Dinner Party (which we will encounter in the 'Monstrous Women' chapter), and in Germaine Greer's attempt to tame the expletive power of the word 'cunt',

both of which encouraged a recognition of women's bodies as a source of power and awe. Punk and mainstream feminism in the twenty-first century have also claimed women's sex organs as activist symbols, with the example of the Russian feminist activist group Pussy Riot and the widespread wearing of pink 'pussyhats' at recent women's marches all over the world. But while the power and agency of the vulva and vagina have been adopted by women as a gesture of activism against the denigrating oppression of patriarchal ideals, the ubiquity of the classical Venus still contours the expectations of how women's bodies should look, from body-sculpting fitness classes to our cultural obsession with hairlessness, while the 'c-word' is anything but neutral.

Venus appears in another guise in which she is more brazen than bashful. Very often you might see the *Venus pudica* pictured on a bed, flipped onto her side, in a more supplicant and inviting pose, seen either full frontally, or from behind (just like the Rokeby Venus). Sometimes known as a 'reclining Venus' or as an 'odalisque', this Venus makes no effort to shield herself from the gaze of the onlooker but directly solicits our appreciation and erotic enjoyment. Waiting nude on her bed to be consumed, she flatters the spectator as a privileged owner of the sight of her body. It is another version of the archetype that has been etched so deeply onto our collective consciousness and reproduced in Western art and visual culture from high to low, by everyone from Titian to Picasso, perfume advertisers to Beyoncé.

One of the most enduring prototypes is the 'Venus of Urbino', painted by the Venetian artist Titian in 1534. The

painting, set in the interior of a recognisably contemporary Renaissance palace, is thought to be about the importance of erotic fulfilment in a happy marriage. Venus reclines, coquettish and expectant, fingering a small bouquet of roses in one hand, while the other references the classical *Venus pudica* gesture with its wandering fingers that both conceal and draw attention to her sex. This Venus is not so demure – in fact her bombastic sex appeal is tempered only by the superficial references to marriage such as the roses and the myrtle on the window – both plants that would be immediately recognisable as matrimonial symbols to a Renaissance viewer. There are two large chests in the background: these are cassoni, traditional wooden trunks associated with weddings which may have contained the bride's dowry and served as furniture in her new husband's home. From these signs we are led to believe that this Venus is either betrothed, or recently wed. The little dog asleep at her feet is, fittingly, a symbol of fidelity. He snoozes peacefully, for there is no need to bark – the implied spectator who is enjoying the sight of Venus is the master of the house.

Titian's luscious Venus belonged to a man called Guidobaldo II della Rovere, the Duke of Urbino, but with all the symbolic references to marriage, the painting may also have been intended for the sight of his much younger wife. It has been suggested that the more sexually experienced woman in the picture could show the teenager exactly what sort of erotic fulfilment she was required to perform to keep her marriage happy. In this regard, we could interpret the Venus of Urbino as another version of the Griselda panels that entered a young bride's home: an instructional image for a young married woman

on how to behave. And the first requirement of wifehood, the picture seems to say, is to be like Venus in the marital bed.

The image, by contemporary standards, is tame, but scholarly discussions have liked to call the Venus of Urbino 'pornography for the elite', and the painting even piqued Mark Twain, who in his nineteenth-century chronicles suggested that the sensual tone of the picture would be excessive even for a brothel (which almost certainly tells us more about Twain than Titian's painting). I've noticed that when suggestions about the arousing or 'pornographic' intent of a much revered artwork enter public discussion, they too solicit responses that tell us more about public attitudes to women's bodies and sexuality than they illuminate readings of the images themselves. Responses tend to range from violent rebukes such as 'feminism gone mad!' to accusations of incipient fascism and punitive censorship – even when censorship is not mentioned.

These were among the criticisms bitterly levelled at classics don Professor Mary Beard when she invited the general question whether 'nudes in art were soft porn for the elite' on Twitter shortly before the airing of her BBC television documentary *The Shock of the Nude*. A vivid discussion flared up on social media in response. Some art critics even tweeted that the mere association between art and pornography was a 'dangerous' call to arms that would see works of art ripped up and censored, perhaps even slashed, like the Rokeby Venus over a century ago. (Although, as we've seen, the motivation behind 'Slasher Mary's' attack was to highlight the hypocrisy in the treatment of women in pictures and the treatment of women prisoners as opposed to censoring its sensuality.)

I'm interested in how paintings like the Rokeby Venus and the Venus of Urbino are so fiercely protected from any judgement beyond hyperbolic praise about beauty and technical artistic excellence, and why we tend to be so unwilling to separate the prestige in which a painting is held as 'high art' from the open acknowledgement of its sexual content as if the two cannot exist together.

Often when conversations about sex, nudity and objectification in art images are started in public forums, there's a tendency to fall back on discussions around sex positivity without fully exploring and nuancing the issue. Mostly the conversations revolve around a fear of censorship of art that would take us back to a time in which more repressive attitudes about sexuality dominated freedom of expression and desire. Sometimes second-wave feminists weigh into these discussions pointing out that they worked so hard to free women from sexless lives and are disappointed by what they perceive as the demonisation of desire. (An example of this was the infamous open letter signed by 100 women including French actress Catherine Deneuve in response to Me Too that called for more tolerance over the sexual advances of men.)

After all, some might ask if the Rokeby Venus and Venus of Urbino look like they are enjoying the attention they are getting. Aren't they confidently offering themselves up to our gaze and enjoying the pleasure that they give us? But let's think again about whose gaze this is for: an implied male spectator who is proprietor both of the image and of the woman pictured in it who *performs* for him. It might be useful to return to John Berger's *Ways of Seeing* here and his suggestion that the female nude in art

history displays: 'her nakedness not [as] a function of her sexuality, but of the sexuality of those who have access to the picture'. In other words, her sexuality is relative to an implied owner.

Things have changed from the original context in which paintings of reclining nude women were enjoyed in private as the trophies of elite men: now, everyone is expected to be wooed, seduced and edified by paintings of the female nude as ciphers for not only sexuality but also good art and culture. But paintings like the Rokeby Venus and the Venus of Urbino appeal to different groups in different ways: there may be those who want to possess her, or those who want to emulate her, but what does this say to those who see nothing of their desires in her? And how does the woman spectator of these bodies separate her own desire and sexuality from the archetype that has been modelled for her – especially when it is one that is to be understood in relation to an *owner*?

Mary Beard raised a comparable idea about the ubiquity of the male gaze in *The Shock of the Nude*, with reference to the Medici Venus: 'You can't escape [other] questions about sex, gender and the power of desire ... I'm never quite sure ... whether I'm with those guys peering up the statue's bum or whether it's my bum they're peering up. It's those difficult questions about oneself that are the real shock of the nude.'

The Venus of Urbino made Titian a very popular artist indeed, and throughout the history of art, Venus has consistently been an emblem of male virility and creative potency. (Perhaps not so distant from her mythical origin as the severed testicle of her father, the sky god Uranus.) But where does that leave us as viewers? Does the ubiquity of the male gaze exclude

the possibility of women deriving pleasure from the Venus of Urbino, or any other images like her? And is this viewing pleasure always at the expense of our own agency?

The body of Venus has been the legitimate framework to explore human desire and sex in our art and mainstream images for so long that it has become something of an invisible norm. But it's not sex and desire in art that is the problem here, on that I want to be very clear. The problem is that *one form* of sexual desire has been chosen to represent sexual desire universally, and it is a form that satisfies a default male heterosexual gaze and leaves actual female desire without a language, without even a voice. I have a feeling that we've become so used to Venus' knowing performance of sexual availability that this has become synonymous with female sexuality itself, while more realistic, nuanced or complex images of women's sexuality are often censored or obscured, and certainly draw less celebration and attract less value.

Across London, the Tate Modern gallery of twentieth- and twenty-first-century international art considers itself to be the antithesis of the National Gallery's imposing pomp and splendour. Here gilded frames and damask walls are replaced with zigzagging escalators that transport a crowd of tourists and visitors caffeinated with artisanal coffee around the vast, disembowelled industrial power station that houses the collection. This is not a place for slow looking; it is a place to be seen, to Instagram, to snack and to shop.

With its expansive, often interactive commissions in the Turbine Hall, grasping meaning at Tate Modern is secondary to

the overall experience – a fate which accompanies many block-buster museums of modern art that capitalise on a notion of sexy-cool zeitgeist to draw in an audience. But that means that the often radical political message of many of the works that deal with the intersectional issues of gender, race and class within its walls gets diluted into the culture-as-leisure machine. And as long as we see art as leisure, we are losing its power to shape political change. (We might also rightly question here what meaningful power art really has to shape political change anyway if it is always seen in privileged settings such as art galleries and museums.)

The traditional Venus with her classical curves and Cupid accompaniment is conspicuously absent in this collection, but that doesn't mean that Venus isn't here in one of her more mod-ern guises. In 2018 Tate Modern staged a double blockbuster feat of exhibition programming that showcased the work of two giants of modernist painting. The first was *Picasso 1932: Love, Fame, Tragedy*. The leitmotif of the exhibition was Picasso's searing desire for his lover Marie-Thérèse Walter. It was a feast of Venus, even with self-conscious references to the art histori-cal tradition with an imitation of the lounging Rokeby Venus with her mirror. In another painting called *The Dream* (1932), Marie-Thérèse leans back in a chair, her eyes closed in post-coital bliss, while the fingers of both hands make a claw-like frame around her groin – perhaps a nod to Titian's confident Venus of Urbino. And to make sure that we were in no doubt who this fantasy version of female sexuality serves, Picasso painted his own penis as one purple half of Marie-Thérèse's face.

A familiar process of myth reinforcement unfolded across the exhibition, one that presented Picasso as the untamable

beast who went where no mere mortal could go in exploring the depths of his libido in order to give great art to the world. Nowhere in the exhibition did we see Marie-Thérèse the woman, the individual. We know next to nothing apart from the shapes he reduced her to, the circles and odalisques and even his own penis. Moreover, man, woman, gay, straight, cis and trans alike were expected to be wooed and seduced by the male artist's libidinous vision, a vision that has dominated and come to define our perception of genius, beauty and value from the perspective of the white heterosexual male artist.

On the other side of the Tate Modern hung the similarly blockbuster Amedeo Modigliani exhibition, a career-spanning retrospective of painting and sculpture that wowed critics and public alike. The penultimate room of the exhibition – the one critics were most keen to talk about – throbbed with a discomfiting charge as nine large-scale paintings of nude women returned the glances of the gallery audience. Some were sexy odalisques, others were riffs on the pose of the Knidian Aphrodite with some figures artfully covering/revealing their breasts, while others appeared full frontal: in other words, all poses that display the internalised body language of Venus performing for a male heterosexual gaze.

Seen in tandem like this in the same museum, Picasso and Modigliani's 'Venuses' represent a sort of iconoclasm in their self-conscious rejection of the cold, perfectly-finished, stuffy beauty of the Western tradition of art. For the contemporary viewer they have become a reassuring confirmation of left-of-centre politics, of anti-establishment positions and of an intellectual kudos that doesn't need art to look classical to be

meaningful. And the frankness of the male artist's unflinch-ingly libidinal vision is taken as evidence of the separation from restrictive bourgeois respectability and taste.

Modigliani's triumphant assembly of nudes asked us to look openly at sexuality: the last time this group had been seen together was in an exhibition in 1917 which police shut down on grounds of indecency – some of the nudes were painted with resplendent pubic hair, taking them too far from the palatable version of the hairless marble Venus. Visitors to the 2018 exhi-bition were congratulated for having a more urbane and less bourgeois understanding of sex and sexually mature bodies. But again, the question prickled me as it did in the Picasso show: an understanding of sex from whose perspective?

Wall text in the Tate's Modigliani exhibition tried to empower Modigliani's models by suggesting that because they earned twice as much by getting their kit off for Modigliani than they would have earned working a day in a factory, and the fact that they wore make-up and had bobbed à la mode hair, it was somehow emancipatory. But to me this is a just another example of the commodification of women's bodies and the miserably limited options for working-class women (and the false prom-ise of freedom and empowerment in the use of make-up). Yes, given the chance I would probably pose naked for the scabrously intense artist than grind out a day's labour in a factory, but let's not pretend that this is any sort of freedom.

And no matter how much these young women earned, it would never come close to the tens of millions that the pictures of their nude bodies now command at auction: in 2018, the two highest grossing sales at auction were artworks by Picasso and

Modigliani – both paintings of female nudes traceable back to the Venus prototypes. This reinforces the power of Venus in images to communicate status and privilege and wealth in a way that isn't really any different from the value of Velázquez's Rokeby Venus.

Around the same time as the Tate's Picasso and Modigliani shows, I gave a talk about the subject of the female nude to celebrate International Women's Day and the suffragette centenary. I discussed Mary Richardson's attack on the Rokeby Venus. I mentioned the question of the Modigliani Venuses after explaining how the figure of Venus has changed and how much she has remained the same. While almost everyone got on board with the suffragette's destruction of the classical ideal in Velázquez's flirtatious painting, a terror seized one woman that I might be about to dethrone her favourite artist Modigliani. 'Don't ruin them for me, they're so beautiful!' she cried.

And I agree with her. They are sensuous, strange and beguiling with their heavy-lidded eyes and saturnine auras. But I don't want to get seduced again into thinking that's the best we can do, because Venus – in whatever guise we find her – is so contained by the framework of the male gaze that she obscures the expression of female sexuality on its own terms.

I want us to see what Venus represents more clearly. And I want us to be comfortable with seeing the problems of these images and the appeal side by side, without a blanket demonisation of male desire but also without protecting it from critique.

It's a point raised by the American actress Molly Ringwald, who has articulated the tensions inherent in revisiting the films

of her youth, in the changed consciousness of Me Too. Writing in the *New Yorker* in 2018, she asks: 'How are we meant to feel about art that we both love and oppose? What if we are in the unusual position of having helped create it? Erasing history is a dangerous road when it comes to art—change is essential, but so, too, is remembering the past, in all of its transgression and barbarism, so that we may properly gauge how far we have come, and also how far we still need to go.'

It's the *how far we still need to go* part that resonates with me so tantalisingly in Ringwald's statement. How far we need to go to see women's bodies, desires and sexuality in ways that move away from Venus, or to break away from viewing women's bodies through hierarchies of beauty, power and status, and cultural capital altogether. Knowing how to see clearly and critically, or just knowing what it is we are looking at, can help us separate between the images that empower women and the images of false promises of emancipation that tether them.

Let's go back to Venus' surface beauty, the beautiful yet empty vase. The unreal model of Venus has policed how real women's bodies are expected to behave – bodies that should not bleed or grow hair but retain the illusion at all times of smooth, sculpted flesh.

The display of female body hair in the public arena has been consistently inflammatory. Julia Roberts first bared unshaved armpits on the red carpet in the 1990s, sparking discussions about female hairiness, but little has changed three decades later: in 2017 the model Arvida Byström sported hairy legs in an Adidas advert that prompted rape threats. It doesn't stop at

the legs and underarms. The female body is gripped by societal expectations about hairless pubic regions – expectations that are codified by the smoothness of Venus images. A poll by *Cosmopolitan* in 2017 on preferences and habits for pubic hair removal reported that 57 per cent of women aged 18–35 chose to remove all their pubic hair, while 30 per cent of men would consider the amount of pubic hair a woman had as a dealbreaker in their dating relationship. Teenagers attend gynaecologists with vulva burns from laser hair removal on their pubic areas. And it isn't just the teen market that succumbs to these pressures. There is a whole section of the internet dedicated to discussion boards among women debating whether they should have a full Hollywood wax before giving birth, and their shame about whether their pubic hair will offend the midwives.

Venus, and the tenets of beauty that she symbolises and demands of women, is so synonymous with hairlessness that it's no coincidence a famous depilatory brand has taken her name, and even referenced Botticelli's archetypal Venus emerging from the sea in its advertising. Gillette's Venus is a model for women to imitate in order to (as the tagline suggests) 'feel more comfortable' about who they are. The familiar song 'I'm Your Venus' by Bananarama, which has long been adopted by the brand, sets the tone: 'I'm *your* Venus, I'm *your* fire, *your* desire'. The lyrics tell us a lot already about who this woman's body is for – that is for whoever is looking at her, and anyone but herself. The message is that to be comfortable in one's skin – not even happy, or fulfilled, just 'comfortable' – requires work. And it also unavoidably implies that women who do not shave should start to feel uncomfortable about their bodies being seen.

In a 2017 TV advert by the brand, a model wades out of crystalline waters onto the beach. She unzips her wetsuit to reveal a white bikini and lissom smooth limbs while the camerawork insists on the curves and contours of her body as if she were a walking sculpture. The sequence is a direct quote from Botticelli's *Birth of Venus* and also knowingly references the twentieth-century 'Bond girl' Venus in the shape of Ursula Andress in her white bikini who wades out of the sea in *Dr. No*. The bikini is white – in fact everyone is wearing white and drinking lemon water at this ridiculously clean living beach party, which bolsters other ideas about purity and virtue that are written onto the inviolable body of *Venus Coelestis* in Botticelli's painting. In referencing these examples, the Gillette Venus manages to draw on Venus as the glamorous 'pin-up' seen by an unfiltered objectifying male gaze *and* the divine manifestation of culturally valued high art. (Which reminds me of the way in which the Medici Venus in the Uffizi was both leered at and called the most noble work of genius.)

Everyone on the beach turns, and Venus knows she is seen. A more mature silver-haired woman throws her a look of approval and respect – after all, perhaps she used to be that Venus. This subtle detail does something beloved of pre-modern images in art history: it sets up the beauty of a young woman in contrast to an older woman to remind us that Venus' value is conditional upon fleeting physical beauty and youth.

Hair is considered sexually attractive on women's heads, but ugly and 'unfeminine' when on their bodies. But body hair emerges at a woman's sexual maturity, so, like menstruation, it speaks of burgeoning sexual maturity, and reproductive ability,

but archetypal images of Venus tell us that the sexually mature female body needs to be stripped of any evidence of its hormonal readiness to reproduce. And so our patriarchal Venus hands women an inescapable paradox: that they should be sexually available yet ashamed of the things that signal their sexually mature bodies. From her motherless birth to her hairless bloodlessness to her passive objectification, what Venus images seem to symbolise is the suppression of women's real sexuality.

If the ideal Venus must be hairless, then she must suppress all normal biological functions: her perfectly inhuman appearance suggests a body that is all surface, from which nothing leaks or exits. And images of women that deviate or undermine the ideal of Venus are heavily policed in public forums. The poet and artist Rupi Kaur posted an image of herself on Instagram in March 2015. It shows the artist lying with her back to us in a pose that evokes the Rokeby Venus but without the creamy nudity. There are no aggrandising classical references to Cupid, nor a mirror to define Venus through her awareness of being seen – the simple furnishings suggest that this is not a boudoir space for display and erotic performance but a place of rest and relaxation. A patch of menstrual blood marks the sheet on which the artist has been sleeping, and another seeps through her pyjama bottoms. It is an image that depicts something that half of the population will be able to identify with, but despite this, Kaur's photo was censored twice and removed by the social media platform for violating community terms for appropriate material. The censorship raised an explicit hypocrisy over what we find tolerable in pictures of women's bodies. Kaur stated on her account: 'I will not apologise for not feeding the ego and

pride of misogynist society that will have my body in underwear but not be OK with a small leak.'

Rupi Kaur's image also showed an ethnic minority woman in a picture that subliminally references the reclining Venus of white Western European art history, which brings us to the essential discussion about the erasure and objectification of black and brown women in the history of art and images.

Women of colour are much more likely to experience violence related to sexual racism in our culture and these are issues that are acutely reflected in the history of art and visual culture in denigrating, hyper-sexualising and fetishising images. There's a name for it: 'misogynoir' was first coined by the black feminist academic Moya Bailey in 2008. Bailey, who developed the theory while researching images of black female patients in medical textbooks, suggests that the roots of misogynoir are in the racialised fantasies of slave women as sexually promiscuous and wicked – labels that were then used as a way of justifying their exploitation and abuse by white masters.

Examples of misogynoir can still regularly be found in pejorative depictions of black women in public life: former First Lady Michelle Obama has been crudely described with gross racist references to monkeys and apes, not just by internet trolls but even the mayor of a West Virginia town, and tennis champion Serena Williams has been the frequent focus of denigrating caricatures that depict her as animal-like, including Mark Knight's racist cartoon in the *Herald Sun* that depicted the athlete with exaggerated racialised features and an unmanageable temper.

The history of art has also helped to enforce an idea of

women of colour as hyper-sexualised, animal and 'other' to European standards of appearance. If the 'whiteness' of Venus has become so normal to us as a signifier of beauty and culture that it's invisible, the blackness of women's bodies is opposite to this in its *hyper-visibility*. Blackness has been objectified in the history of art, often seen as secondary, exotic and 'other' to the default white prototype of civilisation and beauty.

Often black and brown women have been anonymous background actors in images, providing a foil to make a white woman or man *more white* (and, the implication is, more civilised) by contrast. Black and brown women have also been the focus of a different sort of sexually objectifying gaze to the 'white Venus' performance of hyper-availability, and have been presented in art images as savage and sexually insatiable, or primordial, exotic and sexually submissive.

The visual tradition of Venus has historically excluded women of colour, which means that they have been held back from being viewed as beautiful and a worthy focus of cultural appreciation in Western art. At the same time, the Venus tradition has provided a reductive framework for seeing some black and brown women's bodies through the historical signs, symbols and mythological reference points of the male gaze.

The first appearance of a 'black Venus' in Western images was around 1800 in Thomas Stothard's etching *The Voyage of the Sable Venus from Angola to the West Indies*. A statuesque black woman with sculpted limbs and wearing nothing but a girdle is seen poised on a huge conch shell drawn by dolphins. The crowned god Triton attends to her from the sea – but with a gaze at her groin that suggests predatory intent – and a retinue

of cherubs above herald her arrival with a glamorous plumage of feathers.

This 'Venus' is on her way from her home on the west coast of southern Africa to the West Indian colonies as a slave, but the trauma and violence of the transatlantic crossing has been sublimated into a palatable companion piece to Botticelli's *Birth of Venus*, which it references with the central focus on a classically sculpted nude female body and the conch shell on the waves.

Thomas Stothard, *The Voyage of the Sable Venus from Angola to the West Indies*, 1801. Photograph © Private Collection / Bridgerman Images

The image was produced to accompany a poem by Isaac Teale that was included in the 1801 edition of Bryan Edwards' book *The History, Civil and Commercial, of the British Colonies in the West Indies*. Teale's poem directly compares the 'Sable Venus' to Botticelli's *Birth of Venus*, in thinly disguised racist terms; not only does it reinforce the idea that the white Venus is the default motif of female beauty, but it also mitigates the poem's taboo fantasy of raping an enslaved woman by viewing her through the framework of an 'appropriate' icon of high culture and the desiring male gaze.[10]

Poet Robin Coste Lewis has described *The Voyage of the Sable Venus* as an image that is both beautiful and horrible. On the one hand it gives us the body of a black woman to view within the framework of classical culture that has normally excluded her. But the way in which it mystifies her exploitation and dehumanisation into a mythogical fiction is nothing short of horror: *The Voyage of the Sable Venus* draws on the authority of Renaissance art and culture to promote a fantasy of the transatlantic slave crossing as a willing and emancipatory voyage for African women and obscures the reality of confinement and abuse that enslaved women faced.

A bare ten years after Stothard's print was made, in 1810, Saartjie Baartman, a woman from the Khoikhoi tribe in South Africa and otherwise known as the 'Hottentot Venus', arrived in London.[11] The name 'Hottentot' draws on the term Dutch colonisers in South Africa gave to Khoikhoi people (possibly inspired by a Dutch appropriation of the sound they understood in Khoikhoi speech).

Baartman was 'exhibited' as a spectacle at Piccadilly Circus

where members of the public paid a few coins to gawp at her body; she either appeared in a cage or was paraded around the room by a 'keeper', as if she were a wild animal. Baartman was one of two Khoikhoi women who were brought to the UK and publicly exhibited as anthropological specimens for an audience fascinated by the women's enlarged emphatic buttocks – a physiological condition known as steatopygia that was common in Khoikhoi women.

Baartman was taken from London to France around 1814 and shown to paying audiences in Paris, where she died from syphilis a year later. Her body was then dissected by the French anatomist Georges Cuvier who believed she represented a 'missing link' between animal and human evolution. Her brain and genitals were put on display in glass bottles in the Musée de l'Homme in Paris until 1976; her remains were sent back to her place of birth in 2002 – an event met with the headline 'Freak Show African Going Home' in the *Telegraph* newspaper.

Interestingly, the same argument that we face now about women's 'choice' in their own objectification also accompanies discussions about Baartman's exhibition – she was a willing participant and shared a portion of the profit with William Dunlop, the man who had enticed her to Europe with the promise of riches. This argument attempts to deflect scrutiny of systems that encourage women to profit (nominally) from their own exploitation.

Baartman was presented as a different sort of Venus to the Sable Venus who so carefully mimicked the classical white prototype. In one French print known as 'The Curious in Ecstasy' from around 1815 (one of numerous cartoons and prints

that parodied her body as a sexualised spectacle), Baartman is pictured on what looks like a stone plinth made for a sculpture while men and a woman ogle her body. The plinth encourages us to see Baartman's body as both an art object and anthropological specimen. One man with his foot raised on a chair leans forward to inspect her haunches in a way that reminds me of the huddle of eagle-eyed spectators focused on the buttocks of the Medici Venus sculpture in Zoffany's painting. But whereas the white sculpted Venus, beloved of aroused sailors and horny grand tourists, is a body in which we dispel anything remotely real about the female body, the 'Hottentot Venus' was presented as a body of physical excess – one that overspilled with everything that was repressed in the white marble goddess.

European audiences saw Baartman's relatively enlarged buttocks as a symptom of deviance and hyper-sexuality, and nineteenth-century scientists, deeply skewed by colonial racism, developed ideas that suggested this provoked the supposedly untameable sexual nature of African men. This belief was perpetuated across the US throughout the twentieth century, fuelling, among other heinous responses, the mob lynching of young black men accused of sexual crimes against white women.

Another way of seeing women of colour's bodies emerged in Western art towards the end of the nineteenth century when artists looked to Europe's colonised territories as prelapsarian idylls. They depicted colonised women as untouched and uncorrupted by the capitalism and industrialisation of the West. Often these paintings represented sexual abandonment and meaningful escape for the white male artist seeking refuge from the modern world and stuffy traditions of academic art.

One of the key perpetrators of this fantasy was artist Paul Gauguin, who abandoned his life as a stockbroker in Belle Époque Paris, leaving his wife and three children behind when he set off for the French colony of Tahiti. There, he had sex with numerous native women, many of whom were adolescents, a number of whom he took as his 'vahine' – or wives – and painted pictures of. In his letters, he described these women as 'nymphs', a term that usually describes mythological personifications of nature who are often accosted in stories by libidinous male deities. Gauguin saw himself as one such entitled deity and professed his desire for the women of the island, some as young as thirteen, describing how he 'want[ed] to perpetuate them with their golden skins, their searching animal odour, their tropical savours'.

Gauguin took the archetypal Venus of Western art and exoticised her with the visual language, symbols and colours of his idyll of Oceania. And while he may have abandoned the marble-like flesh and *pudica* poses of the traditional Venus, similar dynamics of ownership, power, desire and voyeurism remain entrenched.

In *Spirit of the Dead Watching*, from 1892, the artist painted one of his numerous vahines. It's as if he has flipped the Venus of Urbino or the Rokeby Venus onto her belly: her extended brown limbs gleam against the white sheet she is laid out on; her legs are crossed at the ankle, hands planted on the pillow; her head turns with anticipation to the viewer, as if to signal her readiness to be sexually consumed. It is clear from her pose and her gaze that the implied spectator is anticipated and familiar, her domination by him inevitable. Behind her an ambiguous figure (a spirit?) is seen in profile against a miasmic purple background

that is livid as a bruise. The painting abandons all the restraining symbols of marriage or classical mythology that held the frank eroticism of an image like the Venus of Urbino at bay. (Gauguin himself described the painting as 'indecent'.)

Until recently, public opinion has for the most part received Gauguin (like Picasso and Modigliani) as a giant of modern art whose commitment to the pursuit of his desires and the exploration of it in avant-garde art is liberating for everyone who encounters it. Gauguin's story is often portrayed as one of freedom in the face of stifling European bourgeois society; his sexual adventure an impassioned odyssey that brings the artist, and all those who are touched by his work, into a prelapsarian world of animal instinct and emancipatory sensuality. Sex tends to be taken as an automatically liberating theme in art, but we might ask ourselves how liberating the sex was for the women in these pictures.

For decades, art historians have critiqued the artist in light of his colonialist and sexist gaze. More recently, this has been acknowledged in large-scale exhibitions, such as the 'Gauguin Portraits' exhibition organised by the National Gallery in London and the National Gallery of Canada in 2019. The interpretative materials admitted: 'Gauguin undoubtedly exploited his position as a privileged Westerner to make the most of the sexual freedoms available to him.' Yet, in spite of these admissions, it seems like we haven't quite worked out what to do with him, as the question of 'separating the art from the artist', or the 'monster from the genius', have had little impact on recontextualising the difficult questions about masculine genius and the right to desire that his depictions of Tahitian women provoke.

Misogynoir images hide in plain sight in our visual culture, and the Hottentot Venus with her exaggerated buttocks haunts our cultural imagination, shaping racist prejudice and also complex cultural and sexual ideals. In 2014 Kim Kardashian appeared on the cover of *Paper* magazine standing on a plinth, and sheathed in a black dress so tight it renders her immobile, turning her into a smiling sculpture on display. The black gloves she wears on her hands evoke the sensuality of Golden Age Hollywood glamour and in them she holds another symbol of high-rolling luxury – the champagne bottle from which an excited halo bursts like an ejaculation over Kim's head, landing in a glass perched on her anatomically impossible (photoshopped) butt. The spray foam creates a frame around Kim's upper body, marking it out as another image within the image and implies sexual release, excitement and conspicuous affluence. But that effervescent arc of champagne coupled with the tightly encased body also bring us subtly back to the body of Botticelli's Venus and her salty birth on the foamy waves of the sea.

Her black Venus counterpart is latent in that famously stacked butt that cannot but recall Saartjie Baartman, the exploited and objectified body of the black woman uprooted from south-west Africa. Kim's pearl necklaces reference the pearl as a European symbol of luxury, but the tight rows of them resemble the stacked beaded necklaces of Maasai women, and the terracotta brown background subliminally references African clay soil. The image crudely adopts a racist stereotype of black female sexuality within the relatively safe conduit of a light-skinned woman, to create a whitewashed black Venus in disguise. It is perhaps just what the American artist and critic

Lorraine O'Grady meant when she said that in the misogynistic Western imagination black and white female bodies cannot be separated from one another.[12]

It's important to remember here that the author of the artwork is not Kim Kardashian, but Jean-Paul Goude, and the infamous *Paper* magazine shoot is in fact a reproduction of one of his earlier photographs, included in his 1982 book *Jungle Fever*. (Goude commented on his interest in black models by saying in 1979: 'I have jungle fever.') The image in question is called *The Champagne Incident* and depicts black model Caroline Beaumont with the same excitable champagne arc that lands on her impossibly high and rounded buttocks. (Goude is known for his analogue methods of manipulating photographic images to emphasise anatomy and poses.) Both photographs directly draw on the racialised spectacle of Saartjie Baartman as the Hottentot Venus.

It's not hard to see Goude as a twentieth-century Gauguin, a European man searching for inspiration in the bodies of women who to him represent a sexualised exotic other, and using the traditions of Venus and the male gaze to make pictures of them. As Robin Coste Lewis writes in the *New Yorker*: 'ever since Rome, we keep replacing the statues but continue playing the same blinding games.'[13]

Women artists have been reclaiming black female bodies, untethering them from images of art and history that see them only in relation to whiteness or in historically denigrating guises. African-American artist Renee Cox photographed herself posing as the Hottentot Venus in the 1990s to subvert and critique the

archetype and claim agency over the way in which black women's bodies have been seen. More recently, in February 2017, the singer and performer Beyoncé Knowles-Carter did something similar when she posted a selection of images on her website and on Instagram to announce her pregnancy. Photographed by artist and art history graduate Awol Erizku, the photos placed Beyoncé's pregnant body centre stage in a riff on the familiar Venuses of Western art history including the *Venus pudica* and the reclining odalisque.

First up, the *pudica*, reminiscent of the Knidian Aphrodite and Botticelli's *Birth of Venus*. Gone are the shores of the Mediterranean and the benevolent winds that usher the goddess off the waves. Instead, Beyoncé synthesises her take on the image of the Western goddess with a portrait bust of African queen Nefertiti and symbols of Yoruba fertility deities to create a blend of symbolism that reflects the entangled motifs of the African diaspora and colonialism.

Her body emerges from a bouquet of plants, arriving not from the cold, motherless water like the Botticelli Venus, but flowering from the earth, bringing the conspicuously absent notions of fertility and bloom into Venus's body. And rather than coyly covering her groin in apprehension of being exposed, Beyoncé presents us proudly with her burgeoning belly.

The Kenyan-born Somali-British writer Warsan Shire's poem 'Three Hearts' was published to accompany the photographs on Beyoncé's website – the title refers to the two beating hearts of the twins growing inside Beyoncé's maternal body and the body of the mother who Shire calls a 'black Venus'. In Beyoncé and Shire's remix of the Western trope, Venus is

both black and deeply linked to fertility and reproduction, two aspects that are invisible in the tightly controlled image of the *Venus Coelestis*.

These portraits are as much about aspiration and status as any of the art historical images of Venus I've discussed. Beyoncé even draws on the iconography of African queens to assert herself as regal and the head of a dynasty that will be continued with the children she carries. Beyoncé is placing herself directly into a canon that excluded African beauty in the highly cultured terms that the Venus archetype represents, claiming her position within that tradition. It is important to recognise agency here. Unlike the galaxy of nameless women whose bodies were moulded into Venus by artists' brushes and patrons' desire, Beyoncé is the architect of her own image. She decides how she will be seen. Her sensuality and physical beauty is emphasised and offered to us as the evidence of her power, even if her facial expression contains a note of warning: we can look but not touch.

But when we know about the shame hidden in plain sight in the body of *Venus pudica*, or the racial and sexual power discourses written across the surface of all those reclining Venuses, then I'm tempted to wonder how subversive and empowering these portraits can be, especially when they still rely on beauty and sensuality as a definitive metric of power and empowerment when it comes to the images women choose to share of their bodies.

Debra Cartwright's large-scale works of black women resting approach Venus from another angle. Now that we know them, the conscious or unconscious references to the visual

tradition of Venus are recognisable in the landscape of lived-in bedsheets and the odalisque poses. In *Derica's LA Loft*, a black woman lounges artfully on a daybed in a leopard-print chemise, her head resting on a propped-up elbow, one hand gently poised on a drink can. The lighting suggests that this is the middle of the day and Derica is luxuriating in a moment of unfettered relaxation. Despite the inevitable voyeurism we are offered as spectators witnessing her in close quarters, Derica closes her eyes, refusing any encounter with our gaze. So much of Venus' identity comes from knowing that she is being seen and being complicit in it, but this snoozing odalisque jams that circuit, denying the beholder any of the power that comes from seeing the nude aware of performing for our pleasure. Cartwright's black women at rest subtly undermine the power discourses of the Venus tradition with a different form of agency than Beyoncé's sensual self-curated portraits: one of rest and relaxation as a radical feminist act.

In her book *A Burst of Light* (1988), written after her diagnosis with cancer for a second time, Audre Lorde wrote about the power of self-care as a radical act of resistance. 'Caring for myself is not self-indulgence,' she wrote. 'It is self-preservation, and that is an act of political warfare.' The politics of self-care are especially pertinent when seen through the historical exploitation of black people, especially women, as cheap labour. Cartwright's message speaks to this but is also universal – all women can identify with how patriarchal capitalism demands they care for others before themselves, while also creating the additional 'work' of maintaining the appearance of Venus (an extraction of money and time that is falsely marketed and sold as 'pampering'

or 'me-time', even to pre-teen girls). In a world that insists on women maintaining disciplined standards of beauty and hyper-productivity, as well as assuming the burden of care work within the home and working harder for less money in employment, choosing to rest becomes a political gesture of defiance.

Cartwright's women rest in spaces that are claimed as theirs – the title *Derica's LA Loft* hints at Derica's financial solvency and status, affording her desirable real estate. These Venuses (if we can call them that) reflect their own social status rather than that of an owner-spectator, their own pleasure, and their own entitlement to rest from the work of being Venus, from the objectifying male gaze and from other labours.

Debra Cartwright, *Derica's LA loft*, 2020, Ross-Sutton Gallery. Courtesy of the artist

Other women artists have replaced the impossibly beautiful Venus with more broken, messy, or diseased bodies that challenge the societal expectations about women's physical appearance. American feminist artist Hannah Wilke opened up the fantasy of Venus as a perfect body in her confrontational final work *Intra-Venus* (1992–93), a series of photos, drawings and videos that document her physical decay in the clutches of lymphoma and the ravages wreaked on her body through treatment. Across the course of her career, Wilke's work consistently drew attention to how women are encouraged to perform femininity in ways that derive from well-rehearsed Venus archetypes found in magazines and advertisements. (Ironically, Wilke was criticised as a narcissist by feminists in the 1970s because she was considered physically beautiful and used her attractive nude body to critique the sorts of images that informed the goddess fantasy projection of femininity.)

Intra-Venus is her final riposte. Wilke poses provocatively on the clinically white sheets of the hospital bed (and not the inviting boudoir chaise), mimicking the studied poses of the pin-up and the reclining odalisque seen across images from art history to erotica. But this Venus has thinning hair, a sagging body and wound dressings that draw attention to her bone marrow transplant and her impending death. She shows us a diseased and mortal body who still instinctively performs for an expected male gaze in a way that is both tragic and absurd.

It is the surgeon's and not the suffragette's knife that has opened up the body of Venus in Wilke's photographs, but in some ways Mary Richardson's attack on Velázquez's canvas

and Wilke's photographs both point to the same thing: they expose the image of Venus to be a brittle mask that suppresses the unstoppable surge of reality and decay by turning women's bodies into performing art objects.

Sometimes the anti-Venus can be found waiting patiently in unexpected places. *Woman Awakening* is a quietly radical painting produced by French Impressionist artist Eva Gonzalès in 1876. 'Radical' might not be the first word that comes to mind when you look at this image of a pretty woman lying in fresh white sheets, surrounded by the reassuring symbols of haute bourgeoisie domesticity: the vase of lilacs, the plump pillows. But this image is subversive when it comes to nineteenth-century French art because it depicts a woman lying in bed – without reference to sex, or to Venus. Like Debra Cartwright's lounging women at rest, this woman doesn't acknowledge any viewer. We see her waking up in extreme comfort in the soft blue glow of morning with a book she might read. Her private, internal world is shielded from us spectators, as is her reclining body. Drawn in by her red lips and black hair against the white pillow, our gaze meets the blank space of the snowdrift of fabric that surrounds her. It is a picture of a thinking human subject at rest, content in her body and her world. She is, in other words, everything that Venus stops us from being.

Mothers

There is a park at the end of my road under which the old river Effra is buried. It is mostly imperceptible, its course known only through indications of the odd street name that references the subterranean flow. Suppressed in this way, the water rises to ground level in odd ways, contrary to its instinct and at odds with the urban geography that has suffocated it. It is not a bustling city park with smartly tended flower beds; it has a loneliness and emptiness that is sometimes melancholy but often beautiful. A black pond of stagnant oily water near the playground is home to a forlorn community of ducks and squabbling moorhens. With storms and high rainfall, the underground channels of the interred river cause flooding, when the water pools on the grassy verges and also wells up from below the sod, making its slippery presence known. During the day dog walkers and occasional tennis players drift through the thoroughfares, but mostly the park is populated by fatigued women pushing strollers. They too conceal buried versions of themselves, versions that are flowing or stagnating beneath the surface, also waiting to breech the banks when the rain falls.

The playground has a clear vantage point of the city skyline to the north, where a cluster of silver towers marks the horizon and the world of work and commerce. In the winter days of half-light in the afternoon, the red and white lights of the towers blaze on the horizon and become futuristic rocket launchers with toy-shop names: the Gherkin, the Walkie-Talkie, the Cheese-Grater. It is the place where husbands work, or where these women used to work, having set down their tools temporarily, or guiltily, or happily to raise children from here, from the sidelines, among the ice cream vans and the squirrels and the tears.

When I stand here, mechanically pushing a swing and wiping noses, trying not to check my phone and to keep ideas in my head about things I want to write when the children go to bed, I often look at the city on the horizon and think about the artist Berthe Morisot. Morisot lived at the centre of Parisian artistic life in the 1880s, but by virtue of being a woman she was also always at its periphery. That tension of being both outsider and insider was expressed most of all in her life as an artist. Women were not permitted to study in the national art school, the École des Beaux-Arts, until 1897, which was two years after Morisot's death. However, her social status as an haute bourgeois woman allowed for private art training with the approval of her parents, and her marriage to Eugène Manet, the brother of the painter Édouard Manet, granted her access to a world in which she could paint and exhibit her work, but not without crucial limitations. As a woman, Morisot couldn't roam the city unaccompanied in search of modern life. She couldn't while away afternoons with palette in hand watching the human traffic in the Tuileries, nor linger like a voyeur backstage at the

opera and ballet. She couldn't sit unaccompanied in the city cafes watching the dispossessed swill absinthe all day nor watch the laundresses breaking their joints rolling sheets in clouds of steam. Fiercely observed social propriety meant that as a woman she had to stay at the edges of city life, in the suburban kingdoms of the domestic, and so the focus of her gaze and the subject matter of her art was the world of women and children.

Berthe Morisot, *The Artist's Sister at a Window*, 1869, Ailsa Mellon Bruce Collection. Courtesy National Gallery of Art, Washington

For this reason, her work has been routinely overlooked as pleasingly 'feminine', a term which really serves as a euphemism for 'pleasingly unthreatening to male artists'. But beyond the pastel façades and gauzy renderings of fabric and atmosphere, there is nothing about Morisot's work that I don't find troubling and quietly unsettling. Her favourite motif is the threshold, often situating figures in scenes where windows and balconies act as intermediary spaces – dividing outside from inside. But she seems to explore these boundaries from a psychological perspective as well: her canvases present figures of women dissolving amid the flocked thick confetti of her brushstrokes, revealing the flow of consciousness under the surface as the boundaries between interior identity and outward appearance evanesce in colourful, loosely stitched tapestries of paint. She was known as 'the angel of the incomplete' for the sometime inchoateness of her compositions – the ellipses, the fragmented, the sense of unravelling of form – although this label was not necessarily given to her in praise by the critics of her time.

Morisot's is an art of dislocation – from the city, from oneself, from one's environment – a dislocation that brings all the muddied ennui and frustrations of women's experience to the surface. But she has not always been recognised in art history as the radical existentialist that she was.

Morisot understood the stifling narcissism and ennui of middle-class motherhood, with its heavy dresses and empty days. In *The Artist's Sister at a Window* (1869), she paints her sister, Edma Pontillon, sitting at the window of a comfortable haute bourgeois abode and wearing a spotless white morning dress that enshrouds her swelling pregnant body. Early

summer air streams through the windows while across the street two neighbours lean over their balconies conversing and perhaps observing the life of the street below. These figures are impressionistic notations, but we can still read a certain swagger and bodily confidence that suggests they might be men. But while male gazes and a summer breeze siphon through into the room from the world outside, Edma remains on the cusp of anything that lies beyond the heavy interior. She faces the street but her eyes are lowered, her feet rest on the threshold of the balcony that divides the city from her home. Her body is weighed down by the milky folds of that white dress while the child growing inside her represents another internment for both mother and unborn child, both captives held on the inside in different ways.

Just by looking, we cannot know that Pontillon has recently relinquished her own artistic career – a sacrifice required to marry her naval officer husband – but her frustration is palpable in the way she disconnects from her surroundings, with her gaze lowered, restlessly toying with a fan in her lap. Not yet married, Berthe Morisot was at liberty to devote herself to her painting but must have keenly felt her sister's loss. With the support of their liberal-minded, well-off parents, the sisters had trained as professional artists with an education that went well beyond the drawing room accomplishments nurtured in most young women of their class. This was in spite of the scornful contemporary attitude towards women's professional training as artists, and the warning from their painting instructor Joseph Guichard that for upper middle-class women to become painters was a revolutionary, if not catastrophic, move.

In *Woman and Child on a Balcony*, painted three years later, Morisot depicted her sister again, this time accompanied by her young daughter Jeanne in the enclosure of a balcony that overlooks the Parisian skyline. The golden dome of Les Invalides glints against the smoky lavender sky, rising up from the 7th arrondissement in the city. Les Invalides, a complex of monuments and museums erected to celebrate French military history, was a resolutely masculine symbol. It marked a district with no institutional or symbolic place for women. Morisot's wistful image captures the perpetually separate feminine sphere of the privileged woman trapped in the stillness and tedium of the suburbs, away from the throng of modern life and its trophies. The child stares forlornly through the railings, like a pet in a cage. Her mother's eyes are averted blankly. It is best not to look at what she cannot get close to.

My favourite Morisot painting is called *Hide and Seek*, painted in 1873 (the year before she got married). A mother and child are playing a game in an outdoor space that looks and feels something like the one at the end of my road. Hazy horizontal bands of green marking borders, hedges and horizons create a sense of containment despite being in the open air. Seeing the figures held together in this verdant net makes me recall my own long days of bliss and boredom spent looking after children; of the nothingness and the everything played out in the vistas of the park.

Between the little girl and her mother stands a dark tree. It is a brooding presence in the otherwise sunny bucolic haze that washes over them. That tree bothers me; its leaves and branches are too black and too unformed – like liquid charcoal that risks

seeping onto their dresses. It hovers like a quivering cloud over the little girl's head: something that cannot be said, something that cannot be contained.

Berthe Morisot's images of mothering quietly loosened the seams of the perfect archetypes of the 'Madonna and Child' – that avalanche of Christian devotional images of the Virgin Mary that define mothering as something sacrosanct, monumental, self-sacrificing, subservient and desexualised. Instead, Morisot allowed the instability and ambivalence of maternal experience to overflow those restrictive containers, making seemingly straightforward domestic images freighted with psychodrama and existential uncertainty. This was perhaps the first time that the mask had slipped since the Virgin Mother's debut in images in the fifth century CE, after the Council of Ephesus had decided in 431 that Mary was the Mother of God. Mary appears in the glinting mosaics of early Christian art as a body shrouded beneath stepped terraces of blue fabric, with only her face, or sometimes a breast, exposed. Subsequent images, evolved by the early fifteenth century, typically show Mary as a beautiful and demure young European woman, unruffled by motherhood's physical and emotional strains and attentive to the male infant on her lap, at her breast or in her arms. As a trope this became known as the 'Madonna and Child' and it is perhaps, along with Venus, the most definitive and prolific archetype of womanhood to be found in pictures.

If ever we doubted how much motherhood is asked to contain, we need only look to images of the archetypal Madonna of Christian images who bears the burden of a schizophrenic number of responsibilities. Mary is a teenage mother to a son

who is later murdered as an adult. She is comforter to the desperate and the humble, and is a meek girl from Galilee but also wears the mantle of queen of the court of heaven. Mary is a personification of the Church, intercessor between the human and spiritual realm, and bride of Christ; all the while remaining uncomplaining, pliant, accepting and silent. Mary is never seen to age and physically atrophy in images (she looks the same age at Jesus' birth as at his death 33 years later), and this eternal youth is not just a symbol of her innocence but because she is supposedly free from original sin. Mary was not conceived through sexual intercourse but miraculously conceived in her mother Anna's womb, and so she did not inherit original sin as passed down from Adam and Eve and their disobedience in eating the apple from the Tree of Knowledge. Those are the somewhat abstract theological terms, but they have a practical implication for women's identity that is still relevant: because our Western perception of mothers has been shaped by images of Mary that have crossed over into secular visual culture, this means that the way mothers *look* on the surface is still an indication of how *good* they are.

Images of Mary in Christian art have enforced her purity and chastity in very specific ways. She is, for example, often accompanied by visual props such as a spotless mirror to convey her flawlessness and lack of any moral 'stain'. The mirror also represents Mary's function in Christian art as the ideal example of womanhood, which reflects back other women's inadequacies in comparison. Another metaphor for Mary's sealed and chaste beautiful body is the enclosed garden, known as the *hortus conclusus*. Images that express this idea typically see Mary

confined in a walled garden, separate from the rest of the world – not unlike Morisot's sister and child on the balcony. The concept comes from the Canticle of Canticles in the Vulgate Bible, also known as the Song of Songs or Song of Solomon: 'A garden enclosed is my sister, my spouse; a spring shut up, a fountain sealed.'

But the enclosed garden is not just about keeping Mary separate and unpolluted from the rest of humanity; it has a biopolitical angle too. Beyond the garden, the untidy and raw instincts of nature (and women's bodies) run wild. Inside its walls, those instincts are cultivated and tamed. To think of Mary's body as 'a spring shut up, a fountain sealed' disturbs me: it suggests something cauterised, silenced, a flow that has been choked. It is the same horror that I feel when I think about my grandmother's generation, gagging on pills that plugged up the well of untidy emotions that postpartum depression undammed.

The more we consider this metaphor of the Virgin Mary, the more it starts to feel like sheer horror: one of our prevailing images of ideal motherhood is a forced fertile garden where life is stimulated but all flow and animation is suppressed. Beneath the starched surface of Mary is a body that has been sealed shut, from which only breast milk and tears escape. These are symbolic of her only two permissible roles: to nourish Jesus as a baby and grieve his death as an adult. And once she has performed her role as a sacred womb and breastfeeding mother, we see little else of Mary until we witness the torrent of her pain at the foot of the cross as she watches her son die.

Her sexuality is denied to her before she ever has a chance to experience it: Mary falls pregnant as a girl with a forced

conception (the work of the Holy Spirit) that censors even the possibility of physical pleasure. Her womb, having performed its service, becomes obsolete: she bears no more children. She is the chaste and obedient mother, the incorrupt angel who cannot be defiled by either age or sex. Mary is beautiful and benevolent, but, like the figure of Venus, she is more a man-made symbol than she is human. She is, as the philosopher Julia Kristeva has suggested, 'a woman whose entire body is an emptiness through which the patriarchal world is conveyed'.

The Virgin Mary is a version of the virgin mother deities of ancient Greece and Rome: of Artemis and Diana, goddesses of chastity and fertility. But in the symbols and stories of earlier cultures, the mother's body was something different. A mountain built from corpses, she was known as Ninhursag in the Sumerian religion of southern Mesopotamia 5,000 years ago. Her symbol is the one now known as *omega* in the Greek alphabet – a symbol that now signifies endings but once symbolised the open uterus, the flowing in and out of life and death. She is Tiamat, the ancient primordial goddess of creation, the slippery and germinative salt water from ancient Babylonian religion. She is the abyss at the beginning of time, known as the 'former of all things', or 'Ummu-Hubur'. Before it was a sealed spring and enclosed garden, the maternal body was a boundless and incomprehensible force not made in the service of God – it was God.

Just as the instantly recognisable *Venus pudica* pose works as visual shorthand for feminine sexuality and beauty, the recurring image of the Madonna and Child is so embedded in our collective consciousness as the ur-mother that any deviation from pictures of Mary as a beautiful blushing rose continues to

invite strong reactions. Charles Dickens, for example, famously objected to the ugliness of what he called a 'degenerate' Mary in John Everett Millais' *Christ in the House of his Parents* (1849). And Chris Ofili's work *The Holy Virgin Mary* (1996) – a black Madonna strewn with clouds of gold glitter and propped up on balls of elephant dung – invoked the wrath of then New York City mayor Rudy Giuliani and the conservative establishment when it went on display at the Brooklyn Museum in 1999. In May 2019 the home of the human rights activist Elżbieta Podleśna was raided by Polish police, who seized images of the Madonna and Child thought to be heretical for the LGBT rainbow flag across their haloes.

While the familiar image of the Madonna and Child was initially a focus of Christian religious devotion, the visual identity of the impossibly chaste and pliant mother also bled into secular portraits of women across the eighteenth and nineteenth centuries. The British Victorian artist Frank S. Eastman's *A Little Sleep* (1906) glows with warm burnished colours reminiscent of a medieval religious icon and shows an anonymous mother with long plaited hair wearing a heavy velvet dress that reflects contemporary fashions. Her pale face looks down submissively and patiently while she cradles a baby in her lap. There is nothing else for her to focus on in the image. Behind her, a large decorative copper dish hanging on the wall acts as a gigantic halo, while the tall, creeping potted plants on either side enclose the woman in a way that recalls the *hortus conclusus*. The effect is calm and intimate and yet almost sepulchral with its sombre colours, conjuring up dank corners of churches weighted with incense and piety, or funereal sitting rooms.

Extending the visual framework of the Virgin Mary from devotional images into secular ones bolstered the widespread sanctification of mothers and wives in the Victorian and Edwardian periods, and the ensuing expectation that they live on a morally virtuous pedestal with impossibly high stakes. Through their direct references to the Madonna and Child, images such as Eastman's *A Little Sleep* stealthily emphasised the period's preferred female virtues of meekness, obedience and frostily maintained chastity, and reinforced and rationalised the containment of women in private, domestic life as their natural place, while men dominated the public and professional sphere. This spiritualisation of mothers in secular imagery was also underpinned by the widespread adoption of the fantasy role model of the 'angel in the house', the name for which comes from the title of a poem by the English writer Coventry Patmore, first published in 1854.

The poem is a eulogy to Patmore's beloved wife, whose submission to her husband and docile self-sacrifice to the family became a cultural model for the wives and mothers of Victorian Britain and nineteenth-century America (although all ages of women and not just mothers were encouraged to aspire to being an angel in the house). Patmore's poem celebrates an impossibly perfect woman with a devout and submissive disposition, her 'countenance angelical', 'her pleasure ... in her power to charm'. The angel in the house is not expected to need any sustenance, sleep or time to herself, but instead maintains the needs of all others. As an idealised image for wives and mothers to emulate, it couldn't be more different to the messy, complex physical and emotional rewards and demands of the lived reality of mothering.

The angel is also the enemy of female creativity, as her capacity to think, want or need is secondary to how she can make others feel. Maintaining the ideal meant censoring the flow of the imagination and denying the woman artist or writer her voice and vision, especially if it were one that might challenge and question the world reflected back at her. In her 1942 essay 'Professions for Women', Virginia Woolf wrote about how the radiant angel in the house haunted her with her expectations. Woolf's angel is a figure who 'never had a mind or wish of her own, but preferred to sympathise always with the minds and wishes of others'. Woolf had to kill her off when she saw the shadow of her wings on the desk as she wrote, and, in doing so, she was free finally to plunge into her imagination, the interior state she described with watery adumbrating terms as 'the pools, the depths, the dark places where the largest fish slumber'.

In killing off the angel, Woolf was also killing off her own mother, who was seen by many of the age as the living embodiment of the nineteenth-century angel in the house. (Coventry Patmore even gave her a signed copy of the fourth edition of his poem.) Julia Stephen was a woman distilled in pictures, appearing as a cold and wraith-like young Virgin Mary in Pre-Raphaelite painter Edward Burne-Jones' painting of *The Annunciation*, and captured in wistful powdery portraits by her aunt, the photographer Julia Margaret Cameron. She more haunts than appears in these images, with her milky opal eyes and a distant gaze (both taken as indicators of extreme beauty). Her husband Leslie Stephen, father of Virginia Woolf, described his wife in terms that could easily be interchangeable with the mythology of the Virgin Mary: as a woman whose 'beauty was

of a kind which seems to imply – as most certainly did accompany – equal beauty of soul, refinement, nobility, and tenderness of character'.

Julia Stephen died in 1895, the same year as the artist Berthe Morisot, and I can't help but read the women in Morisot's paintings as similar domestic angels, beautiful and tender of appearance and yet trapped in their muteness and melancholy. Before Virginia Woolf killed off her mother's influence, Morisot was already playing with the flow of consciousness beneath the surface of those brittle and pretty veneers of angelic womanhood. Her women vaporise at their edges, unsure and unstable in their environments, shifting in and out of focus in evanescent flocks of brushstrokes, bobbing up to the surface of the image to be pulled under again.

The silent Virgin Mary and her descendant, the angel in the house, didn't die out at the close of the nineteenth century but lingered on in advertising and commercial images that have shaped societal expectations of women across the twentieth century and into the twenty-first, such as in the enduring cultural image of the virginal bride in her white dress.

The cover of a *Bride's* magazine from 1949 shows a contemplative woman seen in profile behind a curtain of white lace that conceals all but her face. She appears in an aura of piety; with her arms propped up on elbows, she could be an image of the Virgin Mary kneeling in prayer over the crib of her son, or the figure of a convent novitiate entering the church as bride of Christ. The dressing table she sits at could just as easily be an altar or a pew. The vase of flowers on her dressing table echoes

The Bride's Magazine cover, Late Fall and Winter 1949–50 issue. Courtesy Brides Magazine

the floral symbolism in Mary's iconography, and the bride is subsumed by fabric and furniture in the image, that lace tent of a veil allowing only glimpses of the woman beneath.

The image epitomises the heavily marketed fantasy of the white wedding that was adopted at large in post-war America – a fantasy which revolved around the sanctified figure of the bride. While the edicts of the Virgin Mary and angel are already writ large into the traditional vows of the wedding liturgy, with the bride's promise 'to love, honour and obey', fashions also dictated

89

that brides wore white, as a symbolic outward manifestation of their purity.

By the late 1940s, the white wedding industry boomed as a generation of young women who had been liberated by opportunities to flee their restrictive domestic lives and earn their own money during the Second World War were met with the societal expectation that they return to the traditional female roles of helper and mother – in other words, there was a mass reinstallation of the patient, acquiescent, self-sacrificing angel in the house. The sacramental bride marked the first step in despatching her into her domestic role.

The angelic Madonna and Child image was also hijacked in the twentieth century to advertise consumer baby products, particularly formula milk. By styling their campaigns with images that echoed religious paintings, brands could borrow from centuries of moral messages about the Christian ur-mother to emphasise the choices that 'good' mothers make when it comes to feeding their babies. An advert by Nestlé from 1935 couldn't make this connection more literal. It specifically appropriates an Italian Renaissance painting in the style of Raphael – the Italian master of the meek and mild Madonna – and gives her a bottle of formula milk to feed the infant on her lap. A caption reading 'Motherhood as seen by Raphael' runs across the lower register of the image, with Nestlé's branding interrupting the phrase.

Seventy five years later, infant formula brands continue the exploitation of the archetype. An Aptamil advert from 2010 shows a mother with a downcast gaze of patient devotion holding her male infant to her chest, her chin resting on his downy hair. The image is tightly cropped so we see only the heads

and torsos of mother and baby and they fill the image space, softly glowing with attenuated light against a darker shadowed background, lending a sense of an icon on an altarpiece lit by candlelight.

Formula milk could conceivably be marketed for what it ostensibly offers: freedom for mothers from the burden of being the sole source of nourishment for a hungry infant, or a welcome relief for women who have difficulties with lactation or have babies who have problems with latching on, or for mothers who are just exhausted and depleted. But the advertising images historically used to sell powdered milk still borrow from the language of Christian images of the Virgin Mary to make claims about what the most virtuous and respectable mothers choose to buy to feed their infants.

You know this already, but ads matter. While in the premodern world most images were encountered through religious devotion, today most ideas are communicated through an inexorable flow of advertising images (research from 2019 suggests that we see up to 5,000 ads per day[14]). But more than just encourage consumers to buy products and services, advertising also shapes behaviour by delivering influential messages about identity. The literary critic Mikhail Bakhtin called this process an 'ideological performance', which means that identity is crafted and manipulated (in the service of a brand) and then sold back as the default and normal version of how we are encouraged to see ourselves within our social groups. But the identities that are promoted as the supposedly dominant and correct ones to model tend to exclude far more groups than they serve. And it doesn't require particularly close looking to see that examples of

perfect mothering, from Renaissance altarpieces to contemporary advertising, are predominantly European and white.

In 2018, the clothing company Gap released an advertisement of a black breastfeeding mother that went viral. The ad, for the 'Love by Gap Body' range, features Nigerian model Adaora Akubilo and her 20-month-old son Arinze captured in a spontaneous moment of breastfeeding. The cropping of the image, with the baby seen in profile looking out to the camera and the bowed head of the mother, her tender embrace, and the neutral and calm background make it difficult not to read this image as an example of the ubiquitous Mother and Child.

The brand leans on our recognition of the entrenched image, as a sort of virtue-signalling to suggest that the mother wearing Gap clothes is also the right sort of mother. But in spite of this criticism, seeing a black woman in the place of the unerringly white ideal mother in both art and advertising opened up a space for positive depictions of black mothering that have otherwise been absent. This had real-life implications: A. Rochaun Meadows-Fernandez, now an activist for black motherhood, wrote in the *Washington Post* that the dearth of positive mainstream images of black women breastfeeding had adversely affected her own experience, and reported a profound sense of validation in seeing Gap's frame-shifting example.[15]

Gap's campaign, although pioneering by contemporary standards, was not the first time that a black breastfeeding mother appeared in Western art. In 1931 the German painter and radical socialist Ernst Neuschul painted a work called *Black Mother*. A black woman wearing fashionable clothes is shown sitting on what looks like a bench, against a green background

that suggests she is in a public park. She holds one of her breasts to the child on her lap who suckles her. Both mother and child stare towards the viewer with an assertive and unabashed gaze, very different to the meek downcast demeanours of traditional images of breastfeeding (both religious and commercial).

The painting not only makes the body of a marginalised woman the central focus of the painting (at a time when there were only 24,000 people of African descent in a population of 65 million people in Germany, most of them from Germany's colonised territories) but it also confronts social anxieties and class prejudices about breastfeeding. In the 1930s, as is still the case in many parts of the world now, 'respectable' women were not expected to breastfeed in public outdoor spaces, not least because the practice of breastfeeding infants had historically been outsourced by wealthy families to rural, poor and peasant women for whom wet-nursing was one of two readily available sources of income (the other being prostitution).

But the black mother in Neuschul's painting is not an employed wet-nurse, and the child on her lap is presumably her own (as it would be extremely unlikely for a black family in Germany in this period to employ a wet-nurse). In this way, Neuschul's confident black mother shows us something that we don't often see – an image of breastfeeding which is neither a performance of aspirational motherly virtue nor of social class distinction and privilege. Neither is the breastfeeding woman coarsely sexualised, as was frequently the case in nineteenth-century art that fetishised lower-class women breastfeeding.

Instead, *Black Mother* is something of a defiant reclamation of the maternal experiences that were denied to earlier

generations of black women in slavery, women who were sep-
arated from their own children to feed their white master's
offspring. In its subversion of the traditional Madonna and Child
of Western art, which sacralised the role of the good mother
and in which there had been no visible place for black bodies,
Neuschul's little known painting casts light on an entanglement
of issues concerning race, class and mothering.

If black mothers have been largely absent as idealised mother
models within the visual framework of the Madonna and
Child, then we should look at the framework through which
they've been most visible in the West. One example is the racist
caricature of the 'black mammy', a desexualised and some-
what perversely happy archetype who has been portrayed in
a sentimental manner across American visual culture from
the Hollywood epic *Gone with the Wind* (played by Hattie
McDaniel) to advertising images for consumer products such
as Aunt Jemima's Pancake Mix. The mammy was a surro-
gate mother and carer for the children of the white families
to whom she was enslaved: she performed the physical and
emotional labour of mothering and domestic work (includ-
ing wet-nursing and the care of white children), so that white
slaveholders didn't have to. Frequently depicted as docile
and loyal, the mammy stereotype reinforced and normalised
the exploitation of black women (not unlike the Sable Venus
we encountered in the previous chapter), turning them into
symbols of comfort and nostalgia, while the conditions of ser-
vitude and the separation from their own children remained
under-acknowledged.

While the mammy archetype has receded, one of the dominant portrayals of black mothers in contemporary mainstream media has been that of the grieving black mother, mourning the death of a son killed in acts of state-sanctioned violence or police brutality. Seen through images selected for international news coverage and as the face of social justice movements, the bereaved black mother has become synonymous with the trauma and tragedy of racial violence.

During the convulsive summer of 2020, the murder of George Floyd by Minneapolis police re-ignited widespread Black Lives Matter protests.[16] The American periodical *Time* magazine summed up the mood with a front cover illustrated by artist Titus Kaphar that articulated black trauma through the framework of the Madonna and Child. Kaphar's image shows a black woman clutching a baby-shaped void, her brow furrowed, and her eyes closed by the weight of her pain. They stand in a domestic interior space in front of a window through which a landscape can be seen.[17] The pose directly quotes Renaissance images of the desolate looking Virgin Mary clutching her baby son, her gaze shadowed with the foresight of his death as an adult. On the *Time* cover the mother's cloud of black hair is contained by a hairband that takes the place of a traditional halo, while the compositional format with the adjacent landscape outside of the window mimics the settings of archetypal Renaissance images intended for devotion within the home. It also nods to another visual tradition depicting Jesus and his mother in Christian art – that of the *pietà*, or 'compassion', in which Mary is seen cradling the dead broken body of her son after the crucifixion. (One of the most famous examples is

Michelangelo's *Pietà*, 1498–99, in St. Peter's Basilica in Rome, sculpted from pristine white marble.)

Kaphar's image asks us to consider both current and future maternal loss – the absent baby in the image represents not only a mother's pain at remembering a child who is no longer alive, but also the anticipated grief of all black mothers who know that statistically their children are more likely than white children to die as victims of racial prejudice in all its forms. In the red border running around the outside of the image the names of black victims of police brutality in recent decades are memorialised.

In alluding to the *pietà* to depict the effects of state-sanctioned violence against black men, Kaphar's emotive image can be thought of as part of a relatively well-established tradition in contemporary art. Women of colour in particular have identified with the parallels. These include Renée Cox whose photograph *Yo Mama's Pieta* (1996) swaps the white protagonists of Michelangelo's famous sculpture for a black mother (the artist) and adult black man on her lap. Beyoncé directly quoted Cox's image in her 2013 music video 'Mine', made within the context of the murder by police of black teenager Trayvon Martin. The singer made further reference to the grieving mother of Christian art in the 'Resurrection' chapter of her 2019 visual album *Lemonade*, which features living portraits of bereaved mothers holding framed photographs to their chests of their sons lost to police violence. They are Sybrina Fulton holding Trayvon Martin; Lezley McSpadden with Michael Brown; and Gwen Carr and Eric Garner.[18]

Scholars of black feminism Patricia Hill Collins and Barbara Christian have observed that 'so much sanctification surrounds

black motherhood that "the idea that mothers should live lives of sacrifice has come to be seen as the norm."[19] I wonder also whether mediating both black motherhood and racial trauma through this traditional motif makes the truth of its horror too 'comfortable' and comprehensible, maybe even lending it an air of inevitability (instead of destabilising us).

The echoes of the traditional Virgin Mary of Christian art still resonate in our cultural images today in ways that provide polarised models of black and white mothering: images of white mothers show an impossible virtue, while images of black mothers mostly bind them to unfathomable grief.

Seeing black mothers predominantly as mourners of lost children also obscures other issues that marginalise and threaten them, such as the fact that they are more frequently the victims of racially-biased state neglect than the sons they visibly mourn; or that in the USA they are over three times more likely than white women to die during pregnancy, childbirth or in the post-partum period, and five times more likely to die in the UK.[20]

It is notable too that the prevailing archetype elevates and mourns the loss of *sons* only; images of black mothers grieving daughters wrongfully killed by police remain painfully invisible. This void in public knowledge prompted the development of the US social movement Say Her Name in 2014, which seeks to adjust the public perception that the victims of police brutality are predominantly black men. Some of the names that Say Her Name campaigners are fighting for are Tanisha Anderson, a bipolar black woman who, mentally agitated, refused to enter a police vehicle after her family called for help; or Yvette Smith, killed in her home by armed police officers responding to a

complaint about domestic disturbance when she opened the door for them.

There are many, many more. But there are no images of them or their mothers immortalised in the canonical language of art history or religion. Perhaps it's not so easy to find appropriate images to convey the grief felt for the loss of a black daughter because our visual culture lacks a framework for the unjust sacrifice of female bodies. (As we'll see in the next chapter, our visual language for women's suffering tends to find beauty, rather than injustice, in their pain and death.) This is important because what we are *able to see* – and so what we hold as important, valuable or meaningful – remains conditioned by the archetypes and visual language available to us.

While artists from Berthe Morisot to Beyoncé have opened up the underlying politics and complexities behind images of mothers, mainstream contemporary depictions of motherhood still tend to flatten out the experience of mothering into a binary of suffering or unrealistic virtue. These fall generally into either the comedic archetype of the stressed, depressed and suffering woman of post-feminist television and cinema comedies such as *Motherland* or *Bad Moms* (sometimes referred to as the 'slummy mummy') to the impossibly perfect 'yummy mummies' of social media who represent an ideal just as unattainable as the perfect-looking, passive and self-sacrificing Virgin Mary.

Let's look at the frazzled woman on the verge of a psychological breakdown first, as this has become the standard mother archetype of late twentieth-century and early twenty-first-century film and television. A few of the regular gags have

become strained comic clichés of mum-life. We all know these tropes: there's the permanent to-do list that always involves a school project or cake-baking exercise with impossibly high social stakes; a lazy or absent partner; obligatory coffee cup spilling over work clothes on the way to an important meeting; and the inevitable plotline in which the mother has to choose between sick kid in bed or a career-defining appointment. While these recurrent archetypes invite comic relief and solidarity among those who see versions of their own lives beneath the goofy plotlines, they also serve to normalise rather than critique how our current systems of childcare and parental leave are failing women emotionally and professionally.

The 'bad mom' stereotype superficially explores postnatal depression, frustrated libido, the pressures of gender-based oppressions in the workplace, and the unrealistic expectations and burdens placed on women's lives, but more often than not, this character is reduced to grotesques and amplified for comedic value. The poignancy of what it reveals about the crippling politics of mothering for some white, middle-class women is made redundant as it normalises the collective traumas supported by an unsympathetic patriarchal system geared against women 'having it all'. Moreover, these comedies tend to synthesise the frustrations of a very singular demographic, and pay little attention to the experiences of mothers who bear the burden of their white sisters' return to the workplace: women who leave their own children to nanny for and clean the homes of more privileged super-mums, so that they can get on with bashing their heads against the glass ceiling.

The yummy mummy on the other hand appears not to

work, or, if she does, it is work that promotes the lifestyle and consumer brands that reflect her identity and her status. She is the glossily presented 'mummy blogger' who seems to transcend all physical, financial and emotional limitations in her enviable, curated lifestyle. Most visible in the online sphere (the 'mamasphere') she represents an idealised version of twenty-first-century mothering, something like a twenty-first-century angel in the house.

The 'mummy blogger' is anointed by brands to become an online influencer who markets clothing, experiences and lifestyles that most mothers can't afford. With her disciplined body and sun-baked glamour, she promotes motherhood as a consumer category – one whose metric of success depends on the correct designer changing bags, baby slings, prams and cribs. She has an impact. A recent article in *The Atlantic* revealed the talk behind closed doors at a conference named Marketing to Moms, which revealed that American mothers collectively spend $2 trillion per year on products and commodities related to their children.[21] In Europe, the largest market for so called 'baby-consumables' (including nappies, strollers, baby food and useful accessories and furniture) is Germany, with a market value of €1.76 billion, closely followed by France.[22]

These figures aren't hard to chalk up once you take a look at the brands keen to commodify the experiences of new parents. Let's look at Artipoppe, a designer baby carrier brand whose signature baby carrier is priced at around £300, although the Zeitgeist silk and velvet version will set you back a cool £471 (which is more than three weeks' worth of statutory maternity allowance in the UK). The lookbook images selling the brand

show us a fashionable and sullen version of the Virgin Mary, usually in an anonymous, hot and luxurious destination. Neither mother nor child looks happy, but they do look wealthy, beautiful and, in the mother's case, thin (ditto the celebrity customers wearing Artipoppe on social media feeds), and its these outward attributes that we are led to believe are ultimately more important than happiness.

Anna van den Bogert, Artipoppe, 2020. Courtesy Anna van den Bogert

In one image, the perfectly groomed and fresh-faced mother glares from the interior of a dark and simply-furnished room; she wears a red, draped jacket that subtly echoes Mary's humble clothes from devotional images. The traditional halo may be gone, but the hanging mobile of gold glinting stars that hovers next to the mother and child hint at their blessedness. But it's a different blessedness than conveyed in pictures of the Virgin Mary or the angel in the house. We're encouraged to see this mother and child as blessed for their wealth and spending power; blessed because they have burst through the mud of maternal exhaustion, because they can afford facials and a maternity nurse so they can enjoy restorative sleep; blessed because they have surpassed the chaotic, disordered reality of mothering.

Here's what the brand has to say about its designer slings: 'An Artipoppe Baby Carrier is a way to keep your identity, to demonstrate self-confidence, to feel beautiful and to show the world you care, not only about your baby ... but also about yourself and others ... Keep them close and be beautiful.' The suggestion that feeling beautiful is a demonstration of how you care about your baby, yourself and others reminds me of the injunction for the Virgin Mary to always be beautiful in images, because her external beauty is symbolic of her inner virtue, her humanity and compassion.

But what if we stopped encouraging mothers to look beautiful and to buy things by equating successful mothering with affluence, thinness and style, and instead became familiar with pictures that celebrate different aspects of motherhood – aspects that are currently undervalued and all but invisible?

While the history of art and advertising and online culture is flooded with pictures of mothers, the moment of giving birth remains something of a blind spot. Birth – the opening of one body to produce another, the moment when consciousness and identity potentially start – is the common denominator in the experience of all those living. Yet as a topic for serious art it has been consistently eclipsed by other compelling aspects of the human condition, such as sex, death and war. Birth has been made to seem too horrendous, taboo and obscene to contemplate. It is the antithesis of the *hortus conclusus*; it is the opening at force of the spring, the urgent rush of the fountain.

The Swedish artist Monica Sjöö exhibited her canvas *God Giving Birth* (1968) in St Ives Town Hall in Cornwall in 1970. Inspired by her personal and extremely positive experience of the home birth of one of her sons, it shows a baby's head emerging from the body of a woman of colour against a black cosmic void. Celestial bodies levitate in the inky darkness, suggestive of creation myths, while the repetition of orb-like shapes of breasts, heads and planets conflates the birthing body with the formative shapes of the universe. In Sjöö's cosmos, there is no doubt that God is a woman.

As soon as the painting was installed, the mayor of St Ives ordered it to be removed on grounds of blasphemy. A few years later it was displayed in London and Sjöö almost ended up in court again under further charges of obscenity and blasphemy. Perhaps this was because God is represented as an ethnic woman and not a white man. Or because the birthing body might call to mind a two-headed monster, something to fear. Perhaps because we might think birth is private and not for public consumption.

Perhaps we think of the physical act of birth as something painful and disempowering, so to see God giving birth would undermine our notions of what a powerful god is.

Forty years later, in 2008, another contentious image of a birth went on show in the Birth Rites Collection in London and has, like Sjöö's canvas, repeatedly been censored. It is a photograph called *Therese in Ecstatic Childbirth* by Hermione Wiltshire. The artist used (with permission) a documentary photograph taken from the archive of 'radical midwife' Ina May Gaskin, a practitioner of women's health who has devoted her career to championing positive and empowering births for women. When the artist found out that pictures of crowning in childbirth were withheld from women attending National Childbirth Trust antenatal classes for fear of traumatising them, she looked for an image that would tell a different story to counter the pervasive idea that birth is always painful. (While giving birth is certainly a high-risk event, advocates of positive birthing experiences have been trying to change the conversation that prepares women to believe that giving birth is only ever a medical emergency.)

Wiltshire's photograph radically makes visible something that is never usually seen: a body giving birth in pleasure and not in pain. 'Therese' lies back on soft cushions, ecstatically aglow with an open-mouthed smile as the head of her infant emerges from her body. There are no stirrups, no machines, no doctors in scrubs, no blood, no trauma, no pain. But even in its home in a collection devoted to art about childbirth in a teaching hospital, where simulations of birth are a normal part of the education of midwives, the image has been challenging to display, provoking responses that it is 'too shocking' or even 'pornographic'.

Hermione Wiltshire, *Therese in Ecstatic Childbirth* (from the archive of
Ina May Gaskin), 2008. Courtesy of the artist and Birth Rites Collection,
London

I showed this image in an exhibition I curated in London in
2019, interested in how we are programmed unwittingly to see
this work as sexual.[23] Although undeniably explicit, I wonder
if we are too quick to brand this birthing body as sexualised
because images have taught us that female bodies experienc-
ing pleasure must always – can *only* – be an erotic spectacle
for a presumed gaze. To me, the ecstatic body of *Therese* has an
inflammatory power not just because it presents birth as unex-
pectedly pleasurable but because it gives us a different way of

seeing women's bodies – one we rarely see. It is radical because it represents an alternative to the patriarchally dictated establishment version of women giving birth strapped to hospital beds with their feet in stirrups, managed overwhelmingly (at least historically) by male doctors. And it is radically different to the stiff veneer of the Virgin Mary whose interior body and whose pleasure remain hidden and contained.

What we witness Therese experiencing is something like what the feminist philosopher Hélène Cixous described as 'jouissance', a French term without equivalent translation that conveys an experience of rapturous mental and physical sensory excesses that transcend the physical world and border on the spiritual. For Cixous, female jouissance is political because it is something that traditionally has not been given a space in visual and cultural representation – after all, women's excesses of pleasure when not related to a man are notably absent. And how often have women been censored for being too loud, having too much fun, being too sexual, *too much*? How often do they continue to censor themselves, their thoughts and feelings and their own pleasure?

If we stop and consider it, the only excess our archetypal images of mothering allow mothers to feel is an excess of pain – whether that is mourning dead children or the agony of childbirth (as the standard cinematic trope of a woman giving birth dictates is the norm). When we do see images of mothers experiencing pleasure, it tends to be focused on and fulfilled by the baby and is located anywhere but in the body of the mother.

It is a patriarchal fantasy that mothers do not have sex, that is unless the idea of it is made specifically to cater to male

heterosexual fantasy. This traditional separation is evidenced so neatly by the term 'milf' – a label that crossed over from pornography into the mainstream to categorise sexually attractive women who are also mothers, as if this were an unfeasible anomaly. The milf is where the identity of the mother intersects with the sexually consumable identity of Venus. The term has gained widespread adoption across popular culture, but its mainstream origins go back to the 1999 film *American Pie* in which a character known only as 'Stifler's Mom' (played by actress Jennifer Coolidge) – and therefore without an identity of her own beyond her relation to her son – hooks up with one of his teenage friends before their graduation. Coolidge is still referred to in pop culture as the 'original milf'. Like the character of Mrs Robinson in the film *The Graduate*, Stifler's Mom is presented as a frustrated housewife, and her value is as a vehicle of sexual development for a young male. A few years later, in 2003, the American rock band Fountains of Wayne won a Grammy for their hit single 'Stacy's Mom' – a pubescent eulogy to another milf, more specifically the mother of the narrator's girlfriend, who he decides that he obsessively prefers. The video, starring Rachel Hunter, is a visual essay in sexual objectification.

A discussion of 'milfdom' raises sometimes thorny issues around sexual expression and choice – on the surface, the popularity of the term suggests that today we have departed from the demands of scrupulous virginity and chastity enshrined in the figure of the Virgin Mary and the angel in the house to gladly welcome the fact that motherhood does not exclude sexuality and sexual desirability, and the term sets a welcome tone that mature women are sexually desirable. On the other hand,

search Instagram (that ever-yielding, real-time repository of anthropological data) and you'll find many variations on the milf hashtag, from branded swimwear to unabashed soft-porn. It's clear from these images that achieving milf status requires a lot of work in disciplining postpartum bodies, applying make-up, skin-polishing and preparation to turn mothers back into pre-pregnancy versions of Venus.

Let's take a look at an example from popular culture that purports to do emancipatory work. Fergie's music video for her 2016 single 'M.I.L.F. $' verges on parody in how it carves up women's sexuality into a set of archetypal male fantasies. The cast is made up of the singer's model and celebrity coterie and each one is allotted a clichéd identity from sexual roleplay. Fergie appears in a number of titillating guises, from the flexible yoga bunny, to the sexy teacher with heavy-rimmed specs and tight pencil skirt, to the saucy waitress from an approximated idea of a retro diner.

Superficially, the video claims to be about reducing the stigma of breastfeeding, and promoting mothers as sexually and economically independent from men. I applaud this as a con-cept, but I'm left feeling that the way this is executed obscures the message by objectifying and sexualising women's breasts even more, showing them only in relation to male desire. We see the cast of suburban milfs through the gaze of a young milkman who is so aroused that he is incapacitated – we find him woozily drooling milk that manages to both infantilise him and reference uncontrollable ejaculation.

For a video that is notionally about reducing the stigma of breastfeeding, it paradoxically seems to assert that women's

breasts and bodies can only ever be sexual spectacle: apart from one brief glimpse of Chrissy Teigen in the video's opening sequence, we don't actually see any of the breasts in the video feeding children. As such, the video revolves around an inescapable irony: it's unlikely that a music video featuring *actual* breastfeeding would ever have been possible, as it would most likely have been censored.

While the milf is the language of Venus in disguise, painted on to mothers to make them sexually consumable, the complex sexual identities of mothers is a subject far less explored in either popular culture or art. Catherine Opie's *Self Portrait/ Nursing* (2004) in the Guggenheim's New York collection challenges the received norm of heteronormative mothering with a portrait of queer mothering. The work draws on the recognisable archetype of the Christian Madonna and Child but interrupts the historical male gaze by depicting Opie as a queer mother breastfeeding, one whose tattooed body and pendulous breasts do not conform to contemporary social beauty standards of mothers from either art history or advertising. With short-cropped hair and a lack of the traditional indicators of femininity such as make-up, Opie's portrait presents a defiantly butch mother. Faintly visible above the nursing infant are the traces of the word 'Pervert' that had been etched into her chest for an earlier portrait in which she presented herself as a 'leather-dyke' in a portrait that referenced lesbian sadomasochistic sexual subcultures.

Opie's work disrupts our expectations of heteronormative mothering as the only morally virtuous and 'normal' option, allowing for the possibility that mothers can also have

non-heteronormative sexual identities that are thought of as transgressive. Opie's portrait is a marked contrast to the version of maternal sexuality that is only visible when it satisfies male desire, when mothers are stitched back into Venus milfs by whatever means possible, as the slew of products, marketing and advice on the post-partum body testifies. And while Opie's work has been accepted into the canon of American art history with a place in the Solomon R. Guggenheim collection, less visible still are images of non-binary mothers, non-biological mothers and transgender mothers.

Here, in my park skirting the edge of London, the sky turns the colour of grubby towels. I make my way home, taking the path that clings to the grassy verge of the railway line, where wildflowers spring up indiscriminately around the discarded chocolate wrappers and rusted household appliances like colourful gasps of joy. Once through the front door, time unfolds through interminable labour and chores: washing, cleaning, laundry, folding, cooking, wiping, comforting, and living all other life in the interstices of the day when children sleep or are handed over to the spellbinding colours of the TV. But no task is ever completed. Once over the threshold from the relative expansiveness of the suburban world beyond my front door, I feel the silent throb of the piles of unsorted laundry climbing their way up the stairs, the broken biscuit burrowing into the carpet, the cushions on the sofa that slither like everything else towards the floor. All things in the house have a locomotion: there is no moment of pause when something is not unloosening, shifting or squirming.

It is nothing like the stillness of those pictures of seventeenth-century Dutch interiors with mothers and children embalmed in airless vacuums of beatific domestic order. Pieter de Hooch's *Woman with Children in an Interior* shows a room filled with a peaceful amber glow, soft light filtering in from the window reflected in the lone orange on the mantelpiece, a modest reminder of the exotic riches that come from trade with the world outside. Set between window and fireplace, a mother cradles a docile infant on her lap, while a second child sits obediently at the hearth, calmly feeding a domesticated dog. The child is an echo of her mother, and in feeding the dog she is mirroring her mother's work – a reminder that one day she will inherit her mother's position in the home. All surfaces in the picture – from the tiles on the floor to the window panes to the canopy of the mantelpiece – enforce a sense of order and categorisation with their tidy geometry and repeating patterns that neatly compartmentalise the two female figures. There is no chaotic overspill, no excess, just suggestions of the invisible but tireless labour to maintain the palpable cleanliness of the room. Even the shadows are spotless.

For the Dutch Republic, with its strict observance of Calvinism, the home was thought of as a microcosm of the virtuous nation. Cleanliness and tidiness were considered to be a demonstration of piety and restraint, and so pictures of interiors such as de Hooch's with their neat borders, rational angles and pristine surfaces conveyed the moral virtue of the republic on a micro-level. They also functioned as a metaphor for female chastity and obedience by imitating images of the Virgin Mary which they replaced. In the orthodox Calvinist

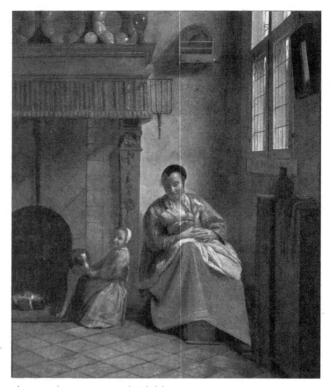

Pieter de Hooch, *Woman with Children in an Interior*, ca. 1658–60, the Fine Arts Museums of San Francisco, gift of the Samuel H. Kress Foundation. Photograph: Randy Dodson. Image courtesy the Fine Arts Museums of San Francisco

republic, religious images were suppressed and so the qualities of motherly virtue associated with the archetype of the Madonna resurfaced through other means. This can be seen explicitly in de Hooch's red-skirted woman calmly and attentively nursing an infant on her lap. Furthermore, contained in their patterned domestic enclosures, these pictures of virtuous women in the home functioned in a similar way to the containment of Mary

in the *hortus conclusus*, demonstrating the expected virtues of a good wife.

Long considered to be evidence of such women's separation from the public sphere, recent radical rethinking of these ubiquitous Dutch home-scapes has suggested that they were in fact contrived images, designed to appease men by promoting a fantasy construct of prosperous and tranquil domestic life on the home front – a warming image for men to conjure up when away from home for extended periods at sea. The images promote a vision of virtuous wives at the centre of the stable and prosperous home (and by extension the stable and prosperous Dutch Republic). But the reality for these women was likely to be a far more chaotic combination of plague, financial instability and solo parenting.[24]

This idealised vision of the domestic, feminine space is echoed in our contemporary presentation of women in home settings, as seen in Pinterest boards, social media accounts, cookery books and, most frequently, in the 'celebrity at home' photoshoot. Highly stylised images – which like their Dutch prototypes are divorced from all reality – promote an idea of 'home' as a stage-set on which an ideological version of family life and feminine virtue is performed. These images help to define today's idea of affluent and successful womanhood, understood in relation to the gleaming objects, fashionable clothes (and fashionably clothed children) and home décor that surround her. Appearing as neither the holy Virgin Mary nor the chaste and diligent Dutch housewife, contemporary pictures of women in the home nevertheless draw on the symbolism of both tropes to establish a model for aspirational contemporary mothering in the West.

There are obvious visual parallels in the composition and presentation of calm and patient domesticity in de Hooch's paintings, particularly *Woman with a Child in a Pantry*, and the photographer Jenna Peffley's 'sneak peek' of American model, actor and blogger Denise Vasi's 'epic marble kitchen' for interiors site My Domaine.[25] Firstly there are the spotless surfaces and rigorous cleanliness and order. As with de Hooch's painting, all lines in the composition – of floorboards or tiles, kitchen cabinets and work surfaces – direct our eyes to the mother, framing her as the central axis of the home-scape. Denise Vasi is pictured handing her daughter a peach, an echo of the fruit on the mantelpiece in the Dutch image. Both mother and daughter appear like figures in a doll's house, dressed in self-consciously rustic looking (yet most likely designer) dresses that hark back to the homely historical styles of the 17th century to suggest authenticity and simple virtue. The spotless garments lend them a demure and angelic appearance, and Vasi's hair is scraped back into an impeccably contained bun that mimics the bonnet of the organised wife and mother in the Dutch painting. The image is almost antiseptically white – allowing for no shadows, no darkness, no uncertainty.

Like its Dutch counterpart, the appearance of Vasi's 'epic marble kitchen' is indexical to the perceived virtues of the woman pictured inside it. But while the impeccably ordered home in de Hooch's painting signifies the humble diligence of the mother, contemporary lifestyle images such as this one borrow traditional symbols of virtue to convey the opposite: a portrait of *affluence and success*. This contrasting impression is bolstered by a range of other symbols in the image. For example, whereas de Hooch's image is empty of worldly possessions, Vasi's marble kitchen

suggests exuberant wealth – confirmed by the title of one of the recipe books stacked tidily on the shelf: *Plenty*. Then there's the groaning fruit bowl and the adjacent smoothie maker which nod to the expensive rituals of 'clean living' afforded only by the privileged. (KitchenAid "artisan" stand mixers like the one shown retail for over four hundred dollars.)

The influencer mom's brand of success is defined in overcoming (at least in appearance) the messy, arduous and chaotic nature of real-life mothering and domestic work. While the Calvinist context of the Dutch examples implies that it is through the labour and chastity of women in the pictures that the home and state are maintained, contemporary images of women in the home often reflect a wealth which gives some women the option to remove themselves from any of the actual work of mothering or housekeeping – a desirable situation, since in a neoliberal patriarchal world, the metric of a woman's success is not in how successfully she mothers, but in how little domestic mothering work she actually has to do.

But what about the invisible labour of motherhood that we tend not to see? What about the truth behind those constructed glowing interiors of the Dutch Golden Age of painting, or their well-coiffed versions of happiness in interiors blogs and magazines? What about the cleaning and drudgery and split bags of shopping on the tarmac and sweeping the floor and washing the baby's clothes?

In the early 1970s, the artist Mierle Laderman Ukeles made art that celebrated just this. Frustrated by the conflicting demands of juggling a career as an artist with her role as a mother, she decided to combine the two and make housework

and childcare the subject of her artistic expression, making mothering her 'work of art'. In 1969 she wrote a manifesto for a new type of art practice called Maintenance Art, announcing: 'I am an artist. I am a woman. I am a wife. I am a mother ... I do a hell of a lot of washing, cleaning, cooking, renewing, supporting, preserving, etc. ... Now, I will simply do these maintenance everyday things, and flush them up to consciousness, exhibit them, as Art.'

Ukeles wanted to expose the disparity between what she called in her own terms 'development' and 'maintenance' – where 'development' was the creative practice of exploring new concepts and ideas and was a traditionally male privilege to pursue, while 'maintenance' was the boring functional work that 'takes up all the fucking time'. 'Development' is only possible if someone else shoulders the burden of 'maintenance' in everyday living by filling the refrigerator, preparing meals and cleaning up, emptying the rubbish, doing the laundry and tending to the children. 'Maintenance' was (and generally still is) women's work.

Like Berthe Morisot, Ukeles turned her gaze inwards to her domestic world to make her art. She exhibited photographs of her daily tasks as a mother: of rinsing out dirty nappies, laying the table, washing the floor, taking out the rubbish; of the tedious and time-consuming tasks of getting her children dressed to go out, and undressed to come back in. In other words, the work that holds the identity of the mother as carer at length from the development of the mother as creator, and the frustrations around the seeming incompatibility between the two roles. Moreover, her photographs speak to the truthful drudgery behind the widespread fantasy image of mothers. They

Mierle Laderman Ukeles, *Dressing to Go Out/Undressing to Go In*, 1973
© Mierle Laderman Ukeles. Courtesy the artist and Ronald Feldman
Gallery, NYC

are testimony to how the actual domestic labour of mothering
remains invisible and undervalued.

The flow of everyday life, even its most mundane and
seemingly insignificant acts, became a focus of interest for
avant-garde artists and musicians in the USA in the late 1950s
and early 1960s who orbited around the figure of Allan Kaprow.
Kaprow organised what became known as 'happenings' – events
with participating audience members that blurred the boundary
between art and everyday life, movement and intentional perfor-
mance. But this cultural legitimacy in seeing art in the everyday
did not extend to the way in which Ukeles' maintenance series
was perceived. While the idea of 'happenings' gained such trac-
tion that the term became adopted by contemporary advertising

(and featured in a song by The Supremes that caused Kaprow to disassociate himself from the movement he had initiated), Ukeles and her work has remained in the margins both of the art history taught in schools and of the works of art chosen in exhibition programming. The artist had her first retrospective exhibition in a major public institution in 2016 (when she was aged 75) and remains, like the majority of women artists of this period, little known outside of expert circles.

As I've already mentioned, this isn't just because of a chauvinist plot to exclude women, it is a result of the fact that what is considered valuable and interesting in art reflects what society finds important and valuable. And we don't tend to find art about gendered domestic labour meaningful or valuable because we don't adequately value any labour performed by women in our society – whether it's art, childcare, housework or *any* profession. But Ukeles didn't just centre her maintenance art on the oppression of mothers within the home, she looked at other labour relations through this lens too, such as the invisible workers who perform the maintenance in keeping our prestigious museums and temples of culture clean, suggesting that the janitor's work is just as crucial as the curator's and yet unacknowledged and undervalued.

Ukeles' art emerged in the context of the women's movement of the 1970s and against the backdrop of campaigns in Europe and the United States that promoted recognition for women's unpaid domestic labour. Silvia Federici argued in her book *Wages Against Housework* (1975) that: 'to want wages for housework means to refuse that work as the expression of our nature, and therefore to refuse precisely the female role that capital has invented for us.' Almost half a century later we are

still struggling against the capitalist noose that assigns women a larger portion of domestic labour within the home, as well as paying them less than men for equal work across all sectors. In 2020, *The New York Times* estimated that women's unpaid labour is worth a staggering $10.9 trillion, while a gender pay gap report determined that in the United States in 2020 women earned approximately one fifth less than men on average (81 cents for every dollar that men earned).[26] Another study from 2020 estimated that the unpaid work of all women (aged 18–100) in the UK had a combined total value of £700 billion.[27]

In her 1972 essay 'Writers Who Are Women in Our Century: One Out of Twelve', the working-class poet Tillie Olsen framed the maintenance worker in another guise, that of the 'essential angel'.[28] Traditionally, she was the woman who kept house so that a man could make art, like Rilke's spinster sister who 'was there or not there as one wished'. But women also depend on the essential angel – she is the one who is paid to do the maintenance so that affluent mummies can work hard at being 'yummy'; it is her invisible labour that makes the surfaces shine in the Pinterest boards of domestic motherly perfection. Often she leaves her own children to work as a surrogate mother and maintenance worker for another family.

The essential angel (unlike the angel in the house) is rarely visible, but Berthe Morisot offers us a glimpse. On first glance her 1879 painting *Wet Nurse and Julie* is a luminous impressionistic remix of a Madonna and Child image: a woman sits calmly enthroned on a bucolic patch of lawn while an infant suckles at her breast. But the woman in the picture is a wet-nurse employed by Berthe Morisot so that she can be relieved of her domestic

maternal responsibilities in order to paint. Her name, coinciden-tally, is Angele. A wet-nurse or 'nourrice sur lieu' was a desirable profession for women of little means, as working for a household like the Morisot-Manet family meant a secure salary, expensive clothes and a richly nutritious diet that aided with the produc-tion of milk to nourish the younger bourgeois generation. But the central catch was that to become a nourrice sur lieu required having a baby – a baby that was necessarily left at home for the mother to live in another house, feeding another woman's child.

Morisot's delicately flocked image is a picture of two women at work, one who sells her milk, the other who sells paintings about domestic life and its labours. But it is also about something that is very seldom addressed: how a mother's ability to work or to create can be so contingent on the work of other women doing the job of mothering.[29]

Morisot's matrix of nineteenth-century labour relations finds an echo in British artist Eti Wade's *Migrant Mothers* series of portraits (c.2014) of women who have left children at home in the Philippines to work as nannies and paid domestic workers in global north countries.

Each portrait shows a woman at home in a humble apart-ment, holding the virtual image of her child on an open laptop screen – a testimony to the physical distance between mother and child and the necessarily virtual nature of their contact. Cradling the digital presence of their far-away children on their laps, the photographs also evoke *pietà* images of the grieving Mary and her dead child. They convey another type of loss and grief felt by mothers – one that is provoked not by the state sac-rifice of young men but by the global care chain.

Eti Wade, from the Migrant Mothers series

Ukeles, Morisot and Wade's art asks us to think about the intersections of class and gender and how value is attached or denied to different sorts of women, their labour and their roles as mothers – whether the creative labour of art making, the pro-creative labour of making and raising children, or the labour of looking after other people's families.

Finally, in my house it's the close of the day. I lie down in bed with each child in turn to read stories, to chat, to absorb the syrupy smell of their hair as they drift off to sleep after many kisses and mutual affirmations of love. It is here that I find the stillness I was craving; bolstered by the heat and weight of their little bodies, my mind can finally wander freely, my thoughts tracing patterns across the dark ceiling with its sprinkle of softly fluorescent stars. I often linger long after they doze off, suspended in the stasis of the dark bedroom, before I leave them and open up the bonfire blaze of my computer screen to work, writing long into the quiet, blue hours.

Turning out the lights on the stairs, I catch a glimpse of a blurred reflection in the window that makes me jump, although I know it is me. My appearance is spectral against the inky expanse on the other side of the thick glass, its outline appears doubled, the two versions overlapping, struggling to match. I peer through my own reflection and into the window of a house on the other side of the dark street, where a light has been left on over a kitchen sink, a moth circling the bulb. Caught here momentarily on the stairs, I realise that the image I see in the window, the mother, the writer, the woman, the maintenance worker, the thinker, is someone I only half know. She is not the beatific Virgin in the *hortus conclusus*, nor the tidy yummy mummy, nor the angel in the house (nor the milf). Like Morisot's women, her presence is uncertain; she is someone who is half seen even to me, someone who I don't have any pictures of.

Maidens and Dead Damsels

A desperate young woman clings to the horns of a bull, her succulent thighs splayed awkwardly akimbo while she struggles to balance on the beast's back. Her gown is damp and clings to her pale breasts and the swell of her stomach. An extended arm covers her face with a shadow from which two eyes white with fear glisten like pearls. The young woman is Europa, a Phoenician princess and the daughter of King Agenor of Sidon, a noble-born maiden who Zeus, king of the Greek gods, desired. To get close to her, Zeus shapeshifted into a tame white bull and enticed the young woman to sit on his back like a magical carousel ride before he took flight across the sea, abducting her. Eventually he landed far from her home on the island of Crete, where he regained his godly form and coerced the princess into sex until she bore him three sons. For her endurance and her pains Europa was rewarded with a constellation in the night sky, a string of diamond stars as a severance gift when Zeus tired of her.

Titian's painting *The Rape of Europa* seethes with sensual menace and foreboding. The maiden looks desperately to the

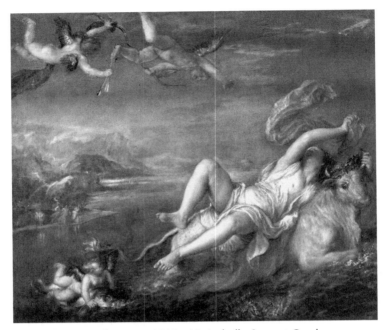

Titian, *The Rape of Europa*, 1560–62, Isabella Stewart Gardner Museum, Boston. Photograph © Isabella Stewart Gardner Museum / Bridgeman Images

shore for her friends and family, but they are fast evaporating out of view, turning into hapless dashes of coloured smoke. The cerulean sky is bruised with livid clouds while flying cherubs taunt Europa with their bows and arrows. They are not here to help her; on the contrary, they serve as Zeus' accomplices – one in the bottom left of the picture even seems to cruelly ridicule Europa's graceless position as he gazes flagrantly between her legs. The beast's flailing white tail leads this cherub's gaze straight to Europa's crotch, reminding the viewer of exactly what Zeus had in mind. It also resembles an umbilical cord, a pre-emptive nod that this abduction ends in forced and violent reproduction.

And then there's the crimson violence of the scarf held clenched in the maiden's fist, unfurling like a screaming tongue.

Titian painted *The Rape of Europa* in 1560–62 for the Spanish king Philip II, a monarch who saw himself as a direct descendant from the mythological Olympian gods. With his expansionist imperial ambitions, Philip styled himself as a sixteenth-century Zeus, whose control of the mythological cosmos was reflected in a dominion that extended over much of Europe and into Africa, Oceania, Asia and the New World. Philip bolstered his status with the help of artists such as Titian who produced images that were an outward display of the king's power and virility. The tale of Zeus and Europa was a popular parable for illustrious male patrons such as the Spanish monarch, for whom it reflected the kingly privilege to pursue desire with unrestricted freedom. And the self-consciously erotic content was held in check by the painting's allusions to a narrative from classical mythology, which made it not only an arousing picture, but one that conveyed the intellectual status of its owner, as it provided the opportunity to ruminate on the nature of power, and even on the power of looking itself.

The story of Europa was first written down by Homer in the *Iliad* in the eighth century BCE and was popularised by the Roman poet Ovid in his collection of myths the *Metamorphoses* 800 years later (although the origins of the story can be traced back much further than this to the Greek Bronze Age). It is one of the serial examples of mythological or 'heroic' rape by the predatory Zeus who took the unsuspecting women he desired by force. These encounters often produced offspring who were revered in some way, or the 'rape' became the procreative act that sired new civilisations and illustrious dynasties.

This was the case with Europa, who at the time of Ovid's writing and throughout the Renaissance period was regarded as the symbolic mother of the European continent. One of her pregnancies with Zeus produced Minos, who founded the Minoan Greek civilisation, sometimes referred to as 'the first link in the European chain'. The abduction and rape had other consequences too, ones that set a new world order into development: in their quest for their stolen sister, Europa's brothers founded towns as they made their way across the Levant and into the Mediterranean and Africa, bringing with them the alphabet and written word from their Arabic homelands.

Beneath the veneer of erotic pleasure and the god-given right to desire, the story is also about expansionism and colonisation, and how rape sits at the heart of that ambition. It is about the creative power of male desire and the defilement of women's bodies as collateral damage; in other words, it is about the sacrifice of the maiden.

The maiden is a frequent protagonist across the history of our images and the stories that underpin them – appearing in those made for pleasure and those made for politics (or sometimes both). Her body is young, powerless, sometimes sleeping, sometimes ill, dead or captured, and whatever happens to her almost always bolsters male identity or male virility.

When the maiden isn't being abducted and raped by libidinous gods, an aesthetic pleasure is taken from her destruction and death. You might have seen her in religious paintings as the virgin martyr, more blessed and lovely when her beautiful body is mutilated. Or the hysterical young woman undone by

love whose tragedy we feast on in paintings and on the stage; she is Shakespeare's Juliet, or 'lovesick' Ophelia. Like them, the maiden often does damage to herself, through self-destruction or suicide.

But she is not confined to high art and literature; the maiden is the screaming woman of silent movies who is tied helplessly to the railway track. She is the damsel in distress of children's bedtime stories who waits to be rescued by an errant knight in shining armour; or the comatose princess waiting to be kissed, saved and married. She is the contorted body in beautiful clothes with a vacant gaze in the fashion magazine.

At best, the maiden archetype has enshrined female suffering as something noble and beautiful, at worst it has contributed to the normalisation of violence against women, by turning it into poetry, religious devotion or beauty, or even just a historically condoned inevitability. The dead or suffering bodies of maidens in pictures and poems have long been the props for patriarchal culture to collectively explore pathos and sadness; after all, Edgar Allan Poe said in an essay in 1846 that ' the death, then, of a beautiful woman is, unquestionably, the most poetical topic in the world'. And in this 'poetry' we find a mixture of desire and aspiration – the maiden's suffering is often displayed in works of art for our aesthetic or erotic pleasure, and the maiden's tears and catatonic grief have even crossed into contemporary millennial culture as a model for women to emulate and for a male gaze to comfortably possess.

The horizontal bodies of maidens line our art galleries, and their influence ripples through fashion photography and advertising that glamorises sexual violence against women

and aestheticises their subordination and despair. At the same time, the canonisation of the pretty 'sad girl' in contemporary popular culture has somehow made young women's anguish aspirationally cool or attractive. The self-destructive maidens of Shakespeare and art live on in the melancholy glamour of singer Lana del Rey and the #sadgirls of social media who picture themselves bruised and tear-stained in exchange for likes and affirmations of their beauty and emotional complexity.

But while we applaud images of female passiveness and victimhood in some of our most prized artworks and in our political symbols (and in social media accounts), we also criticise women for not disassociating from them, for 'playing the victim' instead of projecting strength in the face of male brutality. Feminism's unveiling of women's discontent over issues such as rape culture and sexual harassment has been routinely derailed with accusations (from men *and* women) of a disempowering cult of victimhood. Which makes me think that we like women to be mute maidens whose subjective experiences are turned into grandiose statements about beauty, politics and art, but we prefer to look away when women actually vocalise their upset and ask us to confront our part in tolerating it.

Then there's the fact that we are so used to seeing images of women's discomfort and aestheticised suffering, whereas images of female pleasure and autonomous desire – erotic or otherwise – have historically been obscured and are less familiar to us. Look closely at the history of art and it is unusual to see women enjoying themselves on their own terms, without the involvement of a male character or performing like Venus, for a male gaze. The maiden archetype seems to say that being a

woman means waiting to be taken by force (or force of circum-stances) rather than acting on the strength of one's own desires.

If women's pleasure and desire is mostly invisible in our cultural images, then sexual violence and mythological rape is hyper-visible – to the point that we no longer find it strange when we see images of it in our museums and galleries, on pub-lic monuments or even embossed on the coins in our pockets. Sensual oil paintings like Titian's *The Rape of Europa*, which were once intended for a private elite audience, now exist as mainstream examples of easily digestible culture and high art, printed on tote and toiletry bags, while art by women that coun-ters the historical normalisation of sexual violence or takes us beyond the archetype of the passive maiden continues to haunt the margins of the mainstream culture machine, and is left to languor in avant-garde feminist art history books and seminars.

Titian's *The Rape of Europa* is one of the six images that the artist painted for the Philip II on the themes of erotic love, desire and its dangers. These were known as the 'poesie' or 'visual poems' on account of their layered associations. Under this erudite framework, Titian's paintings for Philip were also intention-ally arousing: the six works were intended for display together in one room and aimed to showcase the nude female figure from different complementary viewpoints (full frontal, behind, three-quarters frontal), in a sensual diorama for the passionate contemplation of the owner of the paintings.

Europa has a permanent home in the Isabella Stewart Gardner Museum in Boston, but I saw it in London at the National Gallery the week that Harvey Weinstein was sentenced

to imprisonment for multiple rape and sexual assault charges. The canvas was united for the first time in centuries with the other five works from the Spanish king's commission as part of a travelling exhibition called 'Titian: Love, Desire, Death'.

At the press view the morning before the show opened, I joined the throng passing through a small vestibule where flashing screens offered an overview of King Philip and his fondness for hunting and women, and presented Titian as a specialist in erotic painting. Once through the door into the exhibition room, six canvases hung at eye level in luxuriant gilded frames, each one illustrating a highlight from Ovid's *Metamorphoses*. Of the 24 figures seen across the paintings, nineteen were female nudes, many of whom fulfilled the role of maiden; along with Europa there was a picture of Danaë, princess of Argos, who was imprisoned in a subterranean chamber by her father. Here Zeus visited her (his desire unrestricted by walls and locked doors) and slipped uninvited between her thighs in the form of a golden shower. According to Ovid's narrative, Danaë became pregnant with the hero Perseus (who later killed Medusa the Gorgon queen).

Perseus appears in another canvas, this time with the damsel Andromeda. She was an Ethiopian princess (Westernised in this painting with Caucasian features as was the custom) who was tied naked to a rock as a sacrifice to a sea monster after her mother had offended the sea-god Poseidon. Andromeda is pictured in a serpentine contortion, one arm suspended over her head, the other corkscrewed gracefully yet uncomfortably behind her (in a pose that is part ballet, part half nelson). Her alabaster limbs are held in place by heavy, glinting metal chains

that make an aggressive contrast with her white, pillowy flesh. Her body is restrained in place for our gaze, with just a slim ribbon of gossamer fabric to cover her groin. She looks toward Perseus who tumbles into the scene upside down in a cartwheel of limbs, brandishing a sword and shield at the gaping jaws of the sea monster. He presents the visual and symbolic opposite to Andromeda's body: his tanned skin a red-blooded counterpart to her smooth, ivory, object-like flesh; his torqued limbs echoing Andromeda's but expressing masculine virility and agility in contrast to the eroticised helplessness of her restricted body.

These oppositions set up another contrast: the sexual objectification of the tethered Andromeda makes the valiant success of Perseus look even more impressive, in the time-honoured tradition that exploits the maiden's torture to amplify the hero. After the rescue, Perseus and Andromeda married and had nine children. Knowing this, we are led to view Andromeda's beautiful body as the fitting prize for Perseus' bravery, to see the maiden's beauty and fertile body as the hero's just reward.

The curator of the National Gallery exhibition delivered an introduction at the press conference, while the gallery's saturnine director looked on. Amid all the usual excitement about the works coming together for the first time in centuries (and the updates about the Weinstein case pinging on my phone), I sensed a prickling awareness that something was changing: that looking at these gilded images with the usual art historical reverence for brushwork, beauty and composition no longer felt right. Seen together in this way, the six paintings seemed able to say so much more about sexual politics than we were giving them credit for as purely aesthetic masterpieces. I began

to think about how their meanings and our ways of seeing them might be shifting and reforming.

The curator seemed to feel it too, as he stumbled over the explanation of Europa and Danaë's rapes, and referred to the models for the paintings in self-consciously politically correct terms as Venetian 'sex-workers' (not courtesans, not prostitutes). But at the same time there was the old-school connoisseur's analysis of the figure of Europa, and the question mark over whether she's in distress or erotic abandon (does 'no' actually mean yes when it's Zeus, king of the cosmos?). I willed him to stop as I felt the inevitable throwaway smirk about the crotch-gazing cherub looking between Europa's legs forming on his lips. It was received with a ripple of low laughter as the assembled critics exhaled, in relief, that they were on familiar, comfortable ground. I thought of my daughter, at school, and hoped she wouldn't suffer similar humiliating indignities.

But this casual sexism was contrasted with the cautious and sensitive terms in which the curator discussed the victim-shaming of another raped maiden – Callisto, a nymph of the goddess Diana's retinue who was sworn to chastity and yet became pregnant by the shapeshifting Zeus who appeared to her in the guise of her mistress and seduced her. Titian's canvas shows the climactic moment in which Callisto is dragged in front of the imperious goddess by the other women in the fold. They reveal her pallid swollen body, grey with fear and pain, with an air of determined glee. Callisto's anguished eyes tell us that she is well aware that it is the rape victim and not the king of the gods who will be punished for the crime. For what is not shown (but a Renaissance viewer would have known) is

that Callisto was exiled from the group by Diana, turned into a bear by Zeus' jealous wife Juno, and almost killed by her own son. Callisto's shame is a bitter reminder that rape is a crime not against the body of the one who suffers, but against whoever has social and legal authority over that body. (The tale has chilling similarities with contemporary honour killings and how families deal with the 'shame' of raped women.)

The raped maiden is not confined to mythological oil paintings for powerful men, or to dazzle twenty-first-century gallery audiences and journalists. She has also become embedded in the public symbols of our political and civic ideals that we encounter beyond the art gallery. The rape of the maiden hides in plain sight as the bedrock of the modern European project: her story is both struck into the metal of its currency and exists in works of public sculpture outside its political headquarters. Glimpsed daily and multiple times without our really being conscious of it, Europa is on the Greek and Italian versions of the €2 coin and is the watermark on the euro banknotes. She appears as a sculpture outside the Justus Lipsius building which, together with the Europa building, houses the headquarters of the European Council and Council of the European Union in Brussels. There she clings like a gymnast to the bull's horns as they take flight together; in another sculpture outside the European Parliament in Strasbourg, she is cast in steel, straddling the bull's back.

Civic images such as these are important because they build a sense of public identity in much more insidious ways than is seen in an art gallery. More visible to a wider audience, they are also often less scrutinised and are embedded invisibly

into everyday life, so their symbolic messages and implications become received as universal norms. And the message we leave mostly unscrutinised is that a young woman's submission to the violent lust of a more powerful man has in fact become a symbol of cooperation, of political harmony, of mutual interests, shared bonds and greater good. While Titian's canvas seethes with violence and eroticism, the public sculptures of Europa and the bull convey a sense of freedom, adventure and dynamism, where the underlying forces of sex and aggression have been neutralised into an emblem of utopian harmony and political pride.

Classics scholars have tended to insist that we can't see acts of mythological rape in our own contemporary criminal terms. They have a point. When Homer wrote down the story of Europa and the bull in the eighth century BCE and when Titian painted his frothily erotic version in the sixteenth century CE, rape as we now understand it had no name. The Latin term 'raptus', from which we have inherited the term 'rape', means to seize, rather than a specific physical act of sexual violation. For this reason, the term raptus also described a violent theft of property, which makes perfect semantic sense because rape was thought of as a crime against property. When a maiden was raped what was 'stolen' was her virginity. Historically speaking, entering the body of a woman against her will was an offence against the proprietor of that women's body – her father or her husband (anyone but the woman herself). Neither was consent an issue because the women of ancient Greece and Rome had few consensual rights, not least any say in who they married.

Perhaps classics scholarship has been reluctant to recognise rape until recently because the semantics of rape – in other

words, *what counts as rape*, whether in mythological stories or in real life – have eluded us, and continue to do so. Until the twentieth century, most crimes against women of a sexual nature – including 'date rape' and 'sexual harassment', the more recent 'upskirting' and sending 'dick pics' – didn't have a name (and therefore didn't exist as crimes either in the eyes of the law or in popular discourse). It was only when feminists and victims insisted that these started to be brought under the rubric of criminal offence. The fact that records of rape convictions began in 2007/2008 in the UK suggests that rape has only recently started to enter the lexicon of crime in quite the same way as other felonies. And this is down to a question of language and the meaning of consent to those who say they were raped, those accused of rape and the members of a jury. The narrative limbo of 'he says, she says' is still strong. So the questions that get volleyed around in discussions that ask whether Titian really is showing us rape or not are actually part of the same issue as the blurred lines of consent we still face today.

There's an intellectual snootiness that draws on this ambiguity of the term 'raptus', a snootiness that also likes to tell non-experts that references to rape in images like Titian's *Europa* should be sublimated into wider philosophical metaphors on the nature of power, retribution and the price of desire for mortals. Undoubtedly they can be. But historical images that glorify mythological rape do not remain within these scholarly parameters; they are reproduced on postcards, gifts and everyday merchandise and revered as lofty testaments to taste and artistic genius. For me, a more powerful discussion lies in thinking about the strangeness of using women's bodies as the

vehicles to explore the abuses and burdens of desire and power in the first place. That rape – that is, the violent force of one body against another's body – should be the rubric for understanding anything metaphorical at all.

Art historical scholarship too has overlooked the nuances and possibilities of understanding rape in these paintings, focusing instead on literary allusions and metaphors, political symbolism and their aesthetic gold standard. Titian is so loved that to see these works through the prism of today's sex politics and Weinstein's crimes is sacrilegious for most art lovers and too heretical for most scholars. I can see why. It would of course be so much easier to just let ourselves be unproblematically seduced by the rhythms of colour and light and flesh on the canvas – as many of the critics who reviewed the exhibition did. But looking at Titian's erotically-charged paintings for the Spanish king asks us to consider the part we play in enjoying these 'masterpieces', and about what it means to look.

Let's think again (as we did with Venus images) about who we identify with when gazing at Europa's splayed thighs, and what is at stake. Do we share Europa's desperation? Or do we quicken with the thrill of conquering her? Ultimately I don't think it's that simple. Titian poses a tantalising note of uncertainty that prevents the painting from collapsing into sadistic, voyeuristic pleasure. The bull's doleful eyes search for the viewer as he lurches offstage, looking out of the canvas imploringly as if to beg: 'Is this really what you want me to do?', as he acts out the script of an ancient poem. Titian seems to leave the responsibility with us, the viewer; do we look away or do we look closer and try to see these paintings

differently? (When we change the way we see, the things we see also change.)

It would also be unfair of me to lead you to believe that it's only the maidens who suffer in Titian's poesie, because although they make up the majority of the bodies in the exhibition, in the midst of these passive maidens lurks another tale. Hanging next to Callisto's fatal exposé is a painting of the story of Diana and Actaeon, the young hunter who accidentally saw the goddess Diana when she was bathing nude with her nymphs. For Actaeon the consequences of looking are fatal: enraged, Diana turned him into a stag who was then mauled to death by his own hounds. The story suggests that not everyone is allowed to look. Diana's fury and Actaeon's death are also a reminder of what happens when we are seen in ways we don't want to be, and that how we are seen, as well as what we see, has the power to transform our fate.

Giambologna's sculpture *The Rape of the Sabines* (1583) dominates the Loggia dei Lanzi in Florence – an open-air sculpture gallery in the Piazza della Signoria that flanks Florence's central government building. Sightseeing tourists congregate here, pausing on its steps, and students meet and smoke. Its location marks the political centre of the city, but it also acts as a backdrop to everyday life.

At the apex of a corkscrew of bodies, a woman with exposed breasts howls a silent scream while she is hoisted up in the air by a muscular-buttocked nude man with tight, virile curls of hair. This man is a follower of Romulus, who by legend founded Rome in the eighth century BCE. His newly formed community

was short of women to take as wives and so Romulus invited the neighbouring Sabine tribe to celebrate a feast day with them. During the celebrations the Romans seized the unsuspecting Sabine women from the crowd and kidnapped them to be their wives and bear children, ensuring a new generation of Romans. According to Plutarch, only virgins were taken (with the exception of one married woman called Hersilia).

As a work it's not subtle with its erotic thrills: we can feast on the bare breasts of the anonymous Sabine when looking at the sculpture head on, and we get to gawp at her attractively squashed buttocks pressed against the bare chest of her captor as we move around the work to see it in the round. It seems like it was imperative for the artist that the kidnapped woman remained sexually attractive during her ordeal.

It is a quirk of the story that the title of the work was given to it long after the sculpture was completed. The sculptor Giambologna wanted to distinguish himself among a group of talented artists who were all competing for the most prestigious commissions in the city, and so he made the work speculatively (instead of the more common custom of being commissioned by a buyer). And when faced with an open-ended brief, Giambologna chose to depict a scene of abduction with sexual intent – of an anonymous woman by an anonymous man while a second man looks on in horror, unable to protect her. The trampled man at the bottom of the statue shouldn't be overlooked as a mere compositional device. This is King Acron, commander of the Sabine tribe. He cowers in surrender to the unknown Roman rapist who defiantly places a beefy leg between Acron's splayed haunches to show us another sort of metaphorical 'rape' – the

Roman emasculates Acron by penetrating his space and hiding his manhood from view. Acron's inclusion is essential to understanding what 'heroic rape' meant in these narratives and their images, as something that was not just a means of seizing female bodies to seed another generation, but also a means of overpowering other rival men and another reminder of how the maiden's plight is a prop for emphasising male virility.

Giambologna found the success he was seeking – the archduke of Tuscany Francesco I de' Medici ordered that the sculpture be put on public view outside the Palazzo della Signoria for all to see. It was only then that an appropriate story drawn from classical mythology had to be superimposed; with a subject like rape, there were inevitably too many to choose from – Giambologna himself mused over smaller bronze models of his sculpture that they might depict the rape of Helen of Troy, or of Proserpina raped by Pluto, the god of the underworld, or a Sabine. For sixteenth-century Italy, rape was so normalised as a gesture of erotic domination and political control that it was generic.

Like the tale of Europa and the bull, the Rape of the Sabines has been passed down over time as a celebratory story about the foundation of national identity that comes about from the rape of maidens. Throughout the Renaissance period in Italy, the story was monumentalised as a patriotic moment of Rome's foundation for both genders: the men were celebrated as virile and victorious while the Sabine women were revered as the mothers of Rome. Images of the story even decorated wedding banners, marriage chests and the interiors of the apartments of noblewomen. The narrative was framed as one not of distress

and violence, but of honour – whatever the original abducted women had to endure being taken from their homes was outweighed by the resulting unions of marriage and the spawning of a new generation and a new city. It reminds me of dystopian stories of reproductive coercion by the state, such as in Gilead in Margaret Atwood's book *The Handmaid's Tale*, where the authorities seize women to be 'handmaids' who are raped and hopefully impregnated and encouraged to feel pride to be of service to the propagation of the state.

The author Livy suggests that the Sabine women shed their resentment at being kidnapped from their homes and families once they were promised marriage and passionate affection, and implies that their subsequent pregnancies were consensual. This seems to suggest that women will endure any abuse if the promise of love and marriage is the reward (and there are certain parallels with the story of the beleaguered Griselda here too). Such an assumption has been reflected in rape legislation around the world, with laws that exonerated rapists if they married their victim or provided her family with a dowry – in a throwback to when rape was seen as a crime against the patriarch of the violated woman's body for spoiling her sexual market value as a virgin. Italy repealed their version of the law in 1981, but Turkey attempted to reintroduce theirs in 2016 and 2020 to allow convicted rapists release from prison on the condition that they marry their victims. Several Latin American countries, the Philippines and Tajikistan are among countries that retain similar laws.

I'm interested in how we might breach the gulf between the liberal world's criminalisation of gender violence, as seen in the unanimous media condemnation of Turkey's attempts to protect

and pardon rapists, and the tacit condonement of rape in works such as Giambologna's seemingly innocuous sculpture on public view. In an attempt to do so, perhaps it is useful to reflect again on our involvement with the work and what we are invited to feel here: is it empathy for the victim? Pleasure in enjoying her eroticised, struggling body? Is it an admiration for the courage of Romans in making difficult decisions in order to sire a new dynasty? Or a reminder that some women have no agency in who they marry and are obliged to have sex with?

If we can start to see the separation between what we find intolerable in real life and what we lionise in monuments and works of art, then perhaps we can further the way in which we talk about systemic sexual violence against women – by bringing the gender dynamics of power and violence that are hidden beneath the surface of everyday life and its images more starkly into the light, and making them more visible and more strange. Inevitably this leads us to a burning question of what we should do with the artworks and public sculptures that contradict our proudly held liberal values in real life: do we take them down? And if we do, what would we do with them and what would we put in their place?

The frankness of the sculpture's message is absorbed by the everyday nature of its display, which makes me think that if we sublimate the trauma of a violent capture and rape into a respected political symbol and monument, then perhaps it makes it even harder to acknowledge the trauma of daily instances of sexual coercion or threat (from micro-aggressions to trolling to aggravated assault), particularly when we can draw no transformative or ennobling narrative from them, or when

they don't make pleasing art images and objects. The cries of the captured Sabine hang in silent suspension in the pigeon- and tourist-strewn piazza – but no one seems to notice or even care. Perhaps that's the thing. Rape hides in plain sight, hovering under the surface, at the edges of so many narratives, from late night journeys, first dates, and taxi rides to gallery visits, history lessons and marriages.

What the Me Too and Time's Up movements established with their flood of testimonies is that most women have a story to tell. Not far from Giambologna's sculpture here in Florence, I experienced my own, as a young foreign student in the early 2000s. I had been in a small car accident near the river on the way back from a party. Not serious enough to have injured me, but enough to have shaken me. In shock and visibly distraught, I wandered alone into the closing train station where the station police officer ushered me into his office to give me water, coffee, tissues. He sat on the edge of his desk, the door closed, listening to my stumbling efforts to explain what had happened through a haze of tears. I remember the authoritative starched smell of his uniform as he reached out his arms and pulled me towards him gently. I remember the shine of the buttons on his epaulette glinting near my cheek as he started to stroke my hair and kiss my neck as he edged his stretched legs between mine.

Keen for the safety of open spaces I hurried back to my apartment through the Piazza della Signoria where Giambologna's sculpture was by now spot-lit in the darkness, while nocturnal cruisers drank wine from cartons. I knew that had I not been able to extricate myself from the amorous expectations of a stranger with authority at the train station, that if things had

escalated, my screams like those of the Sabine would have been equally hollow, falling on stony, impervious ground.

Another type of maiden has seeped into our celebrated cultural images – the lifeless, poetically doomed and incredibly desirable maiden who isn't raped but is seen to do damage to herself. The atmosphere in the room of Victorian paintings in Tate Britain in London feels powdery and stifling. It is the natural habitat of some of the best loved maidens of art history including John Everett Millais' painting of the tragic Ophelia from Shakespeare's *Hamlet*, who supposedly drowned herself in a lovesick hysteria. The painting has become the ubiquitous postcard of the British Pre-Raphaelite movement, that style of Victorian painting known for its depiction of women with opiate-glazed eyes, painted in bright colours like choked hothouse blooms. In the painting Ophelia drowns gracefully, momentarily suspended in her watery grave, hair billowing like seaweed fronds around her pallid face with its blank gaze, her dress exhaling under the surface of the water like a gelatinous balloon.

What we are looking at is a scene from *Hamlet* that happens off-stage: Hamlet's mother Queen Gertrude reports that Ophelia has fallen from the broken branch of a willow tree and into the river where she has drowned. This unseen moment in the play has become immortalised in art history and popular culture with numerous images that we collectively worship of pretty maidens drifting peacefully into death amid bucolic nature. Millais' is undoubtedly the most famous of these, and the work has become not only synonymous with the character of Ophelia, but also with the aesthetically pleasing demise of the

sad girl and the romanticised contemporary figure of the hot mess. You'll see it referenced in magazine shoots and make-up tutorials in women's magazines, as well as in indie cinematography (Lars von Trier's *Melancholia* and Sofia Coppola's *Virgin Suicides* to name just two examples.)

PhotoVogue, the photo sharing platform for photographers curated by *Vogue* editors, cites that one of the most repeated themes in its database of thousands of images is the tragic heroine Ophelia. The website suggests that 'Ophelia embodies the essence of purity and innocence, perhaps a metaphor of the fragility of adolescence, whose death for love becomes an aesthetic manifesto, today, like yesterday, as in John Everett Millais' iconic pictorial representation.' I'd argue that this is a wilful misinterpretation, even a dangerous one that encourages women to model frustration and sadness as something aspirational, stylish and beautiful. Fixing young women as the 'essence of purity and innocence' places them on an impossible pedestal that denies their pleasure and sexual self-realisation, and sets young women up to see themselves not only as capable of being 'ruined' by men but for that outcome to be in some way desirable.

Moreover, Ophelia didn't really 'die for love'. Her role in the play revolves around her relationship with three men: her father, her brother and her boyfriend Hamlet. Ophelia is torn between playing the role that patriarchal authority expects of her as the dutiful daughter prior to becoming the chaste wife and mother, and the fulfilment of her romantic identity as a young woman in love. She suffers the manipulations of Hamlet and the restrictions placed on her by her family. Then her father is killed and her boyfriend turns against her in a misogynistic

tirade. She becomes 'hysterical', the pathologising label for any female response that deviates from patriarchal expectations about correct or appropriate female behaviour.

Ophelia's 'madness' after having lost her would-be lover and her father is presented as an inability to function and find meaning in a world without significant male relationships. Without these men (and with her brother abroad) Ophelia has no strength to live, and no interior sense of self to anchor her – first her speech unravels into lewd streams of consciousness that shock the court, then she slips away in the rushing river to become an exquisite and unproblematic corpse.

I have a feeling that we're still attached to this idea that a woman's mental stability and romantic and sexual happiness should revolve around the presence or absence of men. Today, we still condemn and judge women who lack a patriarchal figure in their lives (as if this is a bad thing) with the sexist colloquial term 'daddy issues', which rides on the assumption that father-less daughters are more hysterical, irrational and 'needy', that they rush to fill the perceived void in their lives with promiscu-ous (read inappropriate) sex, that they are 'damaged goods' in dating terms.

Millais' *Ophelia* and all its many tormented derivatives romanticise the suffering of women in order to make their lives meaningful. In this case, it's taken to the extreme that Ophelia actually dies. Which is also the point when she becomes the most beautiful, most loved and most perfect – at her funeral both Ophelia's brother and Hamlet compete over the strength of their love for her, and she is described as having 'gone to the angels', her innocence and incorruptibility safely secured.

Echoes of Ophelia's transformative death can be found in the 1947 *Time* magazine full-page 'picture of the week' showing the dead body of Evelyn McHale – dubbed 'the world's most beautiful suicide'. McHale jumped from the 86th floor of the Observation Deck of the Empire State Building in New York, and landed on a limousine parked at street level in a remarkably flattering pose: a passing photographer captured the moment which shows her lying peacefully in the crumpled sheets of steel like a sleeping beauty. The photograph transformed McHale from an anonymous bookkeeper in Manhattan to international fame as an exquisite corpse, and the image was later appropriated by Andy Warhol, who reproduced it multiple times in one of his 'Death and Disasters' canvases, called *Suicide: Fallen Body* (1962). McHale, another doomed maiden like Ophelia, entered the popular imagination as a beautiful cadaver whose dead body became a prop for poetic and aesthetic contemplation of melancholy, perhaps even the melancholy behind the American Dream.

In both the photograph of McHale and *Ophelia*, the frightening aspects of death and suicide congeal into something beautiful, to make a perfect image of idealised femininity – one that is passive and silent and doll-like. Death then is a way of smoothing over the disruptive potential of the hysterical maiden – and what better way to express the control of beauty and passion than to preserve it by stilling it and making it incorruptible? In pitying Ophelia as she drowns, there's also a current of sexual fascination in the image, a loving gaze that verges on necrophilia – an urge always bubbling under the surface of Victorian culture with its poems about dead and obedient beauties strangled by

masters who can possess them fully (such as Robert Browning's 'Porphyria').

But what of the impact for a female viewer? In its own time as today, pictures of Ophelia escaped the art gallery and became a way of influencing female behaviour, as pictures inspired by literature and attitudes towards real women became blurred. The fictional Ophelia even became a pseudo-medical diagnostic archetype for assessing young female psychiatric patients in asylums, who were photographed in poses resembling the neurotic maiden. Aspects of Ophelia's tragic narrative also overlapped with the real life of the model who posed for Millais' famous painting. The flame-haired Lizzie Siddall was an artist and poet who became better known for her involvement with the Pre-Raphaelite group as muse, model, mistress and eventually wife to one of its members, Dante Gabriel Rossetti. We know her best through the male gazes of artists who cast her as idealised, gloomy women from myth and literature, such as Beatrice, the vaporous beauty from Dante Alighieri's medieval poem *The Divine Comedy*.

Siddall was known for her ethereal fragility – reports suggest that she was so weak and thin on her wedding day to Rossetti that she had to be carried the five-minute walk to the church. Later she became addicted to opiates as a release from the pain of her ailing health and the loss of a stillborn child. She died from a fatal overdose of laudanum at 32. Siddall's life was canonised into the tragic story of the artist's model turned lover and muse who became an angelic invalid and finally exquisite corpse. Even today, devotees make pilgrimages to her grave in Highbury Cemetery in North London.

The creation of Lizzie Siddall through Pre-Raphaelite paintings and the almost mythological accounts of her life and death presented the most fascinating type of Victorian woman to the public imagination: one who was thin and miserable, who surrendered to illness, and was ungrudgingly compliant. But this is a role under which the real Lizzie Siddall has been buried. Siddall in fact earned a successful enough living as an artist, was hailed as a genius by the notoriously misanthropic art critic John Ruskin, and wrote poetry about the hypocrisy of men who love women only for their physical beauty (one of her poems called 'The Lust of the Eyes' begins 'I care not for my lady's soul'). Her sister-in-law Christina Rossetti was of the same opinion, and wrote about the relationship between the male artist and female muse, of him painting her 'not as she is, but how she fills his dream' in her poem 'In the Artist's Studio' (1856). Siddall's identity was, like many Victorian muses, adapted to fit the artist's dream: her identity contoured by his gaze, his desires and his aspirations. When they married, Rossetti even changed the spelling of her name, removing the second 'l' from Siddall, to a version he found more elegant.

A familiar story is tethered to the accounts of the making of Millais' much loved canvas. Siddall lay submerged posing as Ophelia in a bath of water for hours on end, the water kept warm by oil lamps underneath the tub. Lost in concentration, Millais didn't notice when the lamps burned out, leaving her in stone cold water. Siddall subsequently contracted pneumonia and Millais was forced to pay for medical expenses by her father. This detail is often made to suggest Siddall's almost spiritual dedication to her role as muse, so committed to the creation of

great art that she didn't utter a word of complaint despite her discomfort. I bristle at this faint praise, that suggests that she excelled in compliance with Millais' heroic creation, uncomplaining even when it was dangerous for her. Maybe she knew that the audience of the image would love her more for having endured the torture of the cold bath, knowing that (then as now) we like our maidens to suffer patiently for our aesthetic enjoyment. Or maybe she had dosed herself with enough laudanum that day not to care.

Enduring discomfort is the maiden's virtue, whether that's a kidnapping and rape to build new cities, or the torture she suffers for the sake of poetry, storytelling and paintings. And this reflects how comfort is denied to women in general, who work harder at their appearance, harder at their jobs or in their art to have their efforts remain invisible. Comfort is (like most things) an issue of privilege and politics. In the introduction to her essay anthology *Whose Story is This?*, Rebecca Solnit writes that one of the common responses to Me Too is the complaints of men that they no longer feel 'comfortable' in the workplace (and by implication in other situations that were explicitly geared towards their social, economic and erotic privilege). It makes me think of the way in which detractors of the sexual objectification of women claim their own discomfort at being cast as misogynists, how comfort is as Solnit suggests 'the right to be unaware ... the right to have ... no reminders of suffering'.

If endurance of discomfort, and far worse, is the maiden's virtue, then her reward is marriage – to her aggressor, or to the artist that stills her into a beautiful image which is not even of herself. Like Ophelia in Hamlet's play, Siddall's body was a prop

for the artistic development of the men to whom she was bound. Drained of her own heat and voice and vision, she was filled up to overflowing with the male artist's dream, to buttress his success, a public spectacle for pathos, tragedy and the admiration of male creative genius. Ophelia and Lizzie Siddall are ghosts in the archives; they join the abducted Sabines, Europa, Andromeda, Danaë: the women whose stories and identities are eclipsed by their service as maidens. They are a reminder that for women it is not so easy to wear one's body and be free to make one's own narrative.

In 1972 the American artists Judy Chicago, Suzanne Lacy, Aviva Rahmani and Sandra Orgel invited an audience to an auditorium at Fresno University. In dimmed lighting, audio recordings played testimonials from women who had been raped and female performers bathed in tin baths of eggs, blood and earth. Animal kidneys were hammered to the white walls and one of the performers was bound in gauze like a mummy, while a web of string was created around the stage, trapping the participants in their sticky coverings. The refrain 'I felt so helpless, so powerless, there was nothing I could do but lay there and cry softly' repeated like an insistent drone.

The title of the work is *Ablutions* – a name that draws on the Christian ritual of cleansing for the purpose of purification, which is violently at odds with the processes that unfolded on the stage. The performance belongs to a radical body of feminist artwork about rape produced by women artists in the 1970s – work that broke away from classical patriarchal narratives and art objects that made sexual violence a question of beauty and

an esteemed political symbol. Feminist art about rape was about finding a means of expression for the aspects of sexual violence that couldn't easily be vocalised and which had remained systemically invisible. It was about finding a means to express a female experience that didn't have a visual tradition made by women. The harrowing audio recordings and the confusing acts witnessed on the stage were an attempt to communicate some of the overwhelming physical and emotional experiences of rape – including the sense of being stained, of being bound and silenced, of being dehumanised, of being trapped in an imprisoning web.

Works such as *Ablutions* implicated the spectator in new ways by rejecting the historical default of the male gaze for which the work of art provided a reminder of his power and provided him with erotic enjoyment. In witnessing *Ablutions,* the woman spectator (who may have experienced sexual violence herself) could identify with the confessional nature of the work and have her experience validated in a way that is impossible in images of the historical rapes of maidens. Performance art such as this also invited the audience to look at everyday life with the same attention as had been commanded by traditional artworks such as Titian's *The Rape of Europa* or Botticelli's *Birth of Venus.*

Ablutions can be described as belonging to the artistic language of performance art, which was a new form of artistic expression that emerged in the late 1960s and '70s. It challenged the boundary between what was called 'inside' fine art – in other words, the art found in museums and galleries – and 'outside' art, which had a political focus and took place both in the street and in the community by using the bodies, movements

and experiences of live people. Performance was not interested in making a fixed object that would reside in an elitist space such as a museum, and it purposefully avoided any sense of having a monetary value, which is why it escapes public knowledge in a way Titian's paintings do not. Importantly, it also specifically avoided identification with anything that could be deemed as fantasy, entertainment or eroticism.

Suzanne Lacy, one of the artist-participants in *Ablutions* went on to produce the mixed media project *Three Weeks in May* in 1977. It was a combination of performance, reportage, numerous public discussions and documentation in response to the pandemic of sexual violence in Los Angeles that had earned it the title 'rape capital of the USA'.

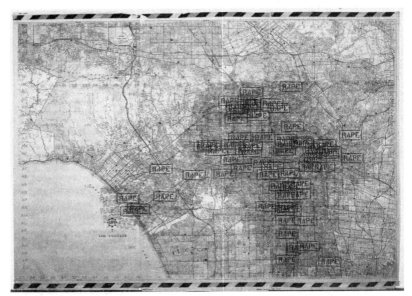

Suzanne Lacy, *Three Weeks in May*, 1977, Los Angeles, California.
Photo: Grant Mudford

The main visual pieces on display were two bright yellow 25-foot municipal maps of the city. These were installed in the non-art space of an underground shopping mall underneath City Hall in Los Angeles. As a location it was central and public, but being subterranean it was still somewhat hidden from everyday view at street level. This setting intentionally underscored the nature of sexual violence in the city as something that was both acutely visible to those raped yet invisible in the wider public imagination. The mundanity of the shopping mall, juxtaposed with harrowing data and statistics about sexual violence, also echoed the fact that while many in the city were performing their unmemorable everyday routines, others were experiencing trauma.

On the first map Lacy printed the word 'Rape' in red over the locations where a rape had been reported to the LA police department in the previous 24 hours. Surrounding each entry on the map she printed the word another nine times in a fainter red. This visualised the prediction that for every rape reported to the police, there were another nine incidents that were not. Over the course of three weeks, the words multiplied on the map like open bloodied weals appearing on the surface of skin, their sheer volume and repetition overwhelming to take in. But with every new addition, the visibility of the word also became cancelled out, its readability obscured. Lacy's evolving map of rape incidents seems to emphasise how the more times something happens, the harder it can be to clearly read it for what it is. A second map was marked with places of resistance and assistance for rape victims such as prevention centres, crisis hotlines, emergency departments and trauma centres, and made visible

an otherwise hidden topography of care and aid in response to sexual violence.

The following year in London, the British artist Margaret Harrison created the mixed media work *Rape*, which made an explicit connection between culturally prized art images and attitudes towards sexual violence in 1970s Britain. Along the top tier of the image are immediately recognisable copies of popular highlights from art history that objectify the female nude body in different ways. There's a sketch of Titian's *Judgement of Paris*, which is the story of a beauty competition among the mythological goddesses who plead for approval from the mortal man Paris; the de-robed damsel in distress Andromeda who clings chained to a rockface waiting for the hero Perseus to scoop her out of danger and into his bed; the mad maiden Ophelia ceasing to cause inconvenience as she drowns poetically; and Manet's *Le Dejeuner sur l'herbe*, which features two fully dressed men picnicking with a woman who has taken off her clothes and sits waiting while they seemingly talk about something they find important.

The final image in the sequence is a reproduction of a popular contemporary advertisement for orange juice featuring an impossibly curvaceous blonde woman in a skimpy bikini and the slogan 'Juicy, Fruity, Fresh and Cheap'. A similar ad for the same product appears at the bottom of the same canvas, as a nod to the widespread sexualisation of women's bodies to sell everyday food stuffs. In between these tiers of mainstream images, the artist attached newspaper clippings containing headlines about judicial bias in rape cases, as well as written accounts and quotations revealing class and gender prejudice in the police and judiciary, such as: "'It is known that women in particular

and small boys are liable to be untruthful and to invent stories", Judge Sutcliffe summing up, April '76'. Chillingly stark images of threatening weapons, including broken glass bottles, scissors and knives complete the picture.

Harrison's work lays everything out on a white background as if it were a dissecting table containing collected evidence to make her point forensically clear: that high art, commodity images, and the attitudes of the legal establishment all intersect to uphold a system that tacitly condones the abuse of women. The work was not considered appropriate for London's Serpentine Gallery in the late 1970s – the reason given was that the gallery was considered to be a 'family space'. (It was later displayed at Battersea Arts Centre and used by teachers to introduce students to discussions of rape.)

Reflecting on that decade, the artist herself states: 'the images of women that we had absorbed almost unconsciously from cultural icons were those of the helpless, passive muse, and adverts portraying us as available to be consumed fixed us in a world we didn't want to occupy.'[30] Harrison makes a point about how images fix and immobilise our possible identities; and how the images that surround us contour a landscape that can be alienating for us to live in if they do not match up to our sense of ourselves.

Art associated with the second wave women's movement emphasised the lived experiences of victims of sexual violence and exposed both the structural systems that authorised sexual violence and the cultural networks that silenced these narratives. In many ways this process of expression, empathy and collective consciousness raising reached critical mass almost

50 years later in the Me Too movement – which demonstrated how everyday sexual harassment is part of a wider rape culture in which male sexual entitlement to women's bodies, and women's silence on the matter, has been made normal.

But the women artists of the 1970s were not the first to provide an alternative to the maiden's story. Born in Bologna in 1638, Elisabetta Sirani created a prolific portfolio of almost 200 paintings before her premature death at 27. Her name, however, remains mostly unknown – even to many art historians who study the seventeenth century. Among her works is a depiction of a rape story from classical history, but one that is surprising because it doesn't involve Zeus behaving badly or result in heroic nation building. Timoclea of Thebes was raped by a captain of Alexander the Great's army in 335 BCE. According to Alexander's biographer Plutarch, after the assault the captain asked her where her money was hidden and Timoclea led him to a well in the garden. When he bent his head into the darkness she pushed him in and hurled stones down on him to kill him. Alexander the Great himself was so impressed with her dignity and bravery that he spared Timoclea from punishment or captivity, even though she had murdered his henchman.

Sirani paints Timoclea with stony determination and a marked absence of any of the erotic details that tend to accompany mythological and classical rape stories. The picture overturns the traditional model of the passive maiden and active male with the unusual sight of a vulnerable male body acted on by the heroine Timoclea, who manipulates the situation from one of violation and victimhood to one of revenge and empowerment. The captain topples in an ungainly jumble of cartwheeling

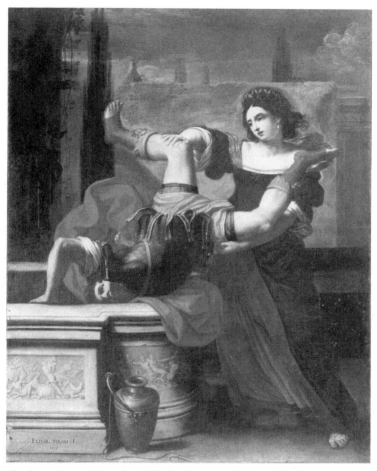

Elisabetta Sirani, *Timoclea Kills the Captain of Alexander the Great*, 1659, Museo di Capodimonte Naples, Italy. Photograph © Mondadori Portfolio/Electa/Luciano Pedicini / Bridgeman Images

limbs into the mouth of the well, swallowed up by the engorged red folds of his cloak. Meanwhile, Timoclea holds his unapologetically exposed groin open to our gaze (reminiscent perhaps of awkwardly akimbo Europa).

The painting belonged to a male collector – a banker from Bologna named Andrea Cattalani who collected paintings of strong and decisive 'heroic' women who, like Timoclea, were not reduced to alluring femme fatales. But this cannot be taken as evidence of a widespread devotion to pictures of empowered women: Sirani's painting remains the only known depiction of the subject in Italian painting of the period (while other images of Timoclea tend to focus on Alexander the Great's magnanimity in pardoning her).

Despite its obscurity in art history, Sirani's *Timoclea* has found a twenty-first-century afterlife in the public imagination in the form of memes, illustrations and even faux-cute needlepoint projects that appeared on social media channels in response to the Me Too and Time's Up movements. Parallels were made in particular with the high-profile senate hearings of Brett Kavanaugh for Supreme Court Justice, who was accused by Christine Blasey Ford of rape. In the midst of the much publicised hearing, Sirani's *Timoclea* filled social media feeds emblazoned with the words 'I Believe Her'. Unlike work by twentieth-century feminist artists, this seventeenth-century painting abandons any engagement with the victim's anguish, focusing instead on her decisive power. I wonder whether the resurgence and traction of the image is because of how it presents women with another way of dealing with sexual violence, one that rejects identification with the passive maiden entirely and acts as something of a riposte to the detractors who have criticized Me Too as a 'victims' movement'.

Sirani's better known contemporary Artemisia Gentileschi has also been adopted as an aspirational model of female

strength and heroism, one who doesn't shy away from violence. Gentileschi's identity has been much sensationalised in art history as a rape survivor who endured a high-profile trial in Rome in 1612, during which she submitted voluntarily to torture to ascertain that she spoke the truth. Her rapist Agostino Tassi was found guilty and compelled to ask for her hand in marriage, as was the customary atonement for the crime against Artemisia's father. (Gentileschi did not marry Tassi, but was quickly wed to another man Pierantonio Stiattesi following the trial, as marriage was considered the best cure for the blighted maiden.)

Although Gentileschi didn't portray any explicit rape narratives in her art per se, she did explore themes of sexual aggression from a woman's perspective, such as the Old Testament story of Susanna (the young woman spied on by older men when bathing), which as a subject was popular erotic fodder across the Renaissance period. Gentileschi departed from the traditional male gaze that made Susanna more like a Venus figure offering herself up to be seen, and focused instead on the prickling discomfort women might feel in response to predatory unwanted ogling.

But it's her paintings of defiantly heroic women that have found new outlets and new contexts in the post-Me Too era. Most famous are her two paintings of the Old Testament Judith, who saved her tribe by slicing through the spine of the ogreish general Holofernes who threatened to oppress them. Or Jael, who lured the warlord Sisera into her tent before coolly hammering a tent peg through his temple. Artemisia's assertive women have frequently been interpreted as vengeful alter-egos

of the artist herself, and they have also become synonymous with liberating models of female self-determination in the face of normalised patriarchal violence.

Female artists have also subverted the necrophiliac gaze that fetishises the suffering fragile maiden. Some have chosen anger as a form of resistance to the maiden's influence, such as Beyoncé, who subverts the romantic normalisation of the archetypal maiden's painful dependency on male relationships. Near the start of her visual album *Lemonade,* Beyoncé plunges off a rooftop and seemingly through time into what looks like a nineteenth-century bedroom that is fully submerged in water. She floats like a foetus slowly orbiting in amniotic fluid, her long, crimped hair swimming around her like seaweed fronds and her ballooning waterlogged clothes and vacant gaze reminiscent of Millais' pitiful Ophelia. Beyoncé riffs with spoken-word lyrics about making herself softer, prettier, thinner, more silent, more penitent, revealing the strategies of self-harm that women adopt in order to fit into a role that is inadequate for them, in this case to make her relationship better by suppressing and abusing herself into an idea of a passive and perfect man-pleasing woman who doesn't question her partner's infidelities.

But this maiden escapes to the surface and breathes again. We suddenly cut to the opening doors of a monumental building unleashing an irrepressible torrent of water that gushes down the steps as Beyoncé glides through it, reborn, her bare feet bathed in the cathartic flow. Dressed in an ochre dress with sashaying tassels, Beyoncé sheds the oppressed Ophelia identity to adopt another more resplendent and violently active one – of

Oshun, the traditional Yoruba river goddess of fertility, femininity and sexuality. She strides along the street smashing up cars and surveillance cameras with a baseball bat. As an image of female rage and violence, Beyoncé's rampage was not without its black feminist critics, such as bell hooks, but I see something significant here: in destroying the surveillance camera Beyoncé seems to resist being turned into an image, stilled, policed and monitored by the gazes of others.

As with her pregnancy photos that appropriated the Western tradition to create a fertile black Venus, Beyoncé again takes us beyond the European canon. What we witness is a transformation from the passive maiden created in pictures, into a dynamic goddess who leaves behind the 'stale, male, pale' vision of the romanticised maiden. And Beyoncé does this by first drowning in the symbolic repressive imagery of the maiden but ultimately passing through it into something new. This 'new' is an expression of the 'black feminine' seen on its own terms, and beyond the polarising framework of white culture that sees blackness (or black femininity) only in terms of non-whiteness and as exotic and 'other'. Here, the bombastic black goddess is no foil to the white European maiden Ophelia. She in fact does a service to all women by flushing that archetype away.

For a black woman to adapt to the archetypal white Western maiden is impossible anyway, because there has been no visual language or space in cultural images for a '*black* maiden'. If we think back to Titian's bevy of damsels in Philip II's collection, the mythological Andromeda was referred to as an Ethiopian princess, but, as customary, was whitewashed in the painting. And this is in spite of translations of Ovid's story of Andromeda

that describe the princess as dark-skinned.[31] Europa, for that matter is never seen in any pictures as Middle Eastern, despite her Phoenician heritage (the ancient territory close to modern day Lebanon).

There is a straightforward reason for this: we don't see black or brown mythological maidens being raped or abducted to build dynasties because Western historical tradition sees the non-white female body as already so denigrated and devalued that it cannot be defiled by sexual violence. This sentiment reflects the fact that the rape of a black woman in the pre-abolitionist United States – and for most of the time up to the present – did not constitute a crime (in contrast to the hysteria over the supposed sexual threat posed by black men towards white women). Similarly, there are no poetic images of tragic black women as prettily expiring muses. Which leads to the conclusion that at the core of maiden imagery is the belief that defilement or death can only be meaningful if the body in question conforms to prized ideals of class, race and beauty.

But that's not to say that we don't see images of black women being defiled. In the Musée des Beaux Arts in Strasbourg, Christiaen van Couwenbergh's *Rape of the Negro Girl* (1632) shows three white men gang-raping a black woman. A seated white man without clothes holds a naked black woman on his lap, presumably penetrating her. A second man, fully clothed, watches on excitedly, while the third looks out to address the viewer, pointing mockingly at the woman being raped with one hand, while the other hand rests on his groin, in an indication that it will be his turn next to violate her. This is a picture of rape. There are no lofty mythological narratives to hide behind.

It's a picture of sexual assault that massages the ego and libido of male white supremacists in seventeenth-century Holland and shows the rape of a black slave as an act of male bonding, and erotic drama for a privileged male viewer and presumed owner of the image. Look more closely and you might recognise the gesture of the pinioned black woman: her left arm is raised in a gesture that is identical to the raped Sabine in the Loggia dei Lanzi in Florence. (It's possible that van Couwenbergh was even inspired by Giambologna's sculpture, as numerous prints were in circulation around Europe at the time.)

American artist Faith Ringgold presents the topic of slave rape from a different perspective; in her 'Slave Rape' series (1972), three large-scale images depict frozen moments of an imagined capture and rape of a black slave woman. The backdrop of green, orange and red leaves conjures up the colours of Africa and sets the scene. In *Fear Will Make You Weak*, a bare-breasted woman cowers behind a plant, her mouth open in a scream. In *Run You Might Get Away*, a woman with gold earrings looks over her shoulder towards the viewer as if she is in running in flight. The third, *Fight to Save Your Life*, is a portrait of a pregnant woman naked but for earrings and a hairband who holds a glinting axe as she looks directly at the viewer. But she is not a passive victim – the unexpected contrast between the pregnant belly and the sharpened axe suggests that she will defend her unborn child, even if the title of the series makes it clear that rape is inevitable.

With only the woman pictured in each scene, Ringgold places the spectator in the position of the implied aggressor/ slave trader/rapist, instead of their usual place as a voyeuristic

(and distanced) witness. As such, it's a direct invitation to think about how looking at pictures (and at people) can also be a form of violence, asking us to question the West's lurid fascination with the black female body as something animalistic, taboo and in need of conquering.

Ringgold paves the way for later black women to be the architects of their own stories and images, and her work can be seen in terms of the Afrofemcentrism movement that puts black women centre stage, telling their version of their story, through means that relate specifically to African culture, and not through the lens of Western culture and its denigrating stereotypes of black women. As the artist herself states: 'I have a strong story to tell – the story is about the rape of women during slavery. We know the story of the Black man in slavery; everybody tells it. I'm a Black woman. I'm telling her story.'

Ringgold not only disorients the familiar visual dynamic of images that depict rape (one that is made for the comfort and excitement of the viewer), but she also chooses an alternative to the familiar language of Western art history. The series combines oil on canvas painting with silk fabric to produce stitched quilts inspired by Tibetan silk thangkas which were historically used as an aid in Buddhist meditation. She draws consciously too on African art, especially tribal masks, in her representation of the women's faces, but also on her own identity as a descendant of an enslaved African brought to America: the artist used her features and those of her daughters as the models for the women of the Slave Rape series. In this way, the images are also a narration of ancestral oppression, and of how the legacy of antebellum slavery and rape is carried forward in the bodies

of subsequent generations. It compels us to see rape as more than an act against an individual person but as something that is mired in collective networks of silencing, blindness and generational trauma.

While all archetypal images of women in patriarchal society are about the invisible frameworks of power and tacit control of women, it's on the body of the maiden that the violence of this dynamic is most visible. Male artists have typically presented women's bodies to be enjoyed as spectators while the maiden herself is without agency and appears or disappears because of her attachment to a male figure. Moreover, it's in images of sexual encounters that this acting out of power by one body over another has become most normalised as an expression of desire. Behind the maiden is the overriding presence of male desire – to create works of art, to procreate new powerful social orders, or to satisfy a lust for sexual domination and violence. It's there in the necrophiliac gaze we adopt when looking at Ophelia, a gaze that is comfortable with seeing a young woman's inconvenient passions suppressed and stilled. It's there hiding behind the frothy sensuality and pleasure in Titian's rape scenes.

As I've mentioned, the ubiquity of these images, from their places in the heart of our political imagery to the works of art that we love best in our national collections, means that this male desire obscures any other forms of desire. There are, for example, no mainstream images of women taking men they desire by force. There are no images on coins of powerful women abducting men that become metaphors of political union. And we don't see images of men waiting to be rescued by dynamic

women either, or their self-harm and sadness as a poetic vision that bolsters the career of women artists.

And so it tends to be that women are only offered a way to imagine and visualise sex as something that is done to them, and not for, with or by them. I wonder if women are caught between the role of the maiden who says no and is taken by force, and Venus who lays out her availability as a pleasing performance, neither role matching the true, complex nature of their desires. And with that in mind perhaps it is a focus on female pleasure in our art and culture, rather than sadness or anger that might allow us to leave the maiden behind. This is a radical approach, as women's pleasure (sexual or not) is so rarely the focus of the cultural gaze.

In her essay 'Muteness Envy', the critic Barbara Johnson argues that there seem to be 'two things women are silent about: their pleasure and their violation [and] the work performed by the idealisation of this silence is that it helps culture not to be able to tell the difference between the two.'[32] I can't let go of these words as I look again at Titian's *Europa*, and the standard reading that the painting's tension lies in the ambiguity over whether the maiden writhes in terror or in ecstasy, encouraging us to read submission as pleasure and gaslighting us into accepting that we are frigid and puritanical if we fail to locate a similar thrill.

New ways of seeing and new spaces for women's self-expression can interrupt this silence and violence to give us alternative depictions of sexual abandon and pleasure, ones that don't portray sex as a demonstration of power.

Canadian artist Ambera Wellmann considers her paintings to be 'a search to pictorially structure female desire', with

images of erotic bodies that unravel the easy tropes of sexual performance for the male gaze. Her canvas *In Teeth* shows us two bodies in a bed, slick with a slippery wetness that projects the feeling of sex rather than an easy narrative scene for the viewer to voyeuristically enjoy. With no fixed viewpoint for the observer to latch onto, we witness a jumbled set of limbs belonging to two bodies that are equally incoherent with pleasure. Neither body takes priority over the other and there is no evident dialogue of power. Instead, hands appear magnified, breasts melt into chin and shoulders, and heads either flatten out or balloon with the intensity of sensation. In places the paint smears and blurs as if the very depiction of the experience slides tantalisingly beyond the powers of expression. When I look at this I see a picture of a woman released from all the paralysing self-awareness of whether her body looks like the ones she's seen in all those films and pictures that tell us what sex should look like.

Is centring women's pleasure enough to counter our culture's tolerance of sexual violence and female suffering? No. But can it provide a different and more empowering model for women (and, we might hope, all viewers) to identify with beyond the silent and passive maiden who is taken by force or harms herself? Perhaps. Not least if it stops us from mystifying young women as innocent and pure, then leaving them open to the fate of the maiden. 'It is because women are mystified,' Simone de Beauvoir says in *The Second Sex*, that 'those useless and charming qualities such as their modesty, pride, and extreme delicacy flourish.' But what if we rejected the images that fashion this idea of femininity for us?

However, embracing pleasure as a strategy for liberation comes with a risk, especially in a world that often doesn't tolerate women's independent pleasure. As Angela Carter wrote in *The Sadeian Woman*: the woman who is free to follow her desire in an unfree society is viewed as a monster. Let's meet some of them now.

Monstrous Women

Among the handmade banners held in defiance of President Trump at the 2017 Women's March in Washington D.C. was the repeated slogan: 'We are the granddaughters of the witches you were not able to burn'. Lifted from Tish Thawer's 2015 novel *The Witches of Blackbrook* and now, like all powerful ideas, commodified and readily available to purchase on sweatshirts, totes, mugs and everything in between, these words have struck a chord with twenty-first-century feminism in calling out the historical oppression of women who do not behave according to patriarchy's rules, nor fit into its predestined archetypes of femininity.

In the months before the Women's March movement took root, a new witch was created in the heated crucible of the US presidential campaign in the form of Democratic presidential candidate and former Secretary of State Hillary Clinton. Mature, politically experienced and determined, but far from perfect, Clinton embodied patriarchy's fear of ambitious, powerful, older women. In moments of optimism, her campaign for the most influential public office in the Western world seemed like a forgone conclusion. But Clinton's adversary drew on the dark

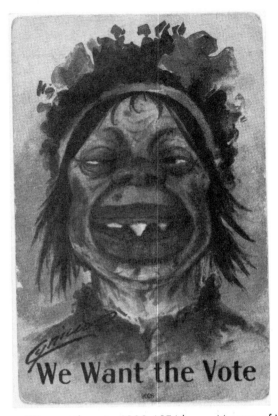

Anonymous, *We want the vote*, 1908, LSE Library, Museum of London
Picture Library © Museum of London

reservoirs of misogyny that Western culture has been steeped
in for millennia and deluged her campaign with well-rehearsed
images of witches, whores and monsters. The internet lit up
with pictures of Clinton with a green face and a broomstick as
slurs such as 'Wicked Witch of the Left', 'corporate Democratic
whore' and 'nasty woman' became synonymous with her name,
while conspiracy theories emerged to 'prove' that Clinton really

was the twenty-first-century embodiment of the biblical whore of Babylon.

Clinton is not the only woman with political influence to have been labelled as a witch, monster or whore. Images like these have always been used to keep women with any power or influence away from their seat at the table. A poster produced in 1908 by the British government emphasised its opposition to women's suffrage using the face of a beast, who stares out of the picture with eyes slightly crossed, suggesting limited mental or social capacity, its oversized mouth gaping to reveal sharpened fangs. Its skin is thick, lined and dirty, and the nose, large lips and brown skin all draw on exaggerated and derogatory racial stereotypes. A floral hairband tells us that this beast is female, or more to the point, a monster masquerading as female. The green ribbon in her hair and the purple dress echo the colours of the Women's Social and Political Union; along with the caption 'We want the vote', they define this beast as a suffragette, an unfeminine monster who threatened the certainty of male authority in the political sphere and interrupted the supposedly natural order of things.

The witch, the whore and the monster are all really the same archetype. Dangerous and unpredictable, they defy the archetypes of ideal womanhood that we have encountered throughout this book. They defy Venus with their ageing bodies and menstrual blood. (All things that are suppressed in our images of Venus overflow in our monsters.) They undermine maiden virginity with their unapologetic sexuality. They don't submit themselves to their husbands, nor are they exclusive with their partners. They are either happy in their own liberated

independence, or they operate in covens of collective woman-hood. Monstrous women know things that others don't, not just facts or magic spells but deep, primeval knowledge about bodies, time, death, and the powers of reproduction. And they age and entropy in a way that mirrors the inevitable flow and decay of all things. They are connected to wild nature in the outdoors, away from the feminised domestic spaces of the house. Most monstrous of all is that they know their power.

They are the elderly and independent women, the plant-doctors, the midwives, the landowners, the gay, bisexual or gender-fluid who have been cast out and vilified throughout our histories. They are the foreigners, and the women who articulate, rather than suppress, their desires and ambitions. They are the ones who do or attempt the unthinkable in a world that has decided what is permissible for women to do (such as become president of the USA). For all of these reasons, they are a threat to the normalised ideals of patriarchy, and a threat to women too – because they show them how life could be.

'All human societies have a conception of the monstrous-feminine, of what it is about woman that is shocking, terrifying, horrific, abject,' wrote Barbara Creed in her groundbreaking study of female monsters in 1993. And across geographies and cultures our images of monstrous women have a lot in common. Often they commune closely with the animal world or have hybrid animal identities. Their voices and mouths are terrifying – they cackle, they bite, they draw blood, they swallow and engulf and befuddle and hex with their words and incantations. They possess powers of transformation. Their sexuality is boundless.

Monstrous women, from fiction to myth to true crime, are almost always depicted as having voracious, non-normative sexual appetites that surpass and usurp male virility. Sometimes she appears as the alluring femme fatale: irresistible to the men who desire her and the women who aspire to be like her. She can be found everywhere from the Bible to Victorian painting, film noir and twenty-first-century TV shows. The femme fatale seems to have it all – she is independent and enjoys sexual fulfilment, but this comes at a price: rejected by society, she is the focus of male aggression and is ultimately always destroyed. As such she is a cautionary tale warning women not to want too much.

The idea of female monstrosity is almost always related to women's reproductive bodies; their vaginas and wombs have been mythologised into lethal traps that emasculate and castrate men, the inside of their bodies imagined as a seething mystery that draws on our primal fears of the archaic mother and the unknowable place of our origins. Not confined to distant folklore, this fear rebounds in the twentieth-century horror movie trope of the self-reproducing monster, from the deadly engulfing blob, to Ridley Scott's Alien – a female monster that multiplies overwhelmingly and corrosively outside of male control. Then there's our hard-to-shake fear of menstruation – traceable at least as far back as classical Greece and perpetuated over centuries by most organised religions, which have mystified women's bodies (even from themselves), making them feel strange, unclean, ugly, sinful and disempowered.

Among the monstrous images that Hillary Clinton was assaulted with during the 2016 presidential campaign, one in particular

stuck: numerous memes appeared with Clinton's features super-imposed onto historical images of Medusa, the mythological snake-haired Gorgon queen-cum-witch-cum-monster whose gaze turned whomever she looked at to stone (a reminder if ever there was one, of the fears about women looking). According to Greek mythology, Medusa was silenced by the hero Perseus (born from the raped maiden Danaë), who was the only man brave enough to slay her by decapitating her snaky head.

During Trump's campaign, images of the Greek hero and Gorgon monster were available to buy emblazoned on mugs, T-shirts, totes and the type of tank top known colloquially as a 'wife-beater', with Trump as grimly victorious Perseus, and Clinton as the decapitated Medusa. This wasn't the first time that the vanquished body of a monstrous woman was used by a power-hungry male leader as a gesture of his political control. The prototype for the Trump propaganda stands in Florence in the most public of city thoroughfares – the Loggia dei Lanzi (home also to Giambologna's *Rape of the Sabines*). Benvenuto Cellini's bronze sculpture of *Perseus with the Head of Medusa* (1545–54) was commissioned by the autocratic ruler and member of the Medici dynasty, Duke Cosimo I. Cosimo saw himself as the contemporary equivalent to the hero Perseus, and the sculpture was a very public visual assertion of the duke's intention for dealing with any threat to his authority: enemies would be slaughtered.

In Cellini's statue, dissent and unruliness are succinctly collapsed into the body of a monstrous woman. Perseus grimly holds up the severed head with its writhing bouffant of snakes, while beneath his feet the severed corpse of Medusa lies

contorted and oozing snaky ropes of blood. Amid this butchery our eyes are drawn to the still smooth orbs of the cadaver's breasts, with their visibly erect nipples. It is a gesture of the complete silencing and the complete objectification of a woman's body – and we are encouraged to read both as necessary for Cosimo to maintain his domination of the Florentine republic.

Thus from the sixteenth to the twenty-first centuries, the story of Medusa and Perseus has been adopted as a symbol of male heroicism in the face of female threat. But the story is in fact an admission of real female power. Because the victorious moment of decapitation, immortalised in Cellini's sculpture and appropriated in Trump merchandise, is not the final climax of the myth. Perseus was driven to kill Medusa not because she posed a threat to him directly, but because her death helped him to become a hero. After his birth, the infant Perseus and his raped maiden mother Danaë were packed into a box and thrown into the ocean by Danaë's furious father, who was terrified of a prophecy that his daughter's child would kill him. They emerged safely on the island of Seriphos, where the island king Polydectes fell in love with Danaë. Perseus was jealous and didn't want his mother to have a relationship with another man. He got in the way, so Polydectes sent him on a mission to bring back the head of the monstrous Medusa – a mission he thought would end in certain death. Perseus prevailed against the odds and secured his hero status by killing Medusa in her cave – with the help of a mirrored shield that allowed him not to have to look at her directly. He brought the head back to Seriphos in a special sack and showed it to Polydectes and his court, freezing them forever into stone, and then gave it to the warrior goddess

Athena, who put Medusa's face on her own shield as a form of protection, a sort of evil eye that would ward off other dark forces. *This* is the story's conclusion, and the one that is all but invisible in art and culture: that Medusa's incomparable power was taken from her and exploited by Perseus for his own gains; that the hero, in other words, actually depends on the monster.

Frightening images of Medusa have been so deeply hewn across high and low culture, for so long, that it's hard to believe she wasn't always a symbol of terror. Her decapitation is one of the earliest stories represented in Greek art – traceable to vase paintings of the seventh century BCE. But Medusa's story is more archaic and her monstrosity far more ambivalent: the ancient world believed that blood from the left side of her head was lethal to those who drank it, while blood from the right side raised the dead. She could, in other words, restore life as well as destroy it, and this power was even harnessed by Asclepius, the demi-god of healing and medicine, to cure those wounded on the battlefield.

Medusa's early identity and snaky attributes are complex and muddied by the sands of time and adaptations using different recycled aspects of goddesses from Ancient Greece and North Africa. Her ancestral roots are intertwined with those of the Greek goddess Athena – who was once the ancient Libyan serpent goddess known as Anatha, who evolved from the ancient Egyptian triple goddess Neith (the 'terrifying one'). Neith was revered as creator of the universe, 'mother of all gods' and 'all that was, that is and that would be'. Part of Neith's triple identity was a snake goddess, who symbolised wisdom and the forces of destruction that were intrinsic to creation.

An important word about snakes before we go on. Before they became symbols of evil, lust and deceit, associated with the biblical fall of man in the Garden of Eden, snakes were ancient symbols of divine female wisdom, regeneration, healing and immortality. They were associated with the moon, which sloughs its shadow as it wanes and waxes – just as the snake sheds its skin. And because the lunar cycle was taken to match the life-giving menstrual cycle of the womb (another cycle of shedding and regeneration), snakes also symbolised fertility and birth. For these reasons, Medusa was 'the protector of sex, death, divination, renewal and of dark moon mysteries', a version of the great Earth mother divinity that has been worshipped since the beginning of time.[33] Some accounts even associate her with a medical school in the Ancient Egyptian city of Zau, which specialised in gynaecology, obstetrics and the education of female doctors, possibly overseen by medical women such as Peseshet, who was born around 2700 BCE.

Medusa is also linked to pre-Greek matriarchal societies such as the Amazons, with some historical sources stating that, as far back as 6000 BCE, she was their priestess, or queen. The Amazons were a race of warrior women who originated from ancient Libya. Immortalised in Homer's *Iliad* and then much later in the twentieth-century Wonder Woman comics, the Amazons were a matriarchal society who fought with javelins, were said to have invented the cavalry, and were known for their valour, ambition and passion for war.[34] But their identity and authenticity has been obscured by spurious legends passed down in Greek and Roman texts – texts that revel in salacious tales of lesbianism, man-eating, male infant massacring and the

unnatural rejection of motherly duties. These slurs reveal some of the long held anxieties about collectives of women living in non-conformist ways and are remarkably similar to the fears expressed about witches in the sixteenth century and women seeking more independent lives in the nineteenth century (as we shall soon see).

Medusa's knotted mythography tells us that for millennia she was the epitome of female power – a mother goddess of healing, birth, immortality and knowledge, who was possibly connected with reproductive care for women and the education of female doctors, and who was a symbolic ruler of matriarchal societies. How was something so strong denigrated into a terrifying menstruating demon, whose power was weaponised against her in the service of the male 'hero'? And why are other versions of her myth so little-known?

One theory suggests that because Medusa and the Amazons represented matriarchy, overthrowing them was necessary for the colonising Greeks to form their own national identity as a virile patriarchal state. (The Greek defeat of the Amazons is proudly sculpted on the exterior of the Parthenon in Athens.) The usurping of Medusa by the hero Perseus is in many ways then an analogous story of Greek victory over matriarchal power and the Amazons, and knowledge of both have faded into historical obscurity. Even now, the idea that a matriarchal society could have existed in which women had non-monogamous sex, were heroic rulers, and used men for sexual pleasure and siring children has been routinely dismissed as fantasy by historians. Denying a credible precedent denies the possibility that an alternative to patriarchy can or has ever existed. But recent

archaeological digs in western Russia have proven not only the existence of Amazonian societies, but that women in these societies lived differently to the way in which we are accustomed to think of our predecessors, for instance that they were both mothers *and* bold skilled warriors. They appear to have lived the ideal of what our society has seen as two seemingly incompatible opposites, and this thrills me. (Most of all I like to imagine how different things might have been if these matriarchs and not the Virgin Mary had become the ur-symbol of motherhood.)

It's possible that the Greeks didn't like the idea of a supreme matriarchal divinity who presided over life and death, destruction and creation, so they created the myth that associated supreme reproductive powers with a male god. Medusa has been linked to the Greek goddess Metis, the mother of Athena, who was born from her father Zeus' head after he swallowed Metis/Medusa. This may remind you of the birth of Venus we discussed in the first chapter, who was born from her father's testicle – another story that overwrote female reproductive agency. (We'll come across something similar later in the story of Adam and Eve, as well as in the persecution of witches.)

Whereas Athena and Medusa had once been aspects of the same triple goddess (Neith), the Greeks cast Medusa's erotic power and sexuality in opposition to the goddess Athena's virginity, an early version of the now familiar virgin/whore or Madonna/Magdalene binary. This type of binary thinking plagues how we see and understand the world, how we see and judge women, and how we have categorised gender identity altogether. We tend to make monsters of the people who don't fit neatly into the system we accept as 'normal': those who refuse

to be defined as men or women, but both, or neither. And we don't only use binary thinking in terms of sex and gender, but in terms of so many values, such as good/evil, light/dark, black/white. Perhaps by rethinking our female monsters, we could become more comfortable with women's – and others' – ambiguity, with women inhabiting seemingly opposite identities at the same time.

Later on, the Roman poet Ovid was responsible for another addition to Medusa's myth. He overlooked Medusa's identity as a goddess and turned her into a beautiful mortal woman who was raped by the sea god Poseidon in the Temple of Athena. In Ovid's tale, the rape angered Athena, who transformed Medusa into a monster the world would fear and ostracise. Both culpability for the crime and responsibility for the punishment were offloaded from the male actors in the story onto women, one beautiful, one jealous.

Latent in this recast myth is the recurrent horror of the reproductive sexual body and the desire to control it: Medusa's symbolic links to fertility and sexuality were overwritten as she became instead a body that was sexually defiled and victim-shamed. Medusa was then dealt the ultimate punishment for a woman in a patriarchal world: she was made horrible to look at.

Medusa's descent into a figure of abject monstrosity continued. By the fifteenth century in Italy, Medusa's snaky hair and destructive gaze were linked to anxiety about menstruation. It was believed that snakes would spawn from the earth where a menstruating woman lay a piece of her hair, and that a woman on her period could stain or dull a mirror just by looking at it (which, incidentally was a theory put forward by the same man

who developed the theory about Venus' divine female beauty, Marsilio Ficino).[35] Menstrual blood was also thought to poison humans, wilt vegetation and blacken bronze.

Who tells the story gets to decide who the monster is. As historian Miriam Dexter writes: '[Medusa] reminds us that we must not take the female "monster" at face value … [but must look to] the stance of the patriarchal cultures which create her, fashioning the demonic female as scapegoat for the benefit and comfort of the male members of their societies.'[36] What does it tell us then that Medusa's early origins and historical symbolism still go mostly unacknowledged in contemporary culture? The Metropolitan Museum of Art staged a retrospective of Medusa-influenced images in art and cultural artefacts in 2018 which focused on the complex history of the goddess as something of a femme fatale – a reductive and easily digested exotic fantasy of female identity as something both beautiful and horrific.

In the butchered history of Medusa and her body we can find an entanglement of fears about women's bodies, agency and their choices of how to live, all of which resurface in later monsters.

With her North African heritage, the face and body of Medusa also represent the foreigner whom the xenophobic Greeks could not tolerate. Hesiod writes in the *Theogony* that Medusa came from beyond the Oceanus river (which ran around the border of the Greek world), and Herodotus says specifically that she was Libyan. Recovering Medusa's African heritage introduces another way of seeing female monstrosity, because the defiled body of the once deified Medusa can also be read as the defiled

body of the colonised woman, her snaky hair a cipher for the curly African locks that became the symbolic antithesis of smooth, 'civilised' European hair. Medusa can be read, in other words, as the unmanageable black woman with unmanageable hair who has been suppressed and marginalised.

In the last century global doctrines about beauty and femininity have politicised black hair, in particular black women's hair. There have been court cases in the United States about the unfair dismissal of women from work who refuse to cut or straighten their natural hair, but, as yet, there has been no resolution among US courts on the right for black people to wear their hair naturally in the workplace. Books such as Althea Prince's *The Politics of Black Women's Hair* and Emma Dabiri's *Don't Touch My Hair* trace how black hair has been a factor in racial discrimination from the first enslavements of Africans, even serving as a justification for slavery and exploitation by colonising Europeans, who argued that black hair was more like woolly animal pelt, making black people like livestock.

Turning black hair into something problematic and unruly was also a way of suppressing its beauty. This was enforced in eighteenth-century Louisiana in what were known as the Tignon Laws. These sumptuary laws compelled Creole women to cover their hair so it wouldn't distract white men, who might find it more attractive than white women's hair. This type of racial profiling has helped to associate black women's hair with issues of suppressed identity and a dangerously fetishised beauty that has the power to 'corrupt' those who look at it.

Like the straightening of black hair to fit with Eurocentric beauty ideals, the blackness of antiquity has also been

straightened out and whitewashed by historians who have wanted to maintain that the heritage of ancient Greece was white and European, 'uncontaminated' by other influences. In 1987 the British academic Martin Bernal wrote the first volume of a history called *Black Athena*. The books revolved around a central premise that the revered culture of ancient Greece was dependent on the earlier cultures of North Africa. His thesis ignited a heated, ongoing debate about acknowledging Egypt's blackness and Ethiopianism.

In many art history classes, a similar norm uncritically centralises Greek and Roman antiquity, which is very often taken as the definitive starting point for the 'birth of civilisation'. The study of Western culture routinely begins in fifth-century BCE Athens, and follows a predictable story which suggests that after the fall of the classical civilisations the world was plunged into darkness, until the blinding light of the Renaissance period – when some of the ideas, images and stories from the classical world were reheated and remixed. What came before and what came in between is often either left in wilful obscurity or marginalised in favour of the greatest hits that take us from the Parthenon in Athens to Michelangelo's Sistine Chapel ceiling and onwards. These conversations and ways of seeing often dance around how much or how little of classical Greece and Rome the artist referenced or rejected while a worldview beyond European shores and beyond the recognition of male artists within this canon is usually completely ignored.

If you think that this has had little impact beyond privileged study on art history courses, it's important to recognise that the classical patriarchal culture of Greece and Rome has

also been plundered by white supremacist political groups. Twentieth-century dictators Hitler and Mussolini both weaponised the signs and symbols of classical art, and alt-right, anti-feminist and white nationalist groups continue to use it to promote their ideas. One example is 'The Hundred Handers', who post racist stickers in public places and identify with the sexual predator Zeus, whom they consider, in a neo-Nazi fashion, to be an 'Aryan spirit'.

It's reasonable, with what we know about Medusa's early cult in North Africa, to ask whether Medusa was originally a black African deity from Libya. But it is a question that classics scholars have wanted to shrug off and undermine. However, the fact that subsequent black artists and poets have identified with Medusa's defilement and erasure and humiliation as symptomatic of their own experience is meaningful.

In a performance at the ICA in London in 1993 the poet Dorothea Smartt made the connection explicit. A black lesbian woman, Smartt was called 'Medusa' as a negative racial slur by children in her Brixton neighbourhood, and the monster/goddess became a persistent motif in her poetry. Smartt writes about 'the nappiheaded nastiness, too tuff, too unruly too ugly too black' to reveal just how the privileging of white culture and white beauty standards projects monstrosity onto black bodies. But the poet also reclaims something of the early pre-Greek attributes of Medusa's mythology: at the ICA performance, with her hair done up in 'loks', Smartt draws on Medusa's mythical, symbolic and sexual power. Her poetry asks us to look again at Medusa's open screaming mouth, to see it as an effort to be heard and understood for who she is and not how she has been manipulated.

Medusa and her ambivalent power, sensuality and 'otherness' has been mapped onto black women in popular culture more recently too. In 2013 the British artist Damien Hirst styled the singer Rihanna as Medusa for the 25th-anniversary cover of *GQ* magazine. Rihanna's self-created, uncensored erotic persona was translated into the image of the snake-haired Medusa, who appears in this image as both lethally dangerous and sexually enticing. Seen here on the cover of a men's magazine that is directed towards men's pleasure, it is a fantasy of black womanhood seen comfortably from a safe distance, through the eyes of a white male artist. Hirst is quoted in an interview inside the issue saying Rihanna is 'bad', which he elaborates on by saying 'you know, she's bad bad'.

On the one hand, when we read an image of a black woman posing as a mythological monster as a symbol of 'badness', we are enforcing a denigrating misogynoir view, because the picture draws on a historically and culturally informed racism. (For example we might find echoes of the sexual fascination with Saartjie Baartman, aka the 'Hottentot Venus', whose body was framed as monstrous, deviant, less evolved and animal-like.) Considering the undertones of the colonial gaze – from the ancient Greeks' suppression of Medusa to the continuing politics of black hair – Rihanna as Medusa conforms to a fetishised stereotype of non-white women as sexually exotic and dangerous.

On the other hand, Rihanna as Medusa could be seen as a *reclamation* of black womanhood, and a way of centring Medusa's blackness, female sexuality and self-assured power as something to celebrate. These concepts have mostly been

invisible in art and wider popular culture – that is until two black women brought the music industry to its knees and conservatives reaching for holy water in the summer of 2020 with the release of Cardi B and Megan Thee Stallion's single 'WAP', the first (and, as of publication, only) rap single by an all-female collaboration to reach number one globally on Spotify. The music video and lyrics put black women's sexual pleasure and autonomy centre stage – their preferences, their appetite, their 'wetness' – in a way not everyone could handle. Medusa's imagery and her erotic, ambivalent power haunt the music video too: at one point the two singers are seen lying down on the floor while snakes slither over their bodies, the sinuous movement suggesting uncontrollable pleasure and sensation (as well as being unavoidably phallic).

The critical reception was complex; some hailed it as a feminist masterpiece, others suggested its explicitness was a backwards step for feminists who have been fighting against the sexualisation of women in the media. Whichever side you fall on, the response to the video made something very clear: society tolerates sexually explicit images of women as long as they conform to an ideal that doesn't relate to women's autonomous erotic pleasure. Encouraged to be hyper-sexualised and available spectacles from a young age, when women focus on their own erotic desires and satisfaction, they are seen as monsters, and even more so when they get rich doing it.

The female monster's sexuality is chief among her threats, but her mouth has also been feared and reviled: whether it's the witch's odious incantations or the female scholar's speech,

monstrous women's mouths often swallow up and consume people like prey. Medusa, for example, is often pictured howling with an open jaw, her mute scream a terrifying black hole.

When Sigmund Freud got his hands on the Medusa myth at the start of the twentieth century, he turned her into a particularly terrifying symbol for men. Freud referred to Medusa's cavernous mouth as the 'vagina dentata', or the toothed vagina – a devouring chasm that castrates men. This wasn't just a perverse bit of psychoanalytic fantasy on the part of Freud – versions of the vagina dentata exist in folklore all over the world. A myth from New Mexico tells of a house of 'vagina women' who consumed men after they had sex with them, but one day a heroic man found a way to overcome the problem. He fed the vagina women some sour berry medicine that made their teeth fall out and their lips pucker so that they could no longer bite but only swallow and provide pleasure to men.

The more we think about it, the worse the whole notion of the vagina dentata becomes for what it says about women's mouths as the site of speech, self-expression and identity, let alone what it says about their sex organs. And this idea is still acutely apparent in the microaggressions of everyday sexism, from the favourite sexist slur that describes women's voices as 'shrill' when they express an opinion in the public sphere, to the now clichéd term 'mansplaining', which reflects an inability to accept that women's voices carry intellectual authority.

Contemporary Indian artist Mithu Sen has drawn on the threatening speech of the monstrous woman in explicit ways in her work. Her performance art is characterised by an

intentionally unintelligible babble that she calls 'lingual anarchy' which contrasts with the sort of language that is used in art criticism to rationalise women artists' explorations of female experience. Sen's 2019 performance *Unmansplaining* references the way in which men's and women's voices have traditionally been gendered: the authoritative and rational voice of reason and culture as male; and the irrational, hysterical, misunderstood voice as female.

For the performance, the artist appeared before an audience of art critics at the Venice Biennale dressed in a crimson-coloured dress, brandishing a staff as she moved sensually and unpredictably around the room reciting her antagonistic, jarring flow of non-language over a background recording of excerpts of commentary by male art critics about art and feminism. In this guise, Sen embodied the archetypal portrayal of Eastern women as 'witch-goddesses' uttering unintelligible incantations – a misrepresentation of south Asian women that the artist is keen to correct.

Sen's performance can be read as part of the artist's wider project of 'unmythologising' – a process of 'unlearning' the way women's bodies have been read and what they have symbolised, a counter-mythology of sorts that uncovers the aspects of womanhood that have been suppressed.

Other women artists, especially from the 1970s women's movement, have addressed the demonisation of women's reproductive organs as sites of mystery, danger and castration. In 1979 Judy Chicago created *The Dinner Party* – a feminist fantasy banquet for 39 historical and mythological women including the ancient deities Ishtar and the Hindu goddess Kali, trailblazing

author Virginia Woolf and the Celtic queen Boudicca. A place is also set for an anonymous 'Amazon'. The banqueting table sits on a 'heritage tiled floor' emblazoned with the names of a further 998 women, including Medusa and the biblical Lilith (whose story we will soon resurrect).

At each woman's setting is a colourful ceramic plate decorated with semi-abstract designs resembling vaginas and vulvas; these lay on intricately embroidered runners and are accompanied by chalices and utensils. Chicago's plates can be read as a reversal of the vagina dentata mythology and the tableware's inescapable connotations with feasting and oral consumption are a reclamation of women's sex organs as a place of sensation and pleasure.

When it was made, the work also functioned as an explicit rejection of the expectations about what 'fine art' should be, as it openly embraced what were perceived as the 'lower' arts of embroidery and ceramics that were traditionally seen as feminine, and thus inferior and less valued.

However, the insistent vulva imagery invited the criticism of different groups. Conservatives were piqued, claiming that the plates were 'ceramic 3-D pornography' (a reminder that, for some, women's bodies can only ever be sexual and taboo). Museums and institutions were reluctant to exhibit it too, and so when the installation first went on tour in the 1980s, it often had to be crowdfunded and shown in awkward non-art spaces such as gymnasiums. Neither was it ubiquitously well-received by feminist critics. Some feminists complained that reducing each woman to a vagina undermined her individual achievements and identities, arguing that the work celebrated rather

than critiqued misogyny. It was condemned as 'essentialist' – a common argument within feminist criticism, which challenges the assumption that women are primarily identified by having vaginas and wombs (and that their value is contingent on their biology).

More problematic is that the historical sweep of the work suggests a universal female experience but remains exclusionary. *The Dinner Party* recognises only one black woman: Sojourner Truth, the nineteenth-century abolitionist and women's rights activist. Truth's setting had one of the only plates decorated not with vulva motifs but with three heads resembling African masks, which Chicago explained were a remembrance of slavery. (The other was for the English composer and suffragist Ethel Smyth.) This point of difference seemed to express that Sojourner Truth couldn't be represented in the same terms as the other women at the table with an iconography that positively reclaimed their sexual bodies; this was read by critic Hortense Spillers as part of a systemic erasure of black women's sexuality, which remained unimaginable and inexpressible for white feminist artists (and, as the furore over Cardi B's and Megan Thee Stallion's 'WAP' suggests, still remains unthinkable for some).[37]

Some women artists have wanted to see *The Dinner Party* dismantled and binned; others have seen it as an empowering celebration of the suppressed voices and histories of a collective (if exclusive) cultural genealogy of women. These continuing debates are a reminder that we can't quite resolve how best to depict women's bodies in a language that is universally empowering and dignifying.

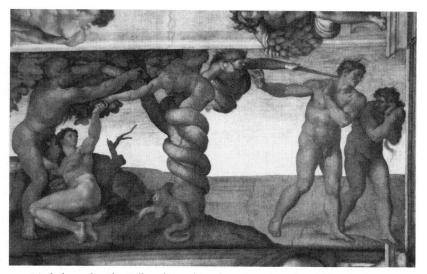

Michelangelo, *The Fall and Expulsion from Paradise*, detail from the Sistine Chapel ceiling, 1508–12, Sistine Chapel, Rome. Photo © akg-images / Album / Prisma

Among the 20,000 or so daily visitors to the Sistine Chapel in the Vatican palace in Rome, most will miss what looks like an interrupted act of fellatio hiding in plain sight. Eve, the mother of humanity, sits perched on a stone in front of the first man, Adam, who leans over her to catch hold of the thick scaly branches of a tree, his penis egregiously close to Eve's face.[38] Both turn their heads towards a muscular half-serpent, half-woman hybrid monster entwined around the tree. This creature has interrupted Adam's pleasure by distracting Eve, reaching in earnest for her hand, their gazes locking as she urgently passes her something. In doing so, she bypasses Adam altogether – coldly snubbing him – although his direct stare and accusatory pointed finger suggest that he recognises her.

This creature is Lilith, known in the Bible and in Jewish mythology as the first wife of Adam and a reminder of what happened when God tried creating man and woman as equals from the same soil. She first appears in the ancient Mesopotamian *Epic of Gilgamesh*, and then around 700 CE in the Babylonian Talmud, and her story is told in the Midrash (a collection of Jewish commentaries and interpretations of the Hebrew Bible) and in the book of Jewish mysticism known as the Zohar. But the most sustained account is in the hugely popular medieval text the *Alphabet of Ben Sira*. These collected texts framed Lilith as a disobedient witch who refused to lie beneath Adam during sex and argued with him about gender equality. She didn't want to be subordinate to her partner and instead chose to leave the safety of the Garden of Eden and spawn copious monster children with demons, including with Satan.

Lilith became known for an untameable sexuality and was thought to steal semen from men while they sleep in order to fertilise herself. She has been linked to early vampire-lore and is still invoked in Jewish culture as the thief of newborn life, known as Lamia, who is responsible for cot death and has to be repelled with protective amulets. She has been described as a primordial serpent, a fungus, a whore, seductress, embodiment of evil and sexuality, and James Joyce called her the patron saint of abortions. In pictures she has appeared as the classic femme fatale, all tumbling tresses and crimson lips, a façade that covers her 'real' identity as an old hag or a serpent – the message here being that she is duplicitous and untrustworthy.

Lilith shares many of the characteristics of other monstrous women: she is sexually liberated, untethered from the

restrictions of marital monogamy, erotically self-sufficient and has an unquenchable appetite for reproduction. Her semen-stealing reputation has echoes of the castrating vagina dentata, and, like Medusa, Lilith is symbolically associated with snakes, including here on the Sistine Chapel where she is wrapped around the Tree of the Knowledge of Good and Evil. In this context her serpent form takes on an ambivalent symbolism between its older archaic significance as divine female knowledge and fertile power associated with Medusa's cult, and its more deviant reputation as symbol of sin and vice.

Knowledge, after all, is what is at stake here in the 'fall of man': Adam and Eve are ordered out of the Garden of Eden for tasting the forbidden fruit from the Tree of Knowledge, an error that is roundly seen as Eve's fault for wanting to know too much (as much as God). On Michelangelo's ceiling, it's Lilith who seems to interrupt Eve's role giving pleasure to Adam and who offers her enlightenment as an alternative. It looks like the new wife and the first wife become accomplices.

Despite her central significance, most visitors to the Sistine Chapel don't notice Lilith. The most reproduced detail is instead the Creation of Man, the moment when God and Adam's fingers meet and the first man is infused with life in God's image. But if Adam is made in the image of God, Eve is propagated in very different circumstances – like a plant cutting, taken from one of Adam's ribs. In an earlier scene on the ceiling we see Eve emerging as a fully grown woman from Adam's flank. Her lumpy undefined body already bows in supplication to an irritated-looking personification of God, who seems to be telling her off from the moment she is born.

In the Christian creation story, male bodies are the ones that reproduce: God makes Adam, and Adam makes Eve. Female bodies are seen as lesser, incomplete derivatives. We might even draw a comparison to the denial of the female reproductive body in mythological stories about the birth of Athena from Zeus' skull and of Venus, birth from her father Uranus' severed testicle. All of these stories express an unease with our dependency on women to procreate.

In the nineteenth century Lilith frequently appeared in paintings and literature as a vehicle for the Victorians to express their anxieties over the so-called 'New Woman', who emerged out of burgeoning movements for female emancipation and suffrage. Such women were sometimes also known as viragos – a term that has been used since antiquity to describe either a 'warrior woman' or a woman who displayed what were typically understood as 'masculine' qualities, ambitions and desires. Viragos posed a threat to gender-essentialist Victorian society by putting pressure on the professional spheres to include women and to educate them to do the sorts of things that had been ringfenced as male.

Lilith became sexually objectified in Victorian art as a way of undermining her, which is still the preferred way of disempowering powerful and intelligent women. The British artist John Collier's 1889 painting *Lilith* sums up the general tone: the bold and autonomous heroine is rendered into a milky-skinned pin-up fantasy nude who nuzzles an anaconda that wraps itself around her curves, constricting and manacling her in an orgy of sensation. As an image it effectively turns the powerful, ambiguous Lilith into Venus (with undertones of the captured maiden) in order to tame her and stem her independence.

While the figure of Lilith persists in contemporary popular culture (as a character in video games and TV vampire tales such as *True Blood*), she has also been reclaimed by feminists and queer communities as an icon of resistance. During the second wave women's movement of the 1970s, Lilith became a model of sexual and economic independence, especially for Jewish feminists and theologians who embraced Lilith's story as an example of a heroine unwilling to defer to her husband, who was unafraid of leaving the security of the Garden of Eden (or the nuclear marriage).[39] Queer women also saw Lilith as a role model who lived outside of a society whose gendered codes and expectations were marginalising and oppressive, and some feminist readings saw a homoerotic relationship between the two wives of Adam latent in the texts.[40]

Around the same time, the artist Sylvia Sleigh painted a version of Lilith for a collaborative feminist art project called the 'Sister Chapel', a temporary installation that premiered in January 1978 at PS1 exhibition space in Long Island City, New York. The artist and creator of the project, Ilise Greenstein, saw it as an intentional contrast to the story of Genesis told on the esteemed Sistine Chapel ceiling – a story that authorises a misogynistic worldview by making women accountable for God's anger and condoning their oppression.

Instead, Greenstein's Sister Chapel is a womb-like tent with eleven monumental paintings of historical, contemporary and mythical women. They range from warrior Joan of Arc to the US Women's Movement leader Bella Abzug, artists Frida Kahlo and Artemisia Gentileschi, the feminist author and activist Betty Friedan, as well as mythical figures such as Lilith and the Hindu

Sylvia Sleigh, *Lilith*, 1976, Rowan University Art Gallery, Glassboro, NJ
© Estate of Sylvia Sleigh

goddess Durga. It is a non-denominational genealogy of female strength, wisdom, creativity and knowledge that poses the question 'Where was woman in man's relation to god?' Although, like Chicago's *Dinner Party*, it betrays a predominantly white worldview.

During its time, the work was sympathetically received; influential critic Lawrence Alloway described it as a 'long-awaited legible iconography of women in political terms'. And

yet the Sister Chapel fell into obscurity for four decades and only found a permanent home in 2016 at the Rowan University Art Gallery in New Jersey.

Sylvia Sleigh's nine-by-five-foot canvas of Lilith presents a figure whose body is both man and woman – one layered over the other – with the female body on top perhaps as a reference to Lilith's refusal to lie beneath Adam during sex. The blending of the two genders emphasises Lilith's equality with Adam, both of them made from the same soil. This Lilith could be read as the literal embodiment of the virago, the woman with masculine traits and bisexual tendencies that frightened the Victorian patriarchy. But she is not bellicose or threatening: set against her floral background, Sleigh's Lilith is a queered update of the objectified Victorian femme-fatales with their tumbling golden hair, fair skin and red lips (the painting self-consciously references Dante Gabriel Rossetti's *Lady Lilith*). She is Venus with a penis, an intersex figure who presents an alternative to the binary essentialism of the biblical story and the archetypal images of women we have become used to.

Beyond the overlooked images of the 1970s women's movement, Lilith's influence is also felt in twenty-first-century television writing. Phoebe Waller-Bridge's wildly successful series *Killing Eve* revolves around the character of Eve (played by Sandra Oh), a frustrated paper-pushing intelligence officer whose intuition and intellect are overlooked and undermined by her employer. An everywoman comfortably stagnating in marriage and career, Eve craves a life more extraordinary, which she finds once she becomes involved in tracking down the glossy Villanelle – a psychopathic hired assassin with an influencer's

wardrobe and an appetite for sex and violence. The two women embark on a mutual obsession with one another in a story that carries undertones of the second-wave feminist re-working of the alliance between Eve and Lilith: both women chase desires and fulfilment beyond the men in their lives (whether these are husbands or handlers), and burning throughout the show's three seasons is the sexual tension between them. Villanelle, like Lilith, offers Eve independence, awakening self-knowledge and the possibility of queer sexuality, beyond the safety net of her comfortably conformist heteronormative lifestyle.

Having said this, the show isn't necessarily the out and out feminist triumph some declared it to be. Villanelle's ramped up sexuality and aggressively erotic persona unavoidably falls back on the stereotypical trope of the femme fatale that equates monstrous womanhood with alluringly non-conformist sex. Writing in the *New Yorker* in 2019, Emily Nussbaum commented on how in the show 'murder and lesbianism feel existentially linked, like two great tastes that taste great together'. As Nussbaum noted, what audiences applaud in their television dramas today is remarkably similar to the marriage of homosexuality and homicide that caused pickets 30 years ago at the 1992 premiere of the film *Basic Instinct*, which was roundly criticised as homophobic for its portrayal of all three villains in the story as gay.

Classical mythology has no shortage of monstrous feminine creatures to haunt the patriarchy's nightmares or provide fodder for misogyny in art and culture. Another popular monster is the sphinx – a hybrid creature from Greek mythology with the head and breasts of a woman, the body of a lion and sometimes

with a serpent's tail and eagle's wings. In Egyptian mythology, the sphinx is an androgynous guardian of desert tombs, but in the Greek version it is a malevolent female beast that guards entry to the city of Thebes. Sent as a punishment from the gods, the sphinx wreaks havoc by asking riddles and eating men alive if they can't answer.

The sphinx reflects recurrent fears projected onto female monsters: she is the woman who perplexes with her questions and her intellect, and who emasculates those who don't understand her by gobbling them up whole (like Medusa's castrating mouth). In the Greek myth the hero Oedipus defeats the sphinx by solving her riddle – What has one voice, but is four-footed, two-footed, then three-footed? *Answer: man* – and the creature hurls herself off a cliff in defeat. Oedipus' victory leads to his coronation as king of Thebes, which makes the story another example of how a heroic male character dispatches the feminine forces of chaos to assume power (in an echo of the Perseus and Medusa myth).

The sphinx, like Lilith, was also a regular motif in late nineteenth- and early twentieth-century painting. Artists including Franz von Stuck, Edvard Munch and Gustave Moreau depicted the sphinx as part nightmare, part erotic fantasy – a duplicitous animal-woman with a carnivorous sexual appetite. Her hybrid form was taken as evidence of her 'degeneracy' and, in a period fascinated by Charles Darwin's theories of evolution, the sphinx woman was made to represent the degeneracy of *all* women and their 'less evolved' nature than that of men.

As ever, this archetype of demonic womanhood was not confined to the art gallery. A cartoon by Bernard Partridge in the political magazine *Punch* in 1922 shows a sphinx enigmatically

winking at the viewer as she casts her vote in the General Election. Her bobbed hair is a nod to the fashions favoured by the more progressive of the first generation of women voters. But it's clear that Partridge's cartoon is less a celebration of universal suffrage than a suggestion that women were too degenerate a species to be given the vote and their new rights would lead to certain chaos.

In the 1930s European artists were still deeply in love with the idea of the animal femme fatale, who seems never to be far away from the dreams of the Surrealist artists. One of the movement's favourite metaphors was of the cannibalistic female praying mantis who devours the body of her male mate during sexual intercourse. What was a woman artist to do to counter these reductive narratives about women's sexuality and the monstrosity of their agency? Although women had access to professional artistic training by the twentieth century, there were still societal restrictions which meant that they were generally only granted access to the avant-garde art world as lovers, students, muses or wives of male artist luminaries. However, Surrealist artist Leonor Fini refused all of these suffocating roles and lived in sexual freedom, making herself an alluring monster – she often dressed in a cat or lioness mask, and identified as androgynous and non-monogamous.

Like Sleigh's non-binary Lilith, Fini also queered the image of the sphinx and flipped the script on the idea of the degenerate femme fatale. In her paintings Fini created ambivalent sorceresses who coolly possessed all of the powers and complexity denied to women of her era. For Fini, these sphinxes expressed what she called 'a perfect fusion of both sexes'.

In *Shepherdess of the Sphinxes*, a majestic-looking human shepherdess presides over a coven of small sphinxes. She cuts an ambivalent figure, neither traditionally masculine nor traditionally feminine: her facial features and hair may conform to feminine stereotypes, but her splayed muscular legs are more androgynous, and the staff she straddles is tantalisingly phallic. Although nude, this heroine reveals nothing of her breasts, and her groin is covered with armour, preventing us from enjoying any erotic view of her body.

Leonor Fini, *The Shepherdess of the Sphinxes*, 1941, Peggy Guggenheim Collection, Venice (Solomon R. Guggenheim Foundation, New York)

With their glistening haunches and tousled hair, the sphinxes sit indifferently around the warrior-like shepherdess in a barren landscape littered with broken eggshells, bones and decaying vulvic-looking plants, as one of them toys with the stem of a flower with blackened petals. At first glance this detritus would suggest death and destruction, but the many hatched eggshells also suggest the creation of new life. Beneath what seems like an impenetrable surrealist fantasy, *Shepherdess of the Sphinxes* suggests something about the organic material nature of living things – that creation is also dependent on rot and decay, that fertility comes from putrefaction. Her sphinxes' procreative powers are not sanctified or made to seem essentially feminine, nor is their sexuality demonic. They are neither divine mothers, nor rampant monsters; they inhabit a world freed from binary essentialism, in which the forces of nurturance and violence, creation and destruction sit comfortably and intimately together.

Before the gargantuan Domino Sugar Factory in Brooklyn was demolished in 2014, American artist Kara Walker filled the space with a 75-foot-long sugar-coated sphinx with the head of a black mammy. The sculpture was named *A Subtlety, or the Marvelous Sugar Baby*.

Built in the 1880s, the sugar factory remains synonymous with the long shadow of the history of slavery and the exploitation of black labour in the Caribbean and the American South, where enslaved men, women and children planted and harvested sugar cane. Walker's gleaming white mammy sphinx embodies the shadow side to sugar's ineffable whiteness and

Kara Walker, *A Subtlety, or the Marvelous Sugar Baby, An Homage to the unpaid and overworked Artisans who have refined our Sweet tastes from the cane fields to the Kitchens of the New World on the Occasion of the demolition of the Domino Sugar Refining Plant*. Installation view: Domino Sugar Refinery, A project of Creative Time, Brooklyn, NY, 2014. Photo: Jason Wyche

sweetness, the monstrosity of its repressed history, told through an ambiguous monument of a black female body.

Despite its monumentality, the Sugar Baby was created to be destroyed after a single showing: a monstrously visible, but temporary, reminder of the history of enslaved black women's bodies. The mammy sphinx's pose references the sentinel Egyptian sphinxes that guard the desert tombs of pharaohs but replaces the head with a black mammy in her headscarf – a symbol of the oppression and exploitation of black women

who provided domestic and emotional labour to white families in the pre-Abolition era. Beneath the mammy's stormy visage are a pair of breasts that echo the sensual and alluring femme fatale sphinx, but also the surrogate maternal comfort found in the breasts of the black mammy who was a refuge for white children.

This sphinx also tugs at the historical discourse connecting black women, animality and sexuality: at the rear of the sculpture, the powerfully coiled haunches parted to reveal the sphinx's ten-foot-long vulva. It was both vulnerably open and defiantly visible – sexually objectified but her sexuality also confidently demystified, in a way that other feminist works haven't historically been able to do for women of colour's bodies.

In her left hand the fingers and thumb make the ancient Roman 'fig' gesture, which is most commonly used as a symbol of fertility or else means 'fuck you', depending on which way you look at it. (Perhaps the two aren't so different after all?)

Visitors were not entirely sure what to do in this sphinx's company. Some wept. Others shuffled sheepishly by, burdened with colonial guilt. Some took selfies, posing near the breasts and vulva, gesturing crude sexual acts. Many were saddened by this violation of a body that memorialised black pain and exploitation, as they watched a real-time re-enactment of the very histories of abuse that the work was trying to trouble. The artist watched on too, filming visitors' responses which she then screened at the gallery Sikkema Jenkins & Co. The casual antics of spectators in front of Walker's mammy sphinx became as much a part of the work as the sculpture itself – a reminder that an artwork never just exists on a wall, on a plinth or in a

museum, but also depends on who sees it and sets its meanings in motion.

A preparatory collage displayed near the sculpture hints at how we might start to unravel this 'marvelous sugar baby's' overload of meanings and associations. It joins a picture ripped from the pages of a magazine of a black woman perched provocatively on all fours in lace lingerie with another ripped picture of the stone head of an Egyptian desert sphinx. Looking between one assemblage and the other – between sculpture and collage – is to yo-yo between a reading of the mammy sphinx as high archaeological cultural object and as faceless erotica.

This ambiguity means that finding concrete meaning in front of the work is elusive: we can't quite reintegrate the mammy sphinx into the reassuring language of classical civilisation, and so we can't see her through the framework of monumental Western culture that has excluded black women. Unlike Fini's sphinxes, who we might read as 'perfect fusions' of apparent opposites, the mammy sphinx tells us something about the violent transferral between blackness and whiteness: it is the riddle of how black experience gets shaped into a narrative that reflects whiteness. And this process itself echoes the grand sugar enterprise of refining dark substance to white matter, as well as classical history's suppression and erasure of its African origins.

Monsters – like the black mammy sphinx, but also Lilith and Medusa – unsettle and agitate and destabilise and resist reduction into perfect takeaway meanings by bringing what is repressed up to the surface. We could think of how we tend to look at art, how we've learned to expect a resolution – a fixed meaning that reassures us that we've cracked the code or

unlocked the underlying message, grasped the artist's intent. But the more I think about this, the more I start to feel that searching for the perfect meaning is in fact a form of violence – it reduces and contains things by purporting to make them fully knowable, and becomes a way of owning them.

Type the word 'witch' into an internet search engine and stand back. First there's a flood of green faces and deformed snarling features, glowing cauldrons, long white hair. Steadily these give way to pointed hats, sequins and suspenders, exaggerated cartoon bodies in bustiers and capes, or little girls with silky hair and broomsticks. Sift through the Hollywood tropes from the *Wizard of Oz* to Angelina Jolie as Maleficent and then you might even find some nice girl witches: the pretty and goofy retro ones who use their magical powers to do helpful chores around the home, or the girl-power witches in crop tops and knee-high boots who parade under the guise of kick-ass feminism. But nestled in this array there are also historical woodcuts of women burning, tied to a stake, or seen hanged from a gallows. Even a cursory visual haul tells us so much about how the image of the witch has been created to suppress women by casting them as frightening nightmares and criminal heretics, or sexually objectifying them so that they fit more comfortably back into misogynistic culture.

Like Medusa, our earliest 'witches' in Western imagination were women deeply connected to the non-human world and to the environment. The first witch in literature is the sorceress Circe who appears in Homer's poem *The Odyssey* (eighth century BCE). She lives happily isolated on an island where

she interacts harmoniously with wild beasts and becomes an expert in plant-based medicine (both practices associated with witches of later folklore and treated with suspicion). When Odysseus lands on her island on the way home from the Trojan War, he ends up staying with Circe for a year and with her help becomes the first mortal to visit the underworld. Circe is a figure associated with death and passing through it, as was her mother Hecate – the supreme goddess of magic, witchcraft and childbirth who is at least as old as Hesiod's *Theogeny* (likely written around a similar time to Homer's epic poem).[41] But, like Medusa, the cultural images that have become representative of both Circe and Hecate have been turned into enduring symbols of vice and terror. Hecate appears on the monumental Pergamon Altar (second century BCE) as a benevolent ally to the goddess Artemis, honoured by all the immortal pagan gods, or in devotional figurines as a three-bodied immortal deity, but by the Renaissance period, Marsilio Ficino called the goddess a 'monster', and in later images and literature such as Thomas Middleton's eighteenth-century play *The Witch*, Hecate became a disfigured hag who boiled babies and had an incestuous relationship with her son.

Circe became known as a demonic temptress who led men to lose their reason. By the time of the Renaissance, her name had become synonymous with the word 'whore', and by the nineteenth century, she became (like Lilith) interchangeable with the sexually free 'modern woman' who threatened to upend the angel of the house figure that kept women in versions of a heteropatriarchal 'Eden'. Hecate and Circe's influences live on in contemporary culture: Circe the femme fatale is the

ancient ancestor of today's sexy sorceress stock character of cosplay, fantasy epics and Halloween erotica, who also appears as a sexed-up villain in video gaming culture. And Hecate the hag informs the now ubiquitous symbol of the child-eating sterile witch with broomstick, animal 'familiars', long straggly hair, hooked nose, and sagging face and body.

Anthropologists tend to agree that the image of the witch is a strategy used to make people, chiefly women, conform to expected social norms, and that witches are prevalent in societies around the globe and across time in which patriarchal institutions have tried to suppress pre-existing matrilineal ones. Today, each culture still has its 'witches', from women in public life with claims to authority to those who are actively persecuted and executed on suspicion of practising magic. The last woman to be convicted and imprisoned under charges of witchcraft in Britain was Helen Duncan in 1944 (six years before the Witchcraft Act was repealed), who is yet to be exonerated for her 'crimes'. Women in China are regularly labelled as witches by rivals who want to appropriate their land and undermine their economic success, while in India, between 2000 and 2012, over 2,000 women were accused of witchcraft and murdered in rural areas.[42]

The most well-known period of persecution, the one most cemented in our imagination, took place over the course of three centuries, from around 1400 to 1700: the early modern witch trials in Europe. Scholarly estimates of the number of executions during this period vary wildly, ranging from 10,000 to 6 million, and many polemical debates continue to rage in witchcraft scholarship, which is often defensive against overtly feminist

readings. The vast majority of those persecuted were female, some as young as eight years old – such as Gertrude Svensen,[43] who was accused of stealing children for the devil and was burned at the stake in Älvdalen, Sweden in 1669.

The archetypal figure of the witch as an old hag was spawned in the woodcut illustrations of the *Malleus Maleficarum*, a hugely influential treatise on witchcraft first published in Germany in 1486. Written by Catholic clergyman Heinrich Kramer, the *Malleus Maleficarum* sold more copies across Europe than any other book except the Bible for nearly two centuries and became the main point of reference for inquisitors and courts across the continent during the witch-hunting period. The book offered judgements such as 'when a woman thinks alone, she thinks evil' and suggested that witches could convince men that their penises had disappeared. (It's easy to find the common fear of castration and emasculation that links monstrous women together here.)

The *Malleus Maleficarum* focused its attack on elderly women, independent women and women with opinions, and it reserved a special hatred for midwives, who were condemned as the most dangerous threat to the consecration of the Church. The midwife's role providing relief to women in childbirth made her a subversive figure to those who believed that it was a God-given directive that women should experience pain in labour as a punishment for the sins of Eve in the Garden of Eden. Moreover, she was the attendant to Mother Nature, who could manipulate the raw mysteries of nature and fertility with her dark arts. Midwives couldn't be trusted, says the *Malleus Maleficarum*, not least because they might ferry newborn souls directly to the devil.

Hans Baldung Grien, *The Witches*, 1510, Metropolitan Museum of Art, New York. Gift of Felix M. Warburg and his family, 1941

Of the many artists that were influenced by the *Malleus Maleficarum* was German artist Hans Baldung Grien, who produced a series of wildly popular images of witches that circulated among an educated elite of male European collectors. His woodcut print *Witches' Sabbath* from 1510 sets up the general theme: women – pictured nude, with coarse bodies, withered breasts and wrinkled skin – cavort around with legs akimbo,

grinding things, and feasting on dead babies. One younger witch rides backwards on a goat, gazing coyly at the viewer with a long staff strategically placed to suggest its insertion between her legs. Among the elite male audience who collected them, these prints encouraged a mixture of erotic fascination with moralising disgust. While the body of Venus allowed a culturally sanctioned way to look at sexually pleasing nude female bodies without being judged (because of the loftier civilised associations with classical mythology), sexually suggestive images of witches allowed a similarly permissible thrill under the safety of the moralising concerns of the Church.

Baldung's misogynistic witch fantasies extended into his paintings. In an image called *The Ages of Woman and Death*, two women stand together like reflections of one another in a barren landscape. One is young and lovely, posing in something of an alluring *Venus pudica* pose, while her future elderly self places an arm on her shoulder, tugging at the younger one's robe in a vain effort to cover her groin. A skeletal figure of death links the older woman's arm, holding an hourglass in which the diminishing sands suggest that it is now time to go. The partnering here of the beauty and the crone promotes one salient idea: that women, no matter how lovely on the outside, are all hags in Venus' clothing, just waiting to be unmasked by the march of time.

Widespread among Christian preachers was the recurring metaphor for the female body as a polluted vase, or vessel, which also had connotations with the German word 'vas' meaning 'womb'. Jars and vessels of noxious looking matter feature in Baldung's prints and act as visual puns for the polluted interiors

of witches (and by extension all women's bodies); they create a direct contrast with the image of the Virgin Mary as the sealed fountain, or the blessed and pure vessel.

While women of all ages were accused of witchcraft during this period, there was a particular focus on the older woman. Whereas once the elderly woman represented the wisdom and experience of old age and provided valuable knowledge to her community, by the sixteenth century, she reeked of death and was disenfranchised from her property and ostracised from the community. The social scientist Silvia Federici argues: 'The witch-hunt turned the image of the old woman upside down: traditionally considered a wise woman, she became a symbol of sterility and hostility to life.'[44]

Women wear time on their bodies in ways that are perceived differently to the way in which men age, and images of the elderly hag as the harbinger of death and sterility have reinforced the value and beauty of women's bodies as indexical to their biologically fertile years. Ageing in women is also not seen to be beautiful because it tends to be linked to an increase in knowledge and confidence (and sometimes, if they are privileged, an increase in economic and social power too).

The odious image of the witch has depended on making the sexuality of older women seem monstrous and perverse. Historical evidence of the witch trials are unequivocal in their accusations of sexual deviancy, and the widespread assumption that women were excessively lusty and unable to control their sexual appetites. As the *Malleus Maleficarum* declared: 'all witchcraft comes from carnal lust, which is in women insatiable.'

Baldung's print *New Year's Greeting* from 1514 shows an intergenerational sapphic orgy, a world of female sexual pleasure without men that reveals male anxiety about female collectivity and the threat of sexual conversion in the coven, of satisfaction to be found beyond the phallus. Equating sexuality with evil, heresy and sterility in the figure of the witch also helped to consolidate the identity of the ideal of womanhood: the youthful virgin mother and her descendant, the angel of the house. The witch-hunts helped to bring about the breakdown of female social collectivity, and the ensuing gendered separation of the public and domestic spheres created the isolated 'lady of the house', susceptible to consumption and flattering maladies, both physical and psychological, that disempowered her.

The witch has been framed as the antithesis of femininity, when in fact she is the suppressed reality of human mortality that has been made destructive and abject, as if it could be avoided if women behaved differently. And she provides a foil for our images of Venus that explains why we idolise pictures of women, but demonise them in real life. Our belief in the monstrosity of the witch then relies on the fact that society continues to believe that the worst fate imaginable for a woman is to be old and ugly. That is, unless we take the witch back from those who have manipulated her into a figure of deviant, festering femininity and use her to repudiate all the nooses with which women have been choked.

In the late 1960s and early '70s women's liberation groups in the United States and Europe drew on the repressed power of the witch to attack the structures of patriarchy and capitalism that they saw as to blame for women's oppression. At the core

of their beliefs was the connection between the privatisation of common land and resources and the widescale persecution of women as witches. (Today eco-feminist movements still view the appropriation of the earth's resources as contingent upon the abuse of women's bodies.)

Among these thinkers, Silvia Federici argued that the transition to a capitalist society involved a separation of the spheres of material production and reproduction, which in other words means one group of society went to work, generating a wage and the production of goods for sale, while the other group stayed at home to have babies. This second group didn't just do the important work of mothering, producing another generation of workers to feed back into the capitalist machine, but were also tasked with tending to the basic needs of the workforce by cooking for them, doing housework and washing their clothes. Thinkers like Federici have suggested that for this to work – for patriarchy to have control over reproduction and get their socks washed and dinner on the table – meant that the women who didn't accept this role were at first marginalised and then eradicated. She writes that, for capitalism to flourish, 'the heretic, the healer, the disobedient wife, the woman who dared to live alone' had to be conquered and punished.

It's in these ideas that we find what is at first glance an unlikely alliance between the domestic and emotional labour of women within the home, and the tradition of persecuting witches. Federici was one of the organisers of the Wages for Housework campaigns of second wave feminism that protested at how capitalism had mystified women into accepting domestic labour as a natural quality of being female. The slogan

that formed the drumbeat of their marches in the 1970s was *'Tremate, tremate, le streghe son' tornate!'* or 'Tremble, tremble, the witches are back!'

Jesse Jones' complex multimedia art installation *Tremble Tremble* takes its name from the Wages for Housework campaign so as to set the history of reproductive and social control, witchcraft and women's oppression into motion. First shown in the Irish Pavilion at the Venice Biennale in 2017, *Tremble Tremble* establishes an empowering counter-myth that draws on the disruptive feminist power of the witch.

At the centre of the installation, two twenty-foot-high screens play a looped film of an intimidating woman with flowing white hair and an expressive face creased by time and age. She moves, illuminated against the darkness, overturning courtroom furniture, sometimes with her face close to the screen, forcing the audience to see her. Towering above the spectators, she is a giantess crone who recalls the forgotten deities of Celtic folklore. She is also the first body of our primal memories, a reminder of the giant birth mother whose mercy and care all infants depend on in their first moments of life.

At one point the camera focuses on her mouth, but, turned 90 degrees, it becomes a bit of Freudian mischief – a talking vagina dentata uttering the testimonies of Temperance Lloyd, a woman tried and burned at the stake for witchcraft in 1682. The crone also recites the (fictional) matriarchal law of 'In Utera Gigante' that will overthrow patriarchal rule. For Jones, this matriarchal law returns reproductive autonomy to individual women, for them alone to decide which life might live in their bodies and which cannot, in the spirit perhaps of the archaic

creator/destroyer goddess Medusa. Deeply informed by the language of pro-choice movements, *Tremble Tremble* was subsequently shown in Ireland in 2018 against the backdrop of the movement to repeal the Eighth Amendment that criminalised abortion. The giantess crone also recites passages from the *Malleus Maleficarum* backwards, as if to reverse them is to peel back the influence of the misogynistic language that has authorised so much hatred of women.

In the foreground of the space, two giant bones reflect light from the screen. These bones reference the bones of 'Lucy', our earliest known bipedal ancestor who walked the earth of Africa over 3 million years ago. Gleaming in the light, they represent history pulled from the sediments of time and the long genealogy of women's history that has been hidden from the surface of things, their bodies and stories erased or smothered and replaced.

Tremble Tremble shudders with these repressed histories of reproductive coercion, and the social oppression of women, but it also presents an opening to something more liberating, even if this is not without a certain amount of dread, as we teeter on its precipice, looking into the darkness at a story that has yet to be written, and at new ways of seeing ourselves and our long histories that have yet to come fully into focus.

Wearing the monster or the witch as the true self, and not as the sexy mask of the femme fatale, might be a step towards women's self-determination that allows us to reject the obsession with Venus' fallacious perfect exterior, to fully embrace the conflicting joys of mothering, and to provide another role model that goes beyond the fragile, passive maiden who surrenders

to sex and abuse rather than is active in her own pleasure. Kara Walker and Jesse Jones' large-scale works show us how important the connections are between monstrosity and what is repressed; and how our power lies in engaging with our collective histories and seeking the origins of the images and histories we accept as the 'truth' or the norm.

Most of all, monsters give us a new way of looking, because they themselves look head on at the male gaze and disrupt it. They allow us to reverse the curse of the Lady of Shalott who died for looking and desiring, and rethink the myths and images that have duped us into believing that the woman who looks at the world is a monster, while the man who does so is an artist.

Still now, the assumption is that for a woman to excel in her art she must become a monster – or an 'art monster' to use a term popular among women writers (most famously Jenny Offill in her 2014 novel *Dept. of Speculation*). Women who write or make art are thought to be monstrous because doing this requires breaking the social code that expects women to do the lion's share of cleaning, caring, nurturing and cooking; monstrous because it requires sloughing the snake-like skin of femininity to reveal the unreconstructed monster who won't be the domestic worker.

In her 1997 novel *I Love Dick*, Chris Kraus posed another, earlier definition. The book revolves around the letters of a narrator, a woman artist approaching middle age who becomes erotically fixated, to the point of obsession, on a cultural critic and academic known as Dick. He represents the very top of a hierarchy of success that is designed for the easy ascent of white men. In many ways Kraus' narrator (also called Chris) conforms

perfectly to the trope of the monstrous woman; no longer the maiden ingénue, she is a childless artist who refuses to cease speaking and writing about her desire as it overflows boundaries of social propriety and personal space. When she is rejected by Dick, she resists the easy cliché of the scorned middle-aged woman 'past her prime' and carves even deeper into her frustration, using it as sustenance. She spills her personal feelings, makes them political and resists self-censorship. At one point Chris confesses to a friend how she aspires to be a 'female monster', like the artist Hannah Wilke (whose work *Intra-Venus* we considered in the Venus chapter): 'Female monsters take things as personally as they really are. They study facts ... Every question, once it's formulated, is a paradigm, contains its own internal truth.'

There's something here of the sphinx and her fatal riddles and questions, and 'studying facts' reminds me of the way in which women's knowledge has been made taboo. Most of all though, I think what Chris means here is that female monsters offer us new ways of looking that go beyond the exchange of seeing and being seen.

They offer us the power and freedom of being more than one thing, of ambiguity. They allow us to be unruly, not easily categorised or contained, to live outside of the roles or behaviours that racist, patriarchal capitalism has set out for women. With this in mind, we might start to move away from these restrictive archetypes – without expecting to establish new ways of seeing women, and art, in their place that are perfect, or that work perfectly for everyone.

Epilogue

Writing this book during the 2020 lockdown with two children at home, my own monstrosity became uncomfortably present to me, my children flinching at the flashing of my eyes when I protested my need for enclosure in my study to work, to write.

But women must write. They must, as the feminist philosopher Hélène Cixous said, 'write about women and bring women to writing'. Continental philosophy isn't generally known for its frankness, simplicity or application to everyday life, but, in Cixous's 1975 essay 'Laugh of the Medusa', the French philosopher wears her heart on her sleeve. She is upfront and impassioned about her desire 'to bring women to their senses and to their meaning in history'. Cixous tells women to look straight at Medusa. She tells them to stop listening to the men who have made history, and if they can do this – if women can claim knowledge of themselves, their fantasies and pleasures, if they can listen to the uniqueness of their bodies and language and speech – then others will also listen to them.

This has been something of my project too: by writing about women in pictures and charting the histories and tangled roots

of the archetypes that limit the complexity of female experience, I also have wanted to bring a sense of meaning to women's place in history, a sense of meaning that goes beyond the roles that Western culture has created for them as mothers, monsters and maidens or that has fuelled their pursuit of the unattainably perfect Venus.

So women must not only write but they must make art too, which after all is a way of communicating the things that language alone cannot cover, a way of voicing the complexities that words cannot adequately contain. As we've seen across the range of brief examples in this book, art can be a form of activism, of consciousness-raising, a means of critique; it can also sometimes be about pleasure and empowerment, and can tell us that there is no one way to be a woman, no one script or set of templates.

Historically women have been denied the tools to express the range of their experiences – to exist beyond the stilling frame of the male gaze, held back from art academies, from looking at bodies or expressing themselves, supposedly for their own protection – as intellectual and creative labour was thought to run the risk of making women bad mothers, infertile or even clinically insane. (For instance, Virginia Woolf was cruelly denied pen and paper when suffering from bouts of depression.) And denying women the tools to articulate the complexity of their experience or interpret the events and contours of their time has been a means of control, and a way of marginalising them if they do not conform.

For this reason, depictions of women's experiences on their own terms must enter the cultural mainstream in order to give

us models and stories against which we can measure and shape our own identities.

As I've tried to show, the discussions we have about women in pictures mirror the discussions we have about women's bodies, about their reproductive choices, about sexual violence, about who is beautiful, about whose bodies are seen, or about who or what is thought to be 'good' and to have 'value'. But it's also important to remember that not all art by women is, or needs to be, about 'women's issues' or women's oppression; it's just that their invisibility and marginalisation as creators is always about this. Take the example of Rosa Bonheur, the hugely successful nineteenth-century French artist famous for painting vivid and energetic images of horses. In order to gain access to the scenes she wanted to paint – the livestock markets, the slaughterhouses where she could better observe animal anatomy – she had to gain special permission from the local police to wear trousers, so that she could pass as a man.

It's fair to say that there's a steadily growing momentum to correct gender and racial inequality in the art world, as the forgotten and overlooked contributions of women and artists of colour are brought out of archives and into the light through numerous exhibitions and publishing projects. In 2017, the Brooklyn Museum of Art staged a landmark exhibition showcasing the contributions of women of colour to the art of the second-wave feminist movement. At the time of writing, there are currently three solo exhibitions in major London institutions by women of colour, and the prestigious Courtauld Institute of Art is advertising for a professor of black art history for the first time. A woman of colour will represent both Britain and the

United States in the next edition of the Venice Biennale, the world's most important international art fair.

International collections of historical art such as the Prado in Madrid and the Uffizi in Florence now routinely make solo shows devoted to women artists, and the National Gallery in London has for the first time ever staged a retrospective show of the work of a woman artist (Artemisia Gentileschi). These exhibitions are undoubtedly welcome, and long overdue, but as Joeonna Bellorado-Samuels, the director of Jack Shainman Gallery recognises, this is just the first step in the institutional transformation that is necessary if we want to start valuing women's bodies, achievements and contributions more equitably. In a discussion about the false perception about progress in the valuing of women's work and their career advancement as artists, she suggested: 'Bodies in the room doesn't change the structure and the impact of what we've always learned about our history, and what we've always learned to be important and valuable, and how to even see.'[45]

Exhibitions dedicated to recovering 'past female masters' tend to crest on a wave of novelty and mystique, but this never gets us past the system of 'firsts' and only does so much when the permanent work on the walls of museums and galleries undermines women and their cultural production so consistently. We also need to go beyond what is sometimes a token focus on exhibiting artists of colour by committing to a sustained, widespread decolonisation of art institutions and collections, and rethinking how and what we learn from them.

For me, it's important that collections and museums don't suggest that 'there were also great women artists' who we are

encouraged to understand within the same framework as the fêted men of art history, slotting them into the canon as special interest lesser derivatives, or eager examples that women could paint and sculpt as well as any man. Nor should women artists be treated as a rare exotic breed, with their own designated space in galleries (lest they contaminate too much the integrity of the collection as a whole). Nor should they be commodified and presented in ways that suggest they are just of interest to women and those interested in feminism.

The way forward is not through censorship of the art of the past that offends our current feminist sensibilities but by interrogating it and taking the opportunity to rethink the stories that have shaped our understanding of power and gender and race. We need to think about the language we use to discuss and judge art in less divisive and inflammatory ways. Hopefully this book has provided some awareness of the nuances and complexities that inform our currently antagonistic debates about objectification, pornography and rape culture; about decolonisation; about gazes and what it means to see and be seen, and the privilege and power behind who is allowed to look, as we all work out new ways to leave behind those limited archetypes that blinker and distract us. Art and culture can afford us more ways to approach the complex personal, social and political realities of our world, and, with the contributions of more than one group, they can be ours to see more clearly.

Acknowledgements

This book emerged from a period of uncertainty after I finished my PhD when I wasn't at all sure how to be an art historian with a newborn baby and another young child. Feeling compelled to diversify, I managed to find audiences willing to listen to my thoughts on women in art and women as artists, in both official and unofficial ways. Dulwich Picture Gallery invited me to curate an evening of talks devoted to the theme of 'Women's Lives Made Art' and Sotheby's Institute of Art in London gave me the space and freedom to build a feminist art history course in which many of the ideas in this book were road-tested. I am grateful to both for granting me these forums to develop my ideas.

I am indebted to a number of people who have been fundamental to this book's development and completion. My thanks first of all go to Ed Griffiths, who was exceedingly generous with his time and with his contacts in helping me get the nascent idea for this project to sympathetic and interested publishers, via my agent Becky Thomas at Johnson & Alcock. From our very first meeting in a cramped café on Caledonian Rd, I felt an immediate affinity with Icon Books and their enthusiasm

and energy. Special thanks to Kiera Jamison, who was a consistently sensitive and attentive editor, and a kindred thinker, and to Thea Hirsi and Marie Doherty for their superlative editorial and production work. My thanks to Amy Cherry at W.W. Norton, who enthusiastically committed to publishing the US edition and whose nuanced edits of the text were invaluable. My thanks also to Claire Potter and Isobel Wilkinson for early conversations that contoured my thinking.

Intellectually, albeit from a distance, this book is indebted to the work of the British school of feminist art historians who I came in contact with as an undergraduate in the early 2000s, particularly Professors Tamar Garb, Griselda Pollock and Lynda Nead. Their work not only gave me new ways of looking and thinking about the world of images (many of which inform the writing in this book), but witnessing them as women at work in the realm of ideas formed a blueprint in my young mind of what a woman with a voice might aspire to be.

Finally, thanks to my mother always, for always believing in me.

Notes

1. As of November 2020

2. According to a joint investigation by artnet news and art advisory agency In Other Words in September 2019 https://news.artnet.com/womens-place-in-the-art-world/visualizing-the-numbers-see-infographics-1654084

3. 'Old Mistresses' is also the title of Rozsika Parker and Griselda Pollock's groundbreaking study of feminist art history, *Old Mistresses: Women, Art and Ideology*, first published in 1981 by Pandora Press, and from which many of the ideas in this book derive.

4. In a letter dated 18th September 1820, Morritt wrote to his friend Walter Scott: 'I have been all morning pulling about my pictures and hanging them in new positions to make more room for my fine picture of Venus' backside by Velázquez which I have at length exalted over my chimney piece in the library. It is an admirable light for the painting, and shows it in perfection, whilst by raising the said backside to a considerable height the ladies may avert their downcast eyes without difficulty, and connoisseurs steal a glance without drawing in the said posterior as apart of the company.' Ed. George Eden Marindin, *The Letters of John B. S. Morritt of Rokeby: Descriptive of Journeys in Europe and Asia Minor in the Years 1794–1796* (Cambridge: Cambridge University Press, 2011).

5. Facsimile of Richardson's handwritten statement reprinted in ed. Midge Mackenzie, *Shoulder to Shoulder: A Documentary* (New York: Vintage Books, 1988), p. 261. Discussed in detail in Part II of Lynda Nead, *The Female Nude: Art, Obscenity, Sexuality* (London & New York: Routledge, 1992). Nead's pioneering study of the female nude,

and her discussion of Mary Richardson's defacement of Velázquez's painting, has been foundational to this chapter.

6. To see a recording of the talk, see The National Gallery's 'The Rokeby Venus: Velázquez's only surviving nude', YouTube, 4 May 2018, https://www.youtube.com/watch?v=bGNAPjNTbCs

7. Maria H. Loh, *Titian Remade: Repetition and the Transformation of Early Modern Italian Art* (Los Angeles: Getty Publications, 2007), p. 34.

8. Until 2019 some of the national tabloid newspapers in the United Kingdom featured a topless glamour model on page 3. Between 2014 and 2019 a number of publications were successfully put under pressure by the NoMorePage3 campaign.

9. As discussed in the Historia Naturalis, discussed by Paola Tinagli in *Women in Italian Renaissance Art: Gender, Representation, Identity* (Manchester: Manchester University Press, 1997), p. 132.

10. *The loveliest limbs her form compose,*
Such as her sister VENUS chose,
In FLORENCE, where she's seen;
Both just alike, except the white,
No difference, no – none at night,
The beauteous dames between. (Edwards: 34–35)

11. Also known as Sara Bartmann. There is some discussion as to whether to use Saartjie, a diminutive of the name, or Sara, the name with which she was baptised in England. For more on this, see: http://www.saartjie baartmancentre.org.za/about-us/saartjie-baartmans-story/

12. Lorraine O'Grady, 'Olympia's Maid: Reclaiming Black Female Subjectivity', in ed. Joanna Frueh, Cassandra L. Langer & Arlene Raven, *New Feminist Criticism: Art, Identity, Action* (New York: HarperCollins, 1994).

13. Robin Coste Lewis, 'Broken, Defaced, Unseen: The Hidden Black Female Figures of Western Art', *New Yorker*, 12 November 2016.

14. Jon Simpson, 'Finding Brand Success in the Digital World', *Forbes*, 25 August 2017, https://www.forbes.com/sites/forbesagencycouncil/2017/08/25/finding-brand-success-in-the-digital-world

15. A. Rochaun Meadows-Fernandez, 'That viral Gap ad sends a powerful message about breast-feeding and black motherhood', *Washington Post*, 1 March 2018, https://www.washingtonpost.com/

news/parenting/wp/2018/03/01/that-viral-gap-ad-sends-a-powerful-message-about-breast-feeding-and-black-motherhood/

16. Protests first erupted in 2013 in response to the acquittal of the police officer responsible for killing black teenager Trayvon Martin in 2012.

17. The work, known as *Analogous Colors*, featured on *Time* magazine cover, 15 June 2020.

18. For an excellent discussion of black feminist depictions of black motherhood and Beyoncé's images, see Ellen McLarney, 'Beyoncé's Soft Power: Poetics and Politics of an Afro-Diasporic Aesthetics', *Camera Obscura* (2019), 34:2, pp. 1–39.

19. Patricia Hill Collins, *Black Feminist Thought: Knowledge, Consciousness and the Politics of Empowerment* (Abingdon: Routledge, 2000, 2009).
 Barbara Christian, *Black Feminist Criticism: Perspectives on Black Women Writers* (Amsterdam: Elsevier, 1985).

20. https://www.cdc.gov/reproductivehealth/maternalinfanthealth/pregnancy-relatedmortality.htm. For UK data, see *Gemma McKenzie*, 'MBRRACE and the disproportionate number of BAME deaths: Why is this happening and how can we tackle it?', *AIMS Journal* (2019), 31:2.

21. Joe Pinsker, 'How Marketers Talk About Motherhood Behind Closed Doors', *The Atlantic*, 10 October 2018, https://www.theatlantic.com/family/archive/2018/10/marketing-conference-moms/572515/

22. Nils-Gerrit Wunsch, 'Baby care market In Europe – Statistics & Facts', *Statista*, 20 May 2019, https://www.statista.com/topics/3735/baby-care-market-in-europe/

23. 'Matrescence' at Richard Saltoun Gallery London, November 2019.

24. Irene Cieraad, 'Rocking the Cradle of Dutch Domesticity: A Radical Reinterpretation of Seventeenth-Century "Homescapes"', *Home Cultures* (2018), 15:1, pp. 73–102.

25. Jenna Peffley, 2018, 'Exactly How to Get Denise Vasi's Striking Old-World Decor Style at Home', MyDomaine, https://www.mydomaine.com/denise-vasi-home

26. Gus Wezerek and Kristen R. Ghodsee, 'Women's Unpaid Labor is Worth $10,900,000,000,000', *The New York Times*, 5 March 2020; the article called on statistics for the gender pay gap from *PayScale Gender Pay Gap Report 2020*, https://www.payscale.com/data/gender-pay-gap

27. Calculated by the Young Women's Trust with data from the Office of National Statistics.

28. 'There is another angel, so lowly as to be invisible, although without her no art, or any human endeavor, could be carried on for even one day—the essential angel, with whom Virginia Woolf (and most women writers, still in the privileged class) did not have to contend—the angel who must assume the physical responsibilities for daily living, for the maintenance of life.'

29. For more on this painting and the basis of this discussion, see Linda Nochlin, 'Morisot's Wet Nurse: The Construction of Work and Leisure in Impressionist Painting' first published in *Women, Art and Power and Other Essays* (New York: Routledge, 1988).

30. Quotation taken from interview with artist via email, April 2020.

31. Ovid refers to Andromeda's dark skin in his texts the Heroides and the Ars Amatoria. For a detailed discussion, see Elizabeth McGrath, 'The Black Andromeda', *Journal of the Warburg and Courtauld Institutes*, Vol. 55 (1992), pp. 1–18.

32. Barbara Johnson, 'Muteness Envy' in *Human, All Too Human*, ed. Diana Fuss (New York: Routledge, 1995).

33. Christine Corretti's study of Medusa has been an indispensable and crucial resource for the discussion of Medusa's early cult and associated symbolism for this chapter: Christine Corretti, *Cellini's* Perseus and Medusa *and the Loggia dei Lanzi* (Leiden: Brill, 2015). For the discussion of snakes, moon and regeneration, see p. 6.

34. For Medusa's identity as an Amazon priestess, Christine Corretti cites Marguerite Rigoglioso's *The Cult of Divine Birth in Ancient Greece* (New York: Palgrave Macmillan, 2009).
 The Amazons populated two specific regions. According to sources such as the first-century BCE author Diodorus, the first Amazons originated in North Africa. Recent archaeological excavations have uncovered remains of later female warrior communities on the steppes around the Black Sea (modern day Ukraine, southern Russia and western Kazakhstan).

35. Marsilio Ficino, *Commentary on Plato's Symposium on Love*, trans. Sears Jayne (Dallas: Spring Publications, 1985), p. 161.

36. Miriam Dexter Robbins, 'The Ferocious and the Erotic: "Beautiful" Medusa and the Neolithic Bird and Snake', *Journal of Feminist Studies*

in Religion (Spring 2010), 26:1, Special Introduction from the Religion and Politics Editor, pp. 25–41.

37. Hortense Spillers, 'Interstices: A Small Drama of Words' in *Pleasure and Danger: Exploring Female Sexuality*, ed. C. S. Vance (Boston: Routledge, 1984).

38. I'm not the first person to suggest this. See Robert S. Liebert, *Michelangelo: A Psychoanalytic Study of His Life and Images* (New Haven: Yale University Press, 1983).

39. See Aviva Cantor Zuckoff, 'The Lilith Question', *Lilith*, Fall 1976.

40. Notably by feminist theologian Judith Plaskow, *The Coming of Lilith, Essays on Feminism, Judaism, and Sexual Ethics, 1972–2003*, ed. with Donna Berman (Boston: Beacon, 2005).

41. See Ralph M. Rosen, 'Homer and Hesiod' in *A New Companion to Homer*, ed. Ian Morris and Barry Powell (New York: Brill, 1997), pp. 463–88.

42. Crime records gathered by the Indian newspaper *Mint*, as reported on by the *Washington Post*, 21 July 2014.

43. She appears in Chicago's *Dinner Party* and some other records as Gertrude Svensen but elsewhere as Gertrud Svensdotter.

44. Silvia Federici, *Caliban and the Witch: Women, the Body and Primitive Accumulation* (Brooklyn: Autonomedia, 2004), p. 193.

45. Bellorado-Samuels, along with Charlotte Burns, Julia Halperin and William Goetzmann, was discussing the paper 'Women's Place in the Art World: Why Recent Advancements for Female Artists Are Largely an Illusion' on the podcast *In Other Words*, No. 66, 3 October 2019, https://www.sothebys.com/en/articles/transcript-66-why-gender-progress-is-a-myth